MW00638008

KUSTOM
BY DEWEY
NICKS

I'M DRAWN TO PEOPLE WHO
DEFY THE LAWS OF GRAVITY,
WHO BECOME OBSESSED WITH
DECORATION, ADVERTISE THEIR
PERSONALITY AND MAKE THINGS
BIGGER, BRIGHTER, LOUDER
AND FASTER THAN THE
MANUFACTURER'S SPECIFICATION

DEWEY NICKS

Thoughts on Kustom by Robert Evans

You enter Robert Evans' house back-to-front. A gate, an intercom, a voice, the right answer and you're in: Beverly Hills Regency Moderne, a John Woolf masterpiece. The twelve-foot black lacquered door swings open. Rio, Mr. Evans' assistant, floats through the main house, across the flagstone pool deck, into Evans' screening room. "May I offer you a refreshment?" Rio inquires, then disappears.

I'm alone, surrounded by the trophies of Evans' Hollywood odyssey. And the room is big, big as a church. A church with a full bar and a sixteen-foot couch.

Enter Robert Evans, all in white. "Oh, please, pour yourself a drink," which is what I'm already doing. The two-story calf-suede walls absorb each vowel and consonant into a womb of silence. Settling into his favorite seat, Evans notices something is missing. "Rio, the fountain jets around the pool aren't on." He hangs up without listening for a reply.

The pool jets come to life.

He's right. It's better with the fountain on. So I say, "Evans, this place is amazing. Is this your art piece?" "I don't do it for that reason. I love the sound of water, and I love to look at it. I'm not out to impress anyone." "I'd like to talk to you about my book, *Kustom*, spelled with a *K*. Does that word, *Kustom*, have any special meaning to you?" A flawless baritone, no hesitation: "No price too high does the original bear."

Evans talks:
Evans: I own one shirt and I have it made in every color and every fabric I can. But it is one specific shirt. Same for the pair of pants. They're my own. Here's the only jacket I have. I have it in cashmere, silk, cotton.

That's all I own. One jacket. It's mine. That's it.

Dewey: Isn't that a uniform?

Evans: No, it's a silhouette. I don't do it to make a statement. I do it because I like it. I'm comfortable in it. That's the only reason I do it. It's a natural thing to do, and I've done it since I was a kid.

Dewey: And you, and you alone, are known by that style. No one else can do you–or it, right?

Evans: I don't give a shit, really, about that. I was going to have a line made: the shirt, the tie, the pants, the jacket. I never got around to doing it because I didn't want to share it [laughs]. This is the key. I go to a party and ten people come over to me and say, "God, Evans, that's a great-looking tie." I go home and I'll shred that tie. I don't want to make the tie look good; I want the tie to make me look good. I should be the foreground and everything that surrounds me the background. Background makes foreground.

Dewey: How would you define your style?

Evans: The celebration of the individual. Fashion is the celebration of the designer. I would rather wear a two-dollar shirt that's my own than wear a two-hundred dollar shirt that says Calvin Klein on the outside or jeans that say Tommy Hilfiger on the outside. Your ass is pedestaling some designer's work. So everything I have originates with me, for better or worse.

Dewey: Is that what it means to invent yourself?

Evans: Invent? That's bullshit. It's instinct; it's something you feel you want to do. It may not be practical, it may not fit everybody else, and I hope it doesn't, because if it's everyone else, it's not you anyway. And I don't mean that from an egotistical point of view. I'd like to take a trip that's my own trip.

Dewey: When you look at pictures of yourself from forty years ago, do you ever say, "What was I thinking?"

Evans: No. I say, "Geez, I wish I looked like that now."

Dewey: You look good today.

Evans: Well, I looked better then. Let's put it that way.

Dewey: You've definitely become an icon. Specifically, your glasses. I've had to wear glasses all my life, and I've come to really love wearing glasses.

Evans: Me too. When I first started wearing glasses they weren't a style item. It was strictly medicinal...corrective reasons. Now every top designer has a line of glasses. It has become no different than a sweater.

Dewey: What are glasses to you? Are they a prop?

Evans: Oh no, not at all. I don't do it for effect. When you notice my glasses, I'll throw them out. I just have different styles that I like. And I like glasses. I play with them. I always have two or three in my hands. I used to wear glasses for a reason. Before I would answer a question, I would take the glasses off. That split second gave me that extra bit of time I needed to hold back. Because I would often say things impulsively. I would be sorry later. Of course today, what was a prop is a necessity.

Dewey: What about your blue lenses?

Evans: I do it for a reason. I have reading glasses and seeing glasses. The seeing glasses all have a tint, the reading glasses are all plain. That way I can decipher what I wish.

Dewey: So you've customized them with blue lenses?

Evans: Yeah, I put a blue tint in. It's a blended tint. It goes up and down, it gets lighter as it goes down. It just makes you see the world a little better.

Dewey: What about seeing perfectly–laser surgery?

Evans: Oh, I would like to have perfect eyesight and still wear glasses.

Dewey: My wife says she's glad I wear glasses because when I take them off at night, that face belongs to her.

Evans: She has something of you that no one else has. That's a style to her.

Dewey: What about the women in your life? Have you designed them?

Evans: Any man who thinks he can design women is a man who knows nottthhiiing!

Dewey: What about plastic surgery? A lot of women in this book have had it.

Evans: Every woman has. The others lied...just how much...they lie about that too. I don't see anything wrong with plastic surgery. If I had a deformity, I'd get plastic surgery. But they've taken it to lengths now that are detracting, not attracting. Because as one gets older, your skull shrinks a quarter of an inch. That's what happens. Your ears and your nose get bigger; everything else gets smaller.

Dewey: The skin can't go along with it.

Evans: No, it can't. If your skull shrinks, it can't. It's against the laws of gravity. There is nothing you can do about it. I suppose the guy upstairs meant it that way.

Dewey: So what turns you on?

Evans: That's my business. I'm a loner. That's one thing that's worked for me and it's worked against me. Everything that's worked for me has also worked against me. And it's easier to lead a different life than the life I've led. There are much easier lives to lead. It's better to read about it than to live it. Promise you that.

Dewey: So what's the Evans credo?

Evans: I say, "I am what I am is all what I am." Popeye said that, Popeye the Sailor Man. "I am what I am is all what I am." So go ahead, call it what you want. I've never had a decorator in my house, I've never had a press agent in my office—things maybe I should have had—but it's all personal to me. It's not manufactured. It comes from the cerebellum. I know what I want. I think of it in my head and say, "It'd be really nice to have it. Let me design it and get it made."

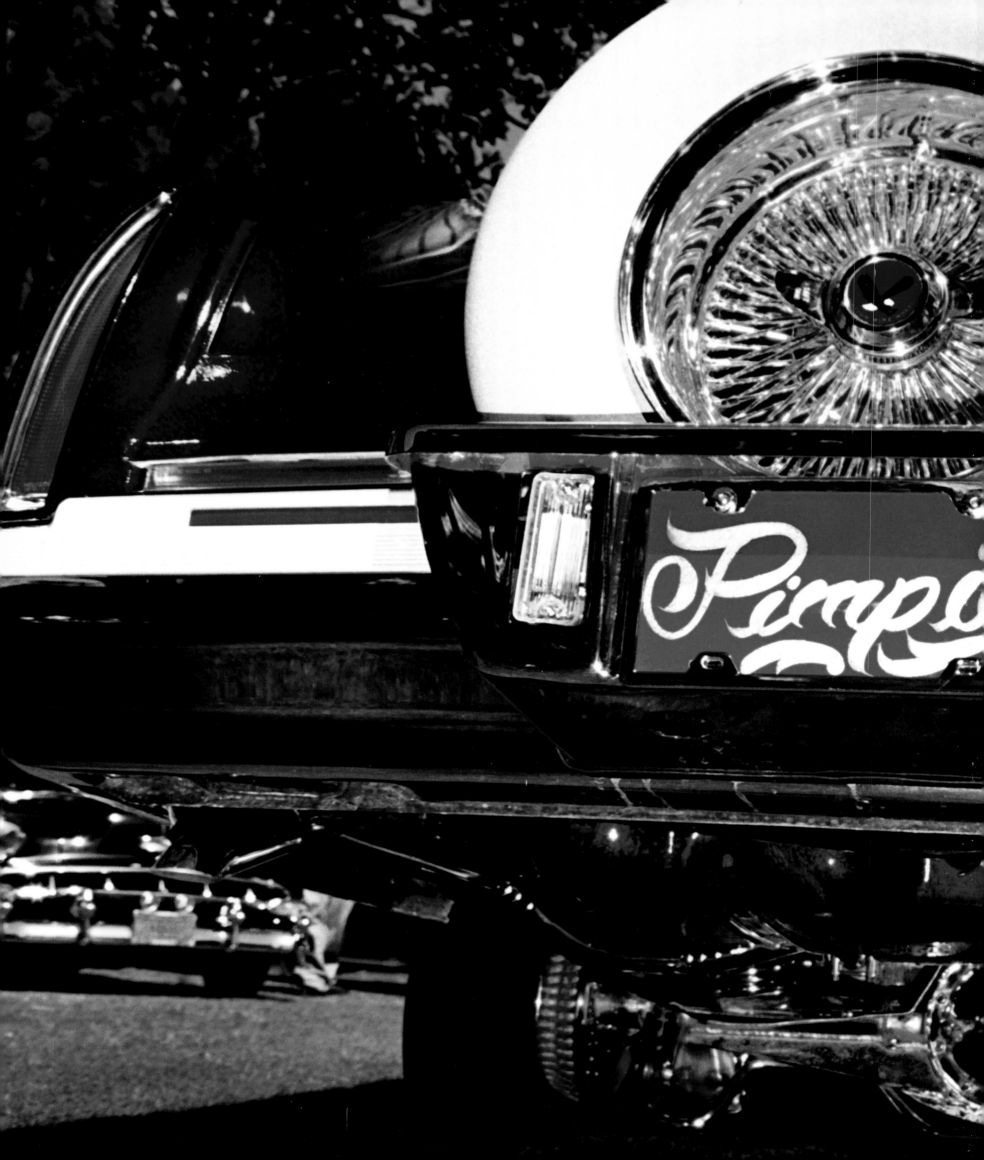

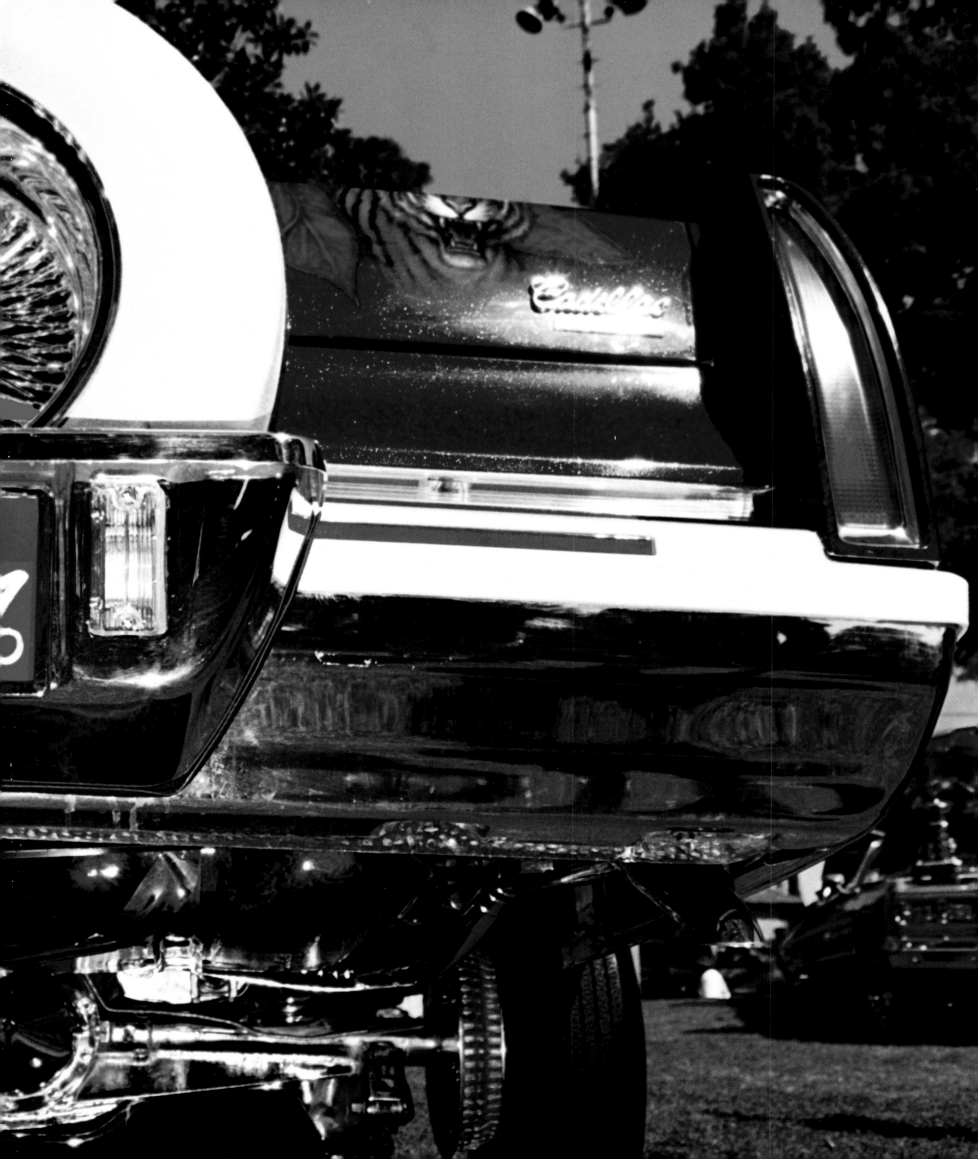

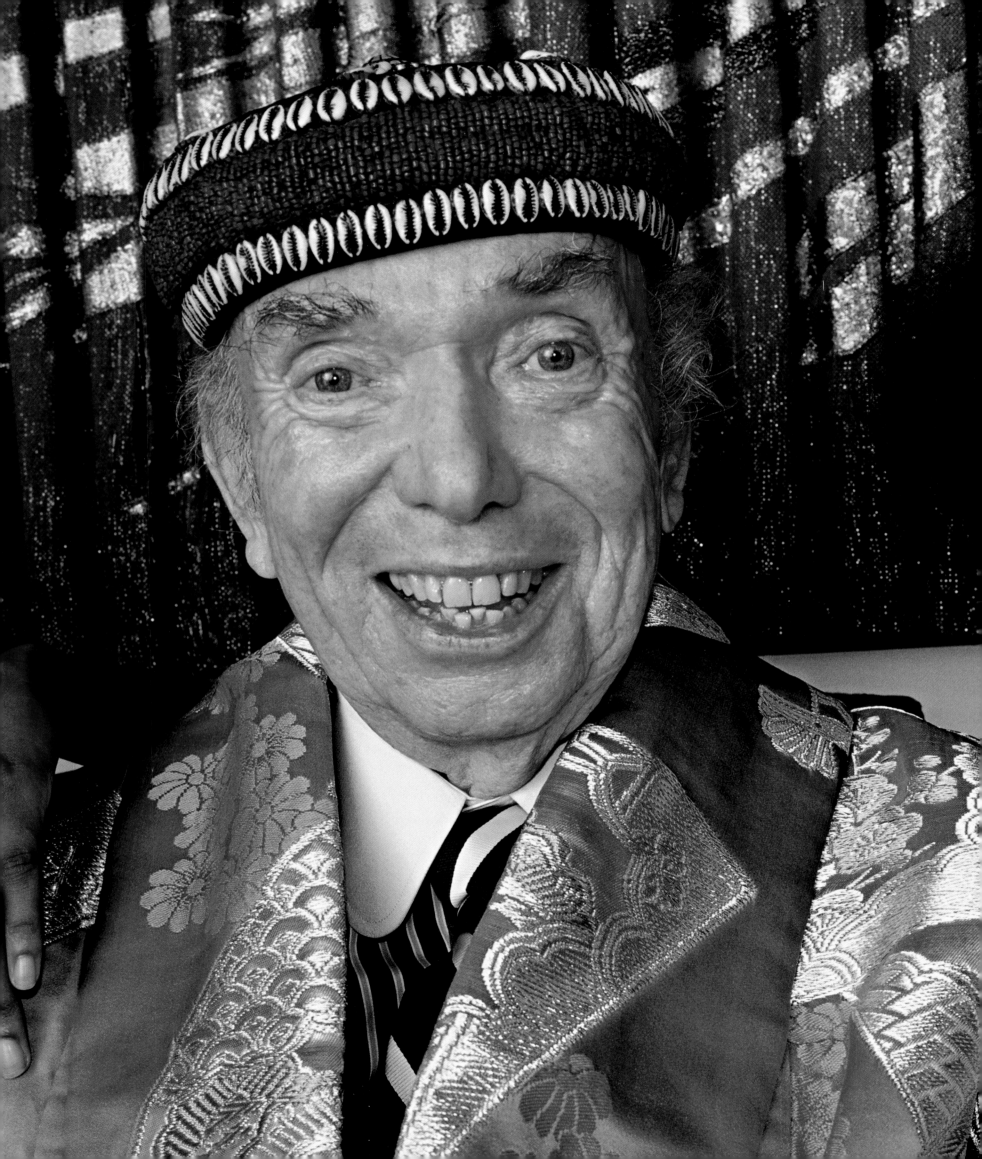

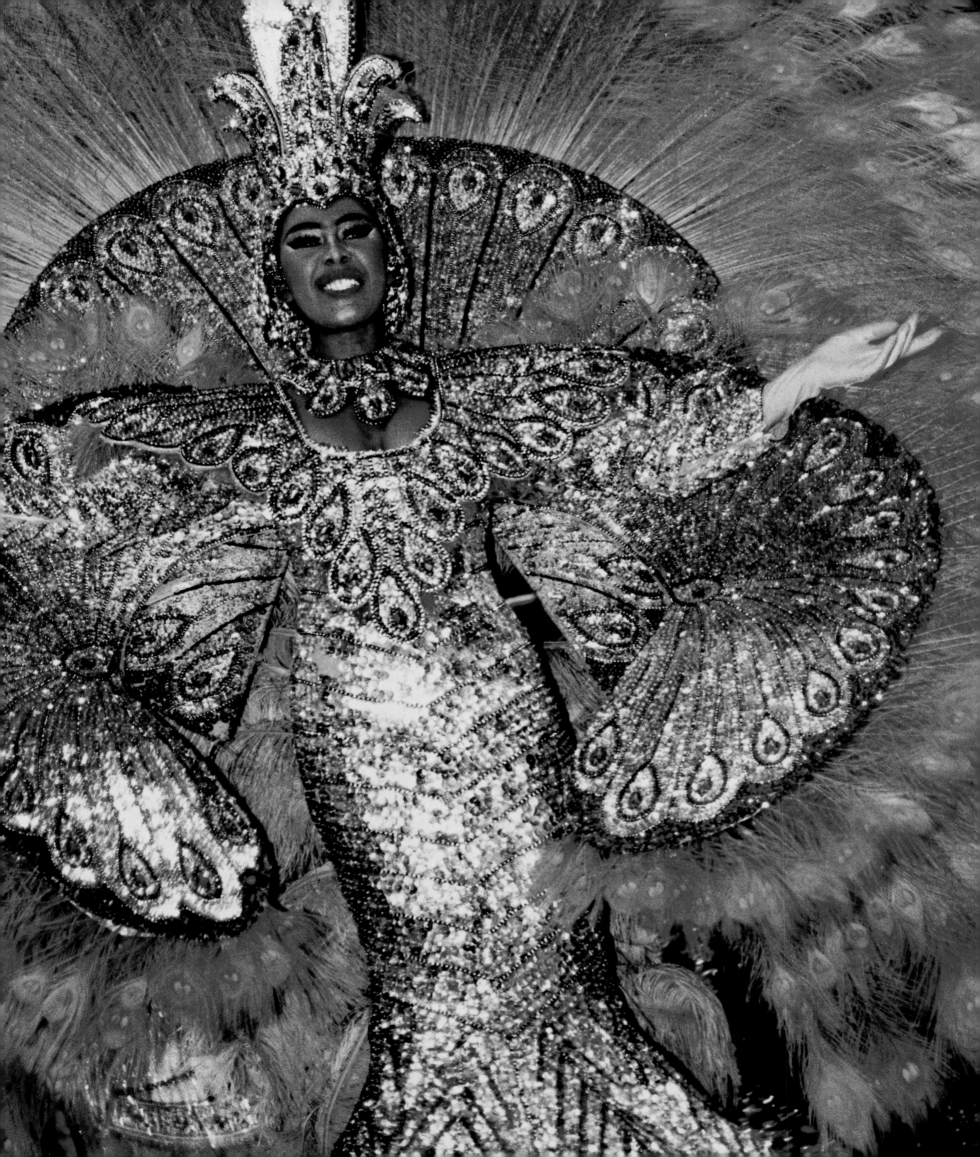

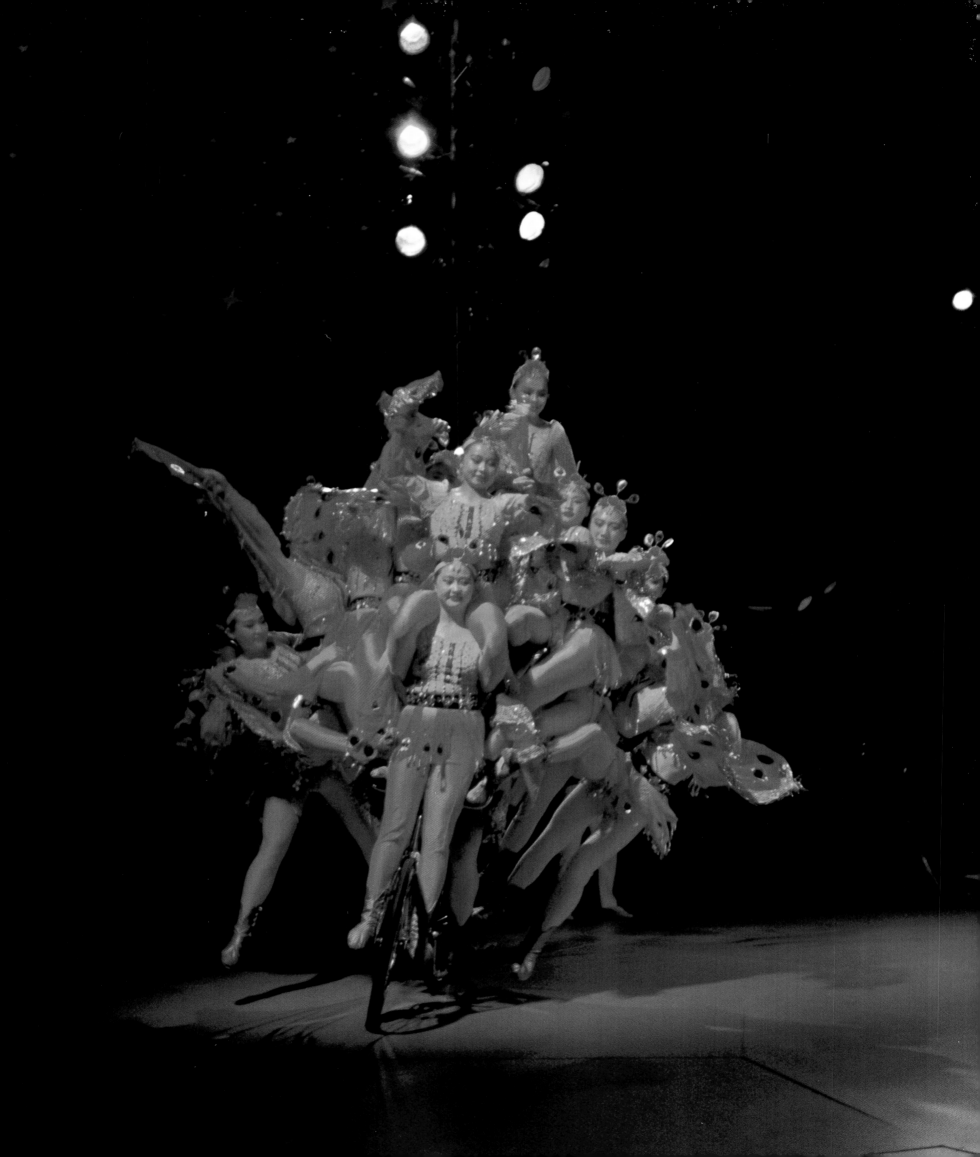

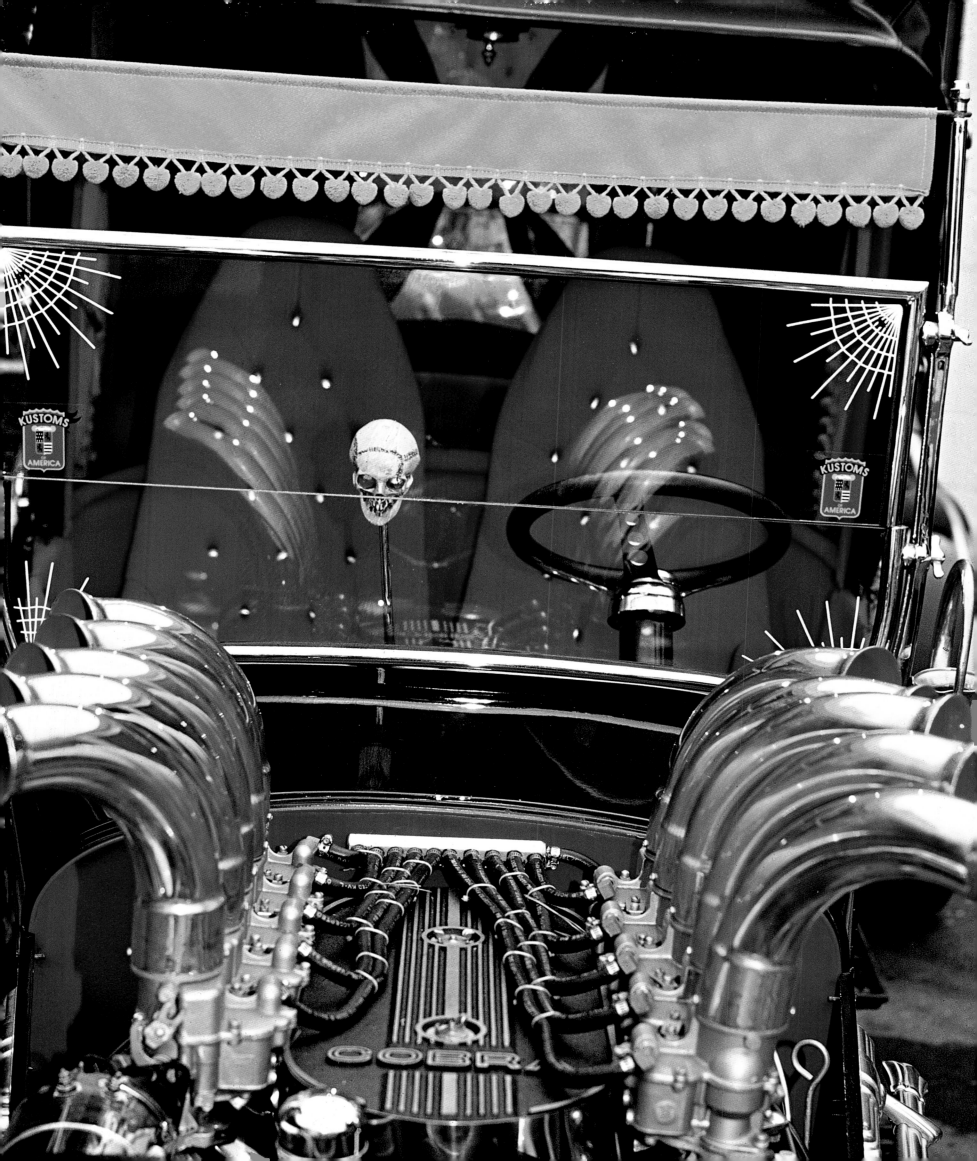

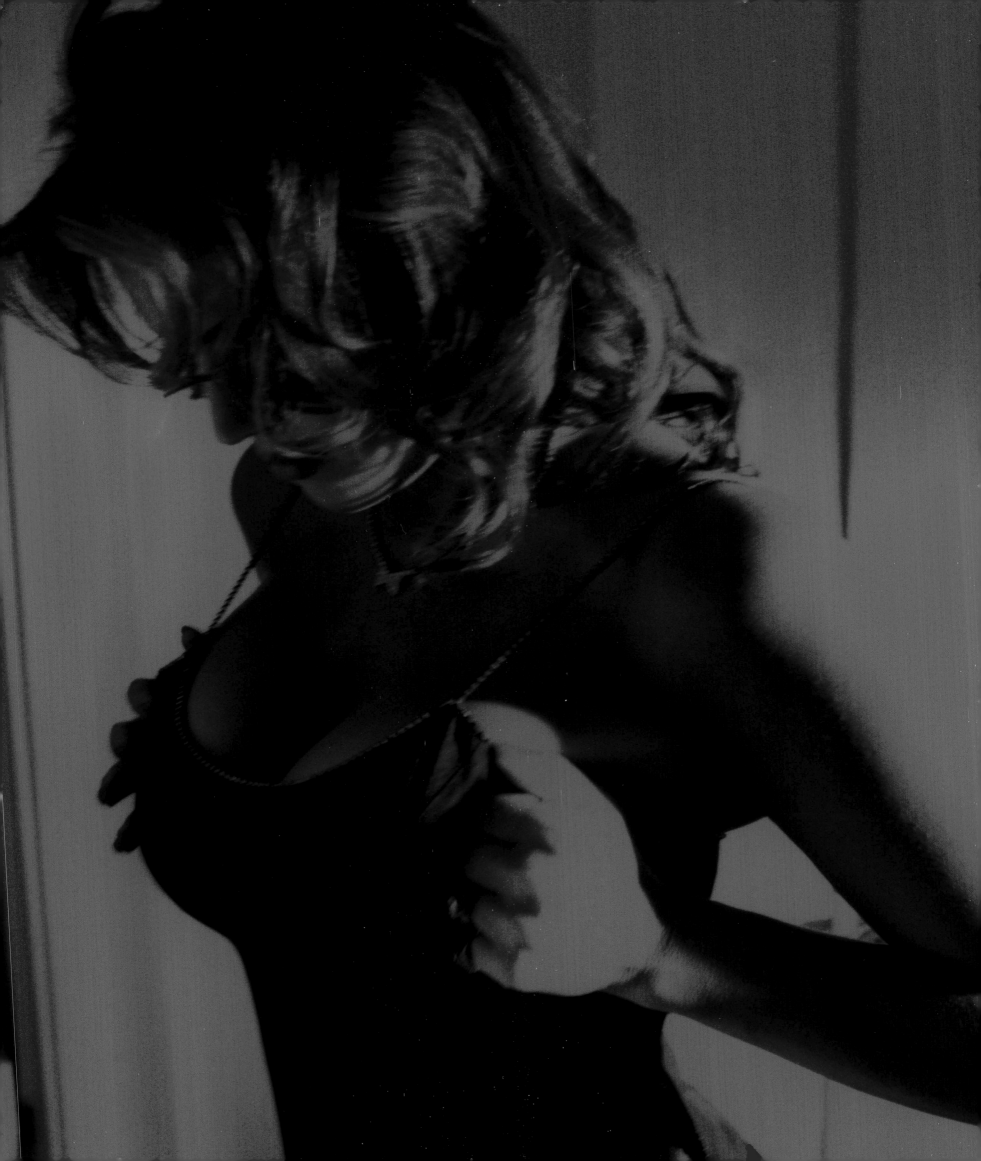

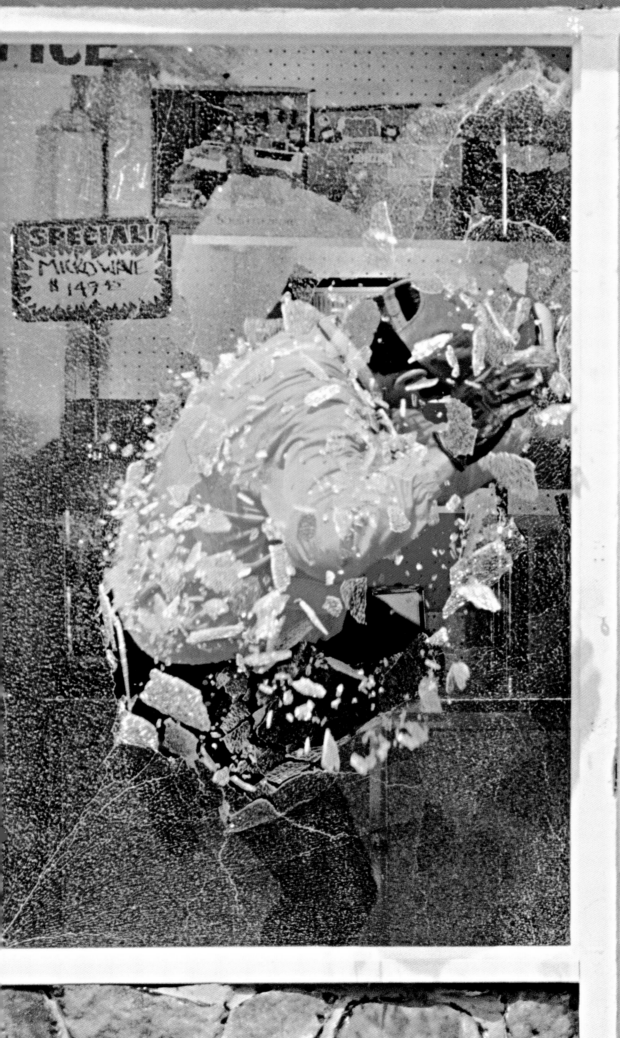
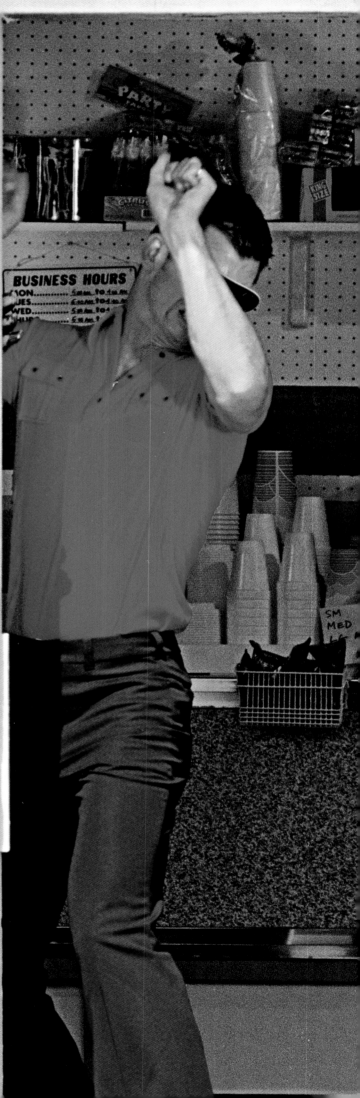

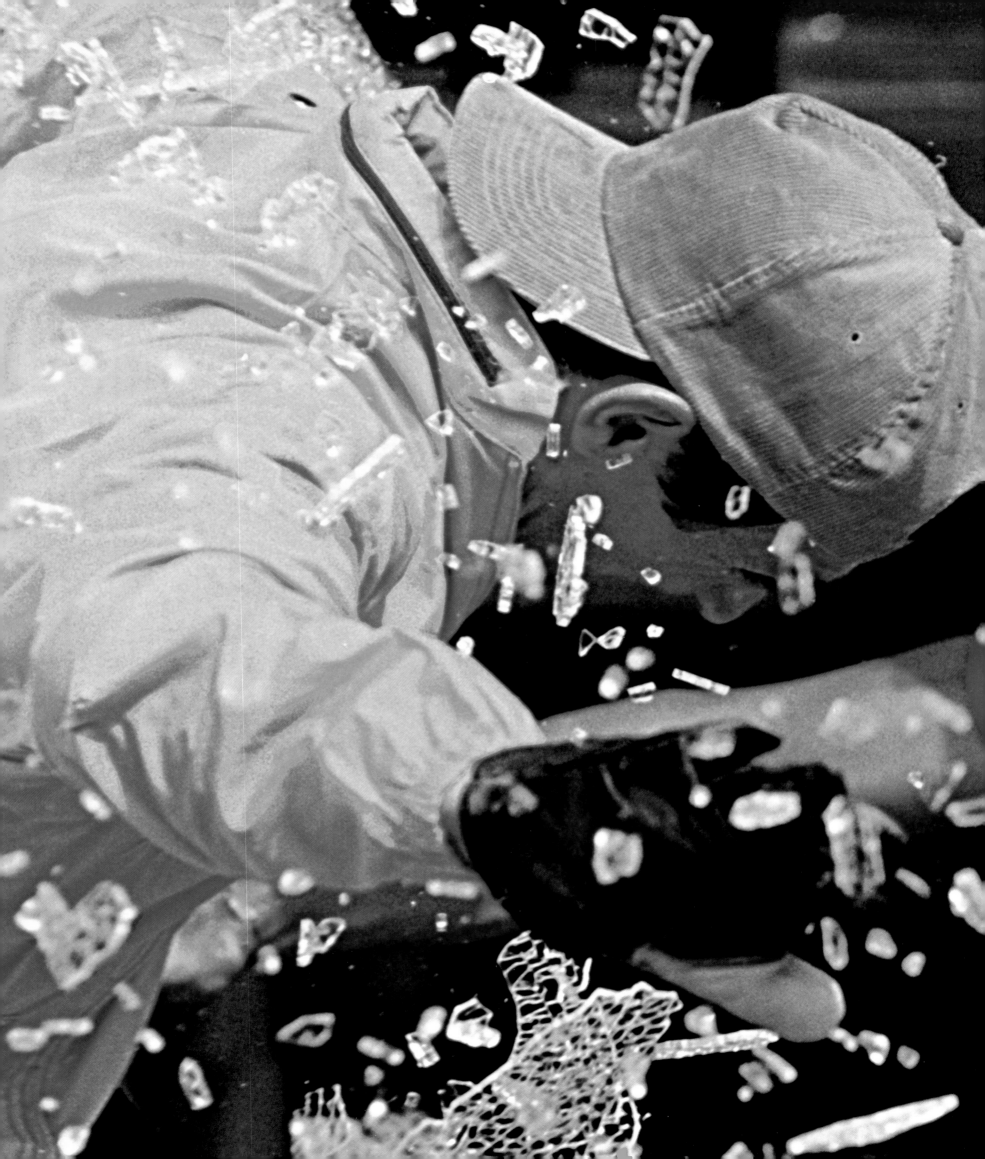

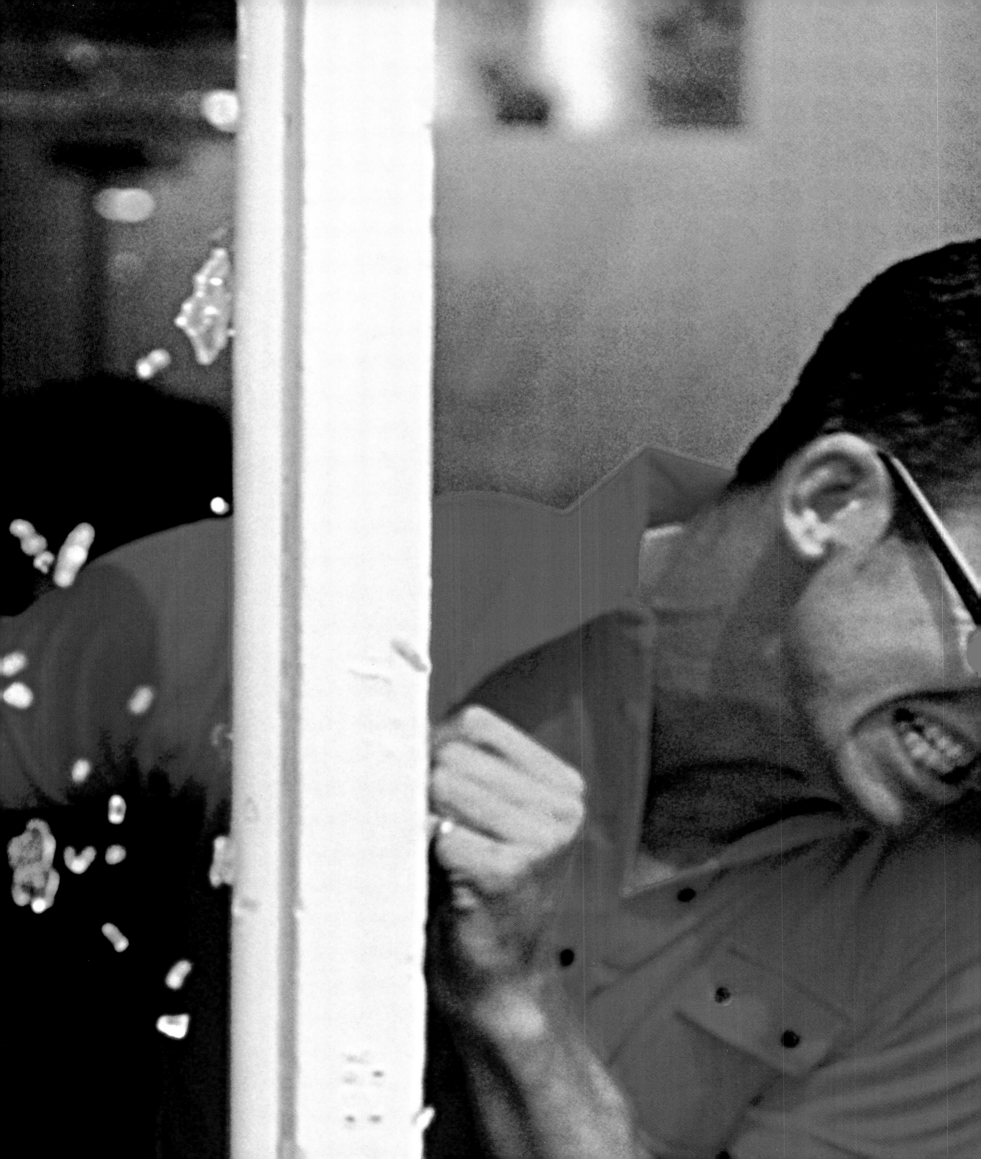

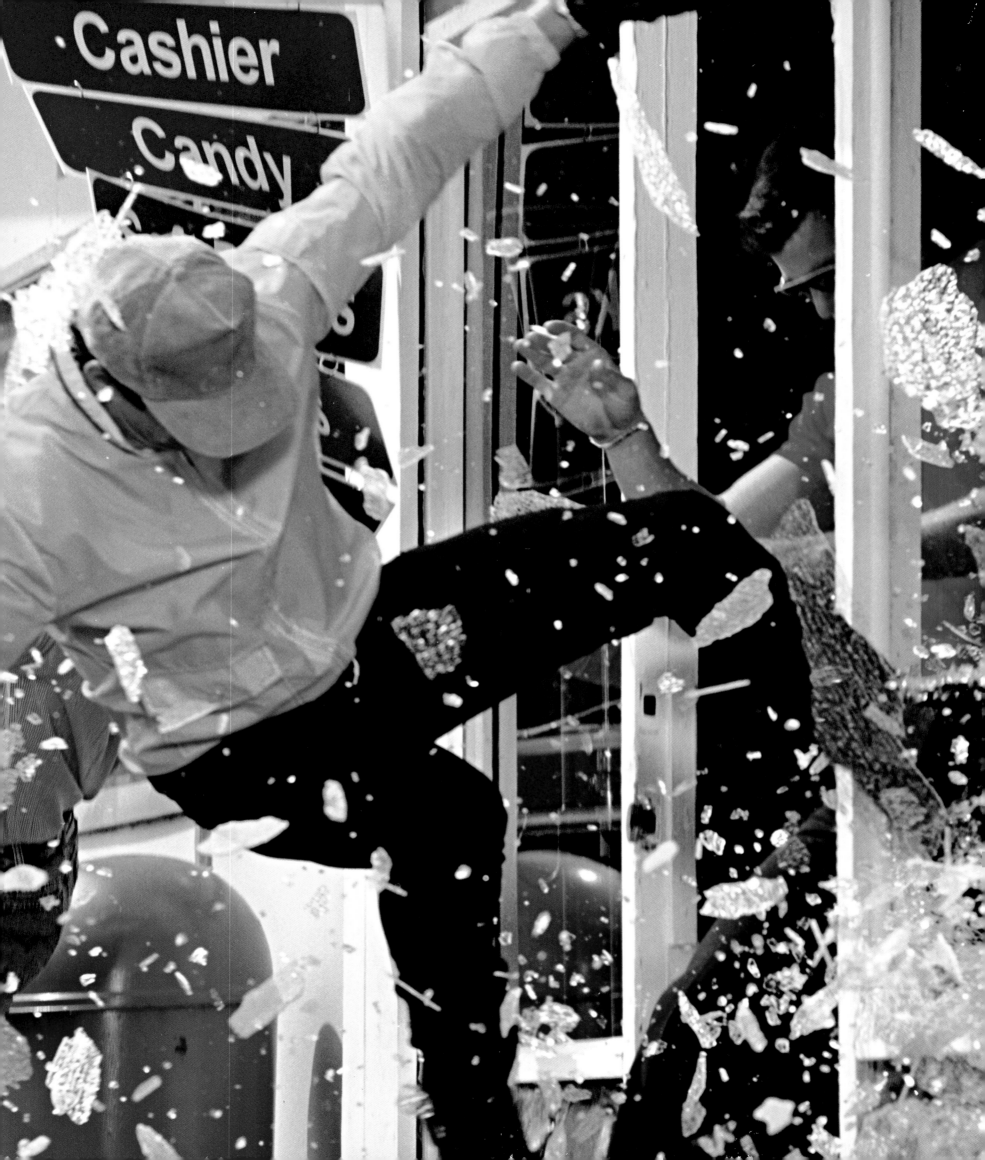

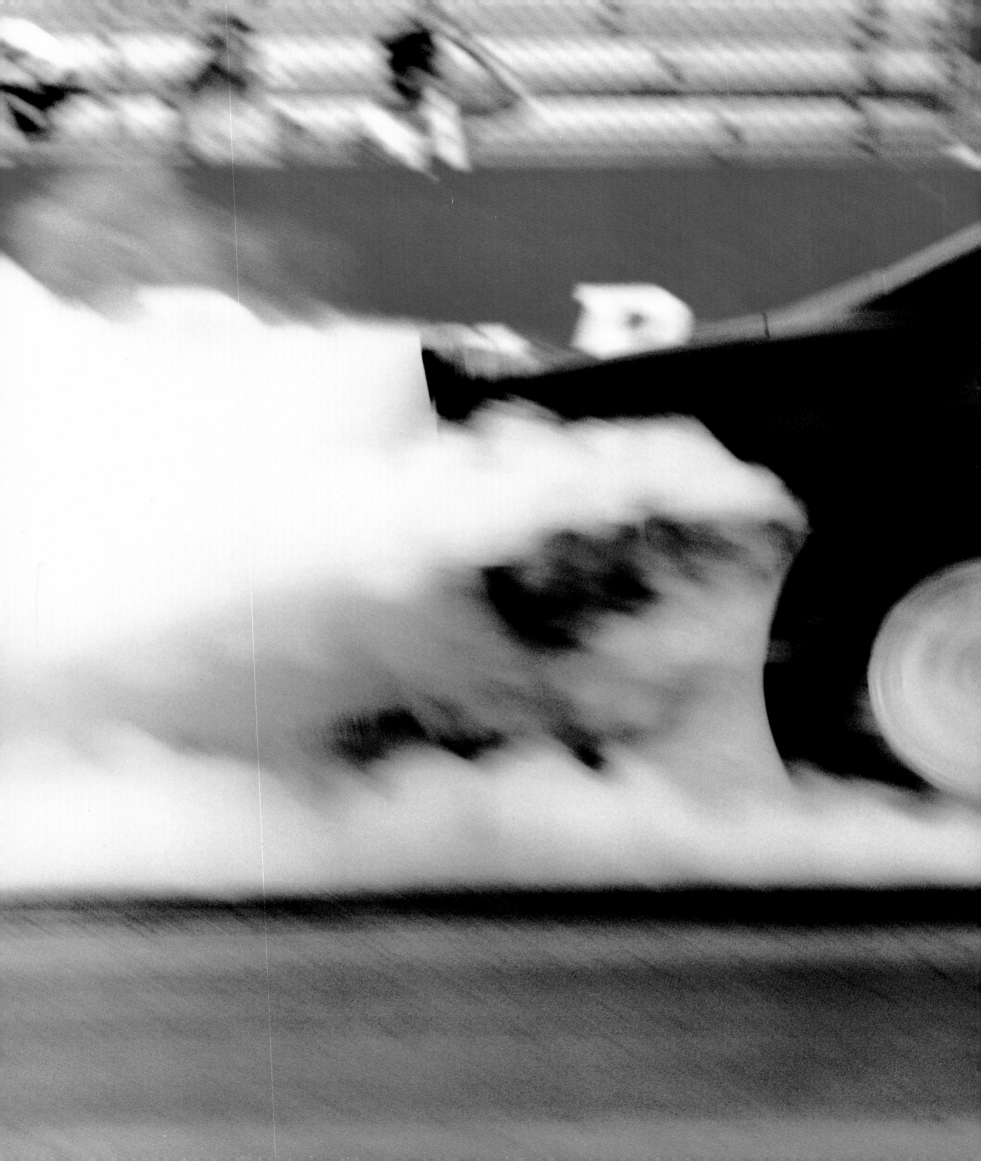

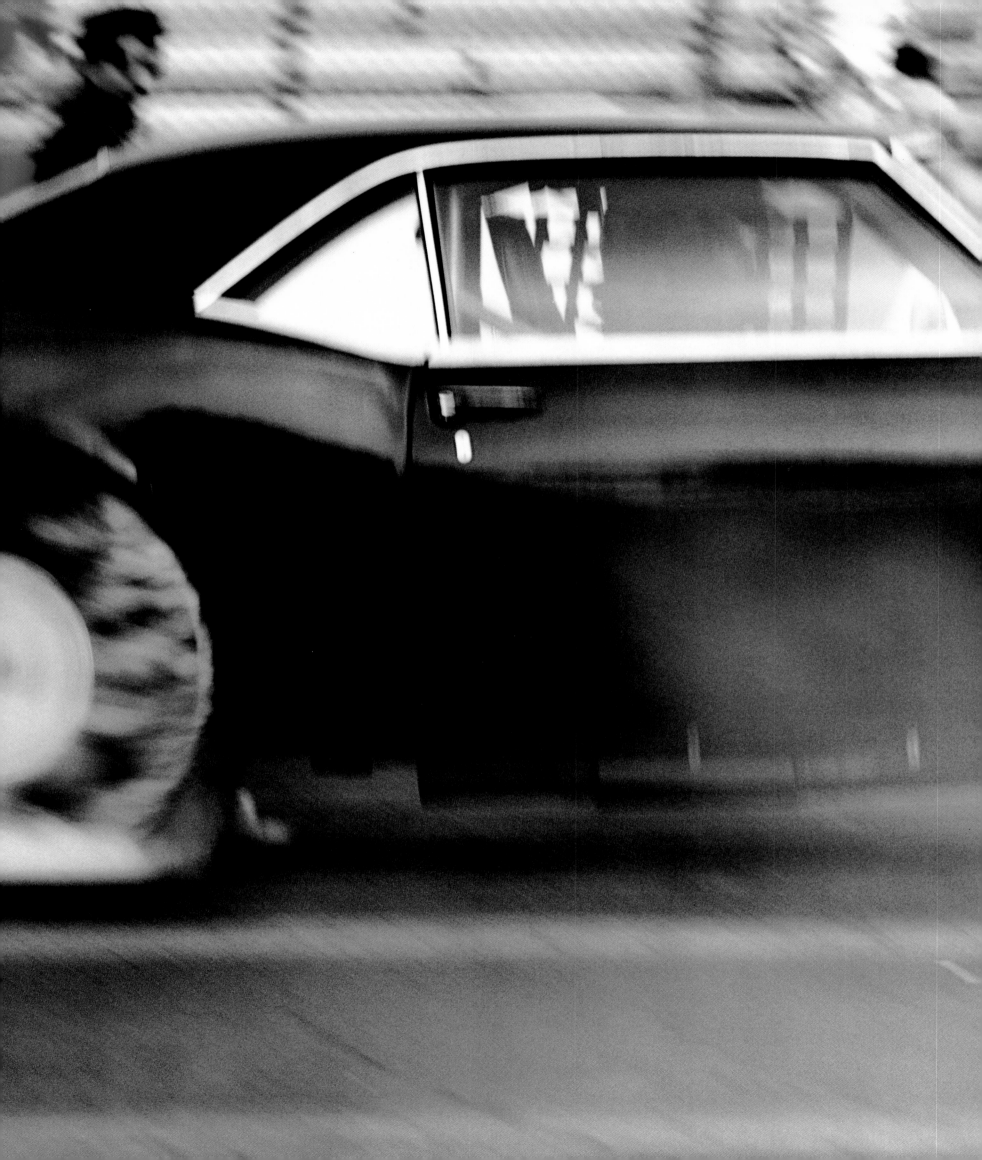

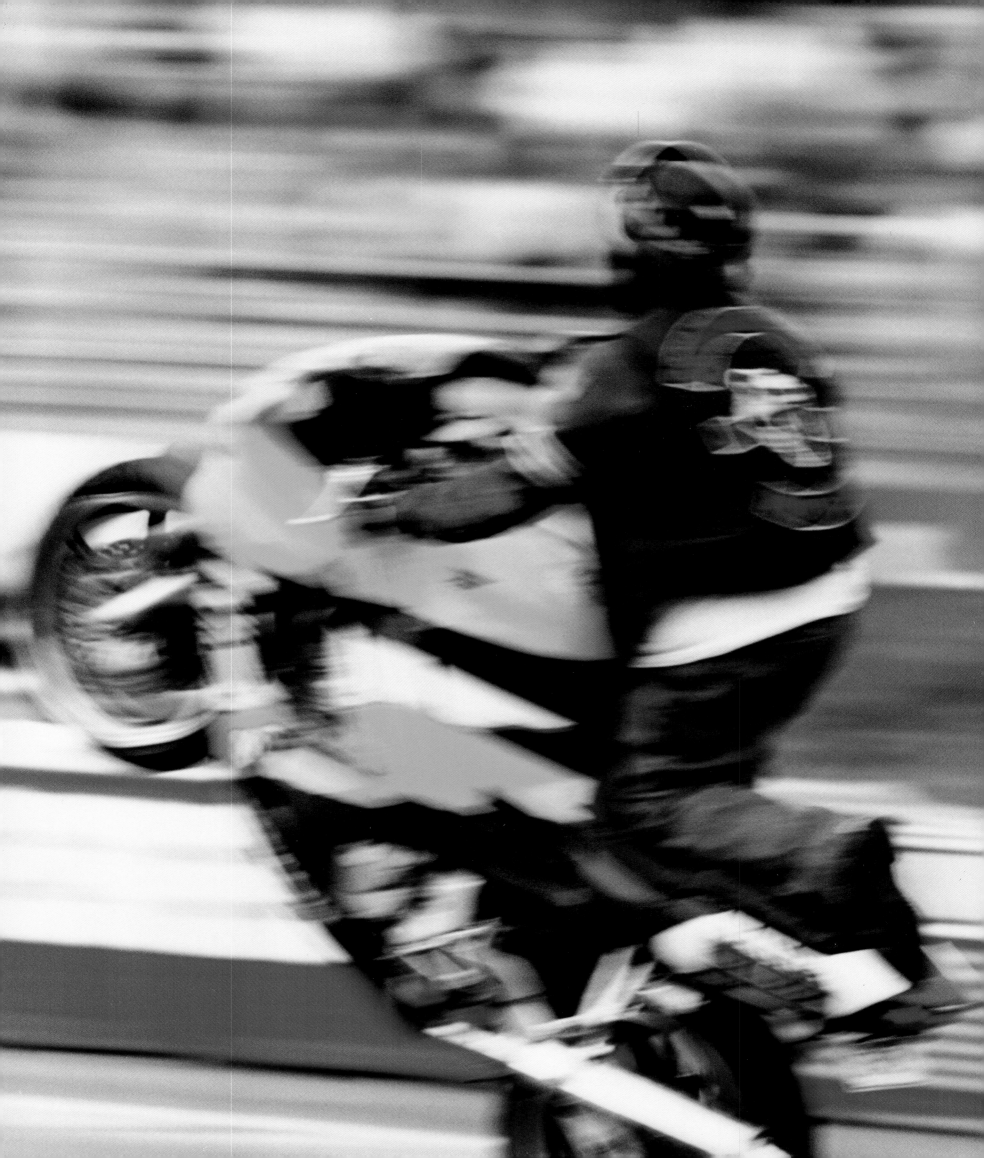

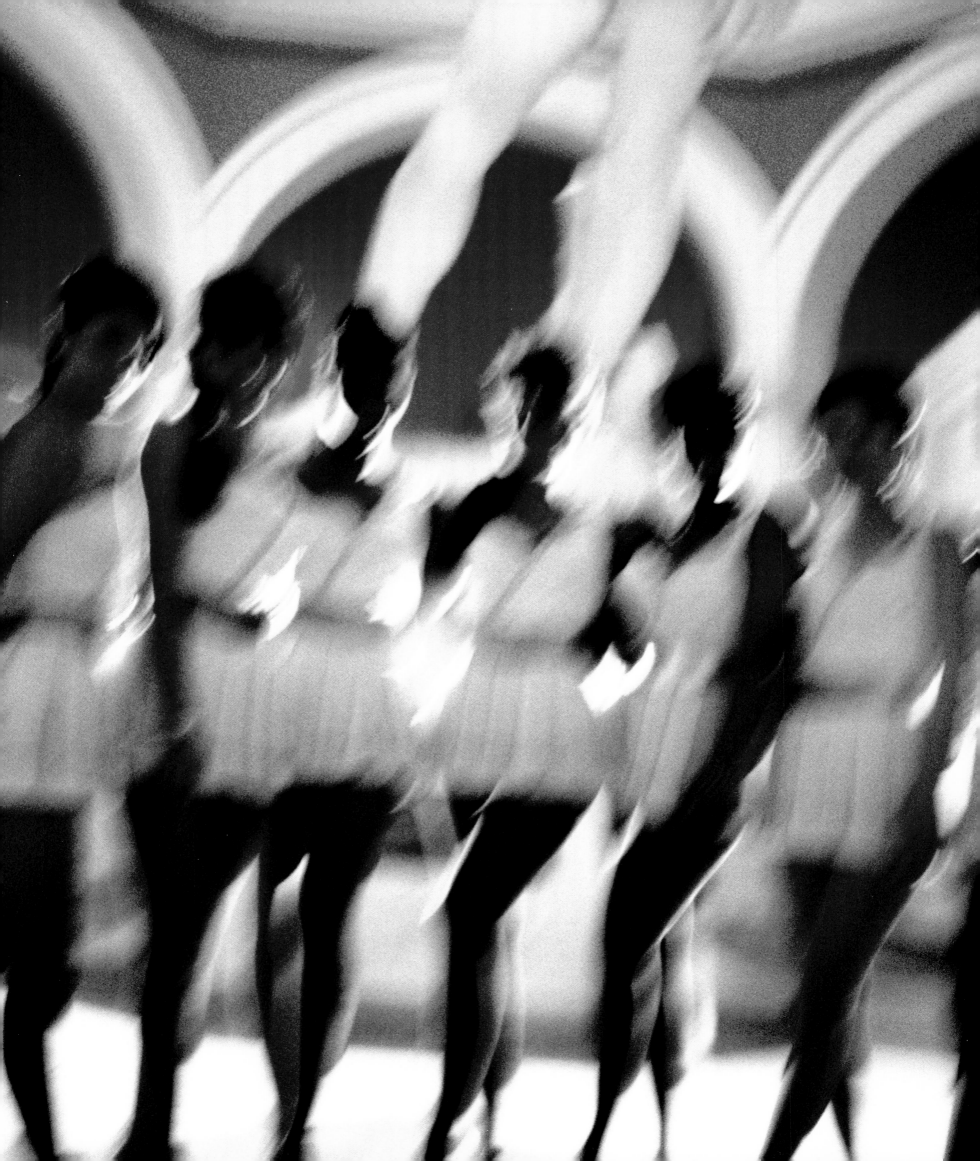

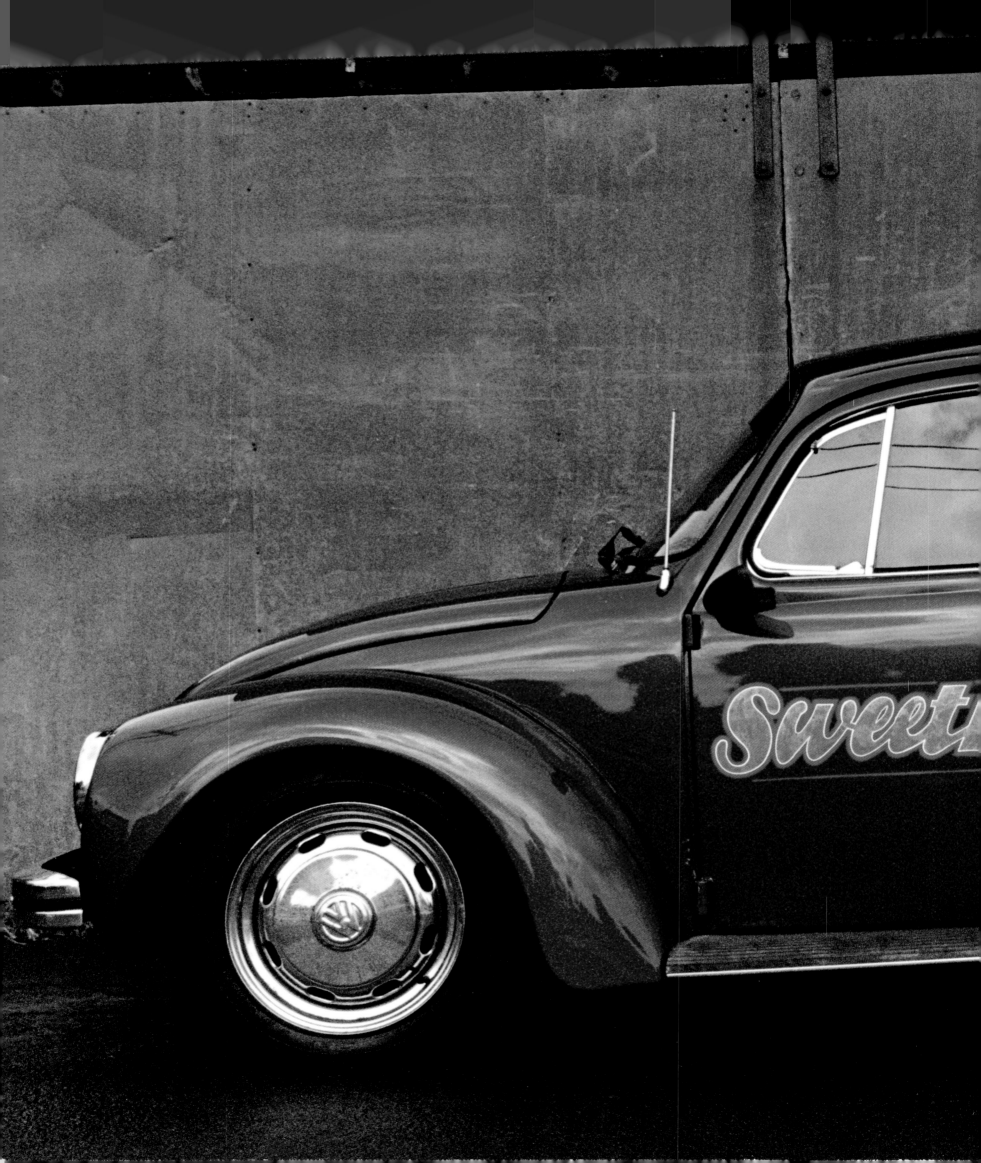

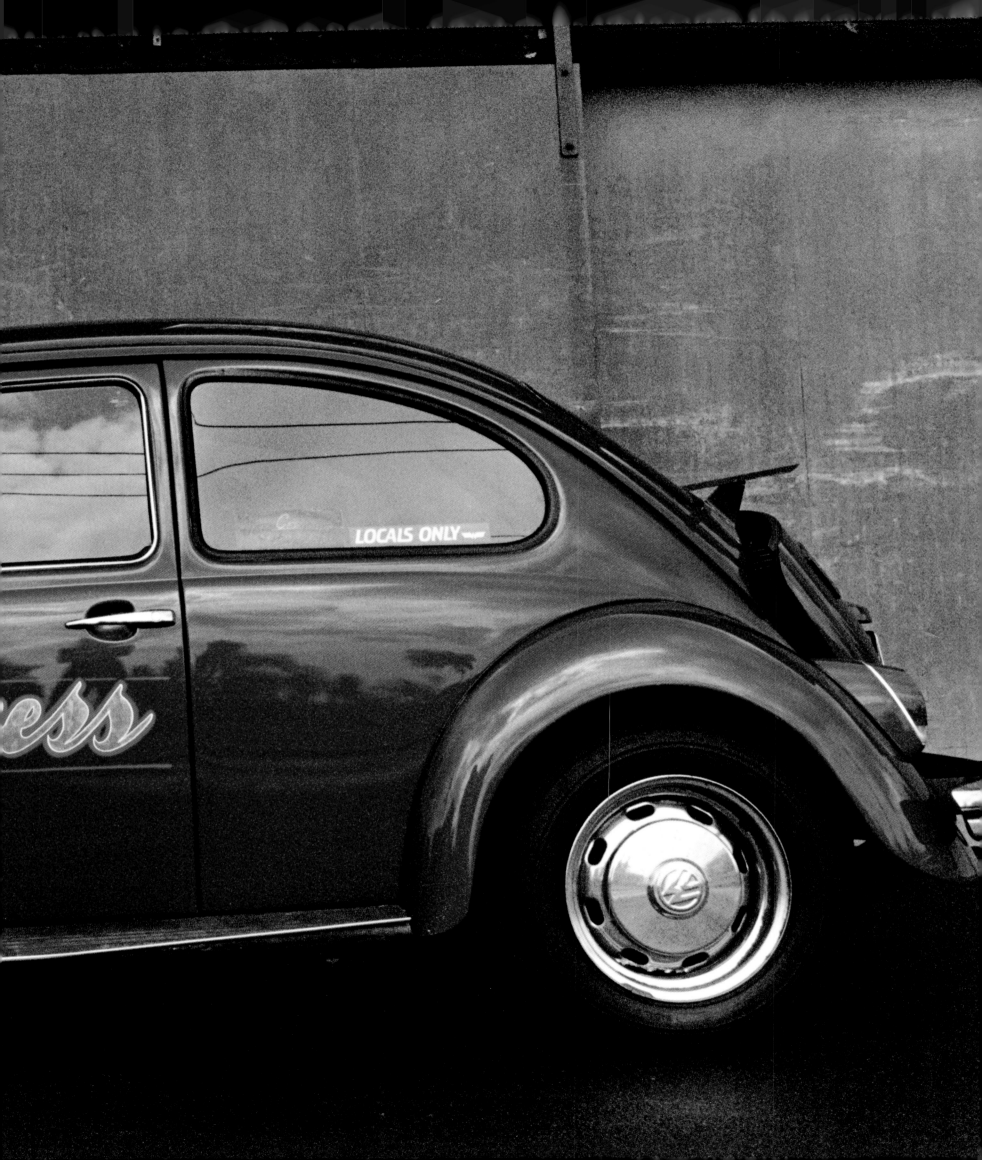

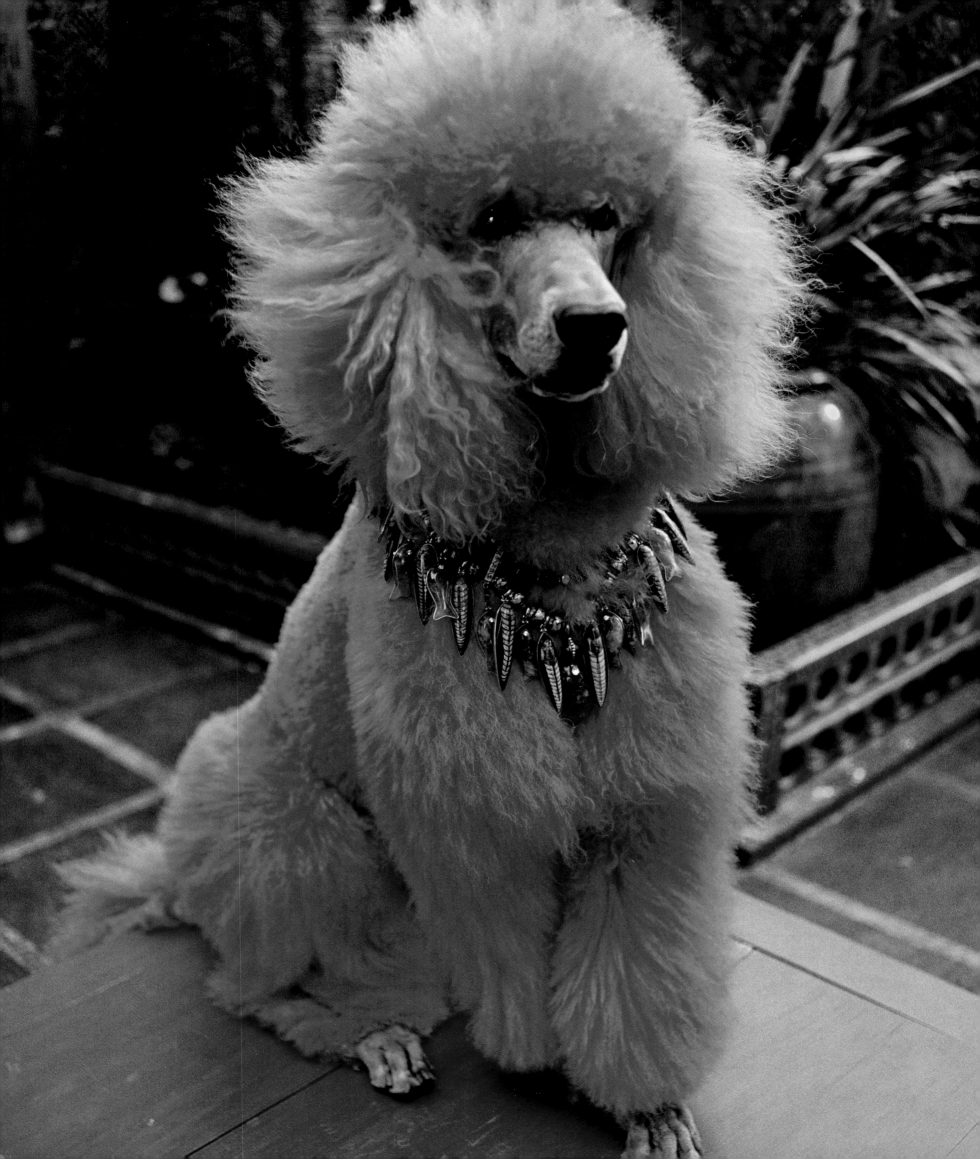

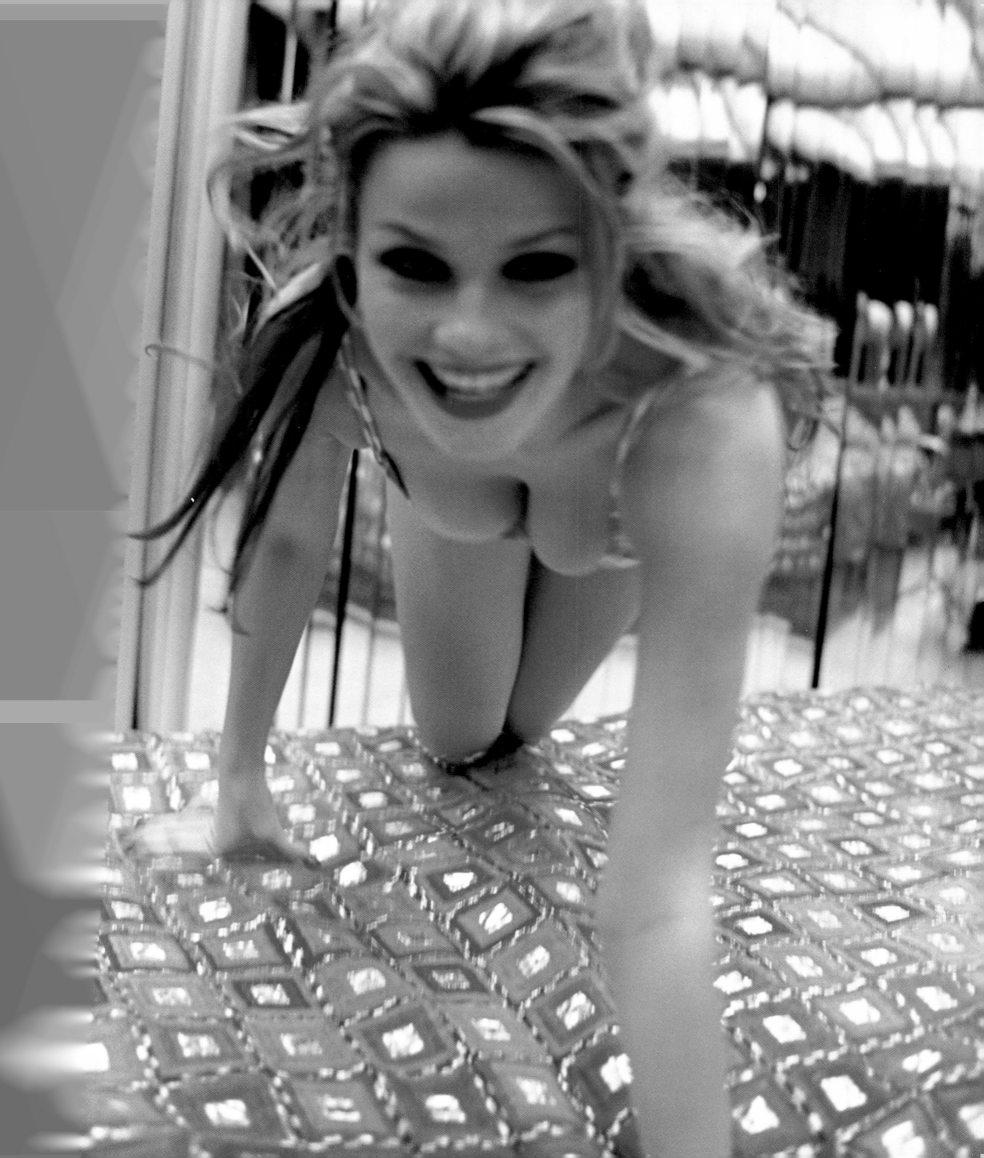

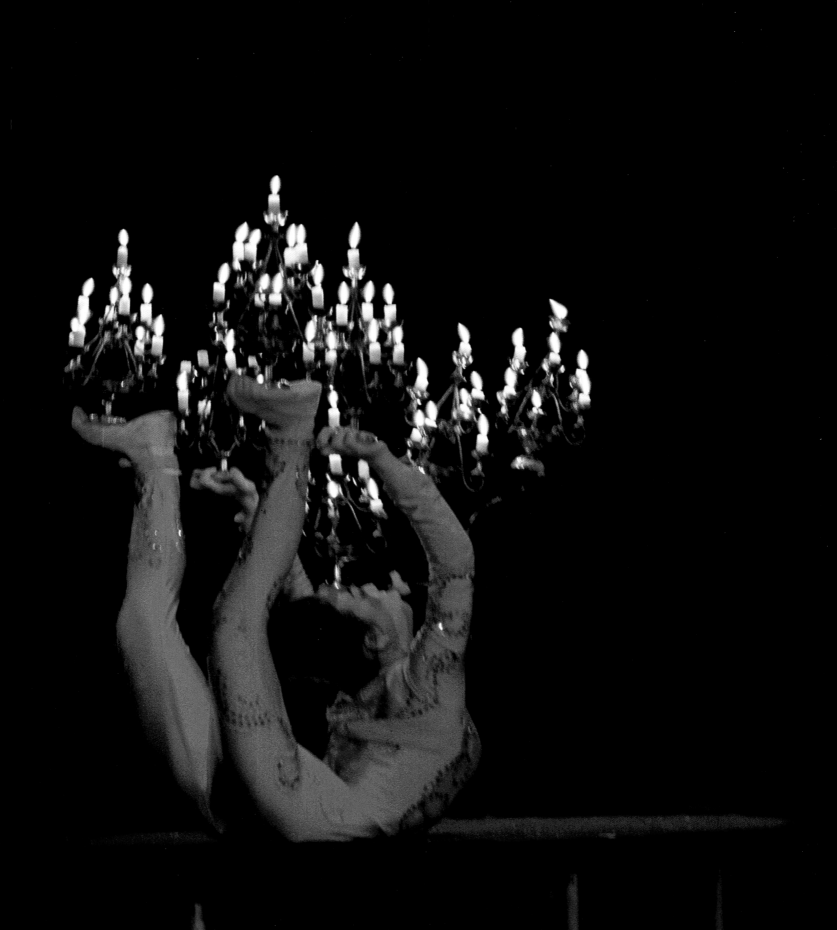

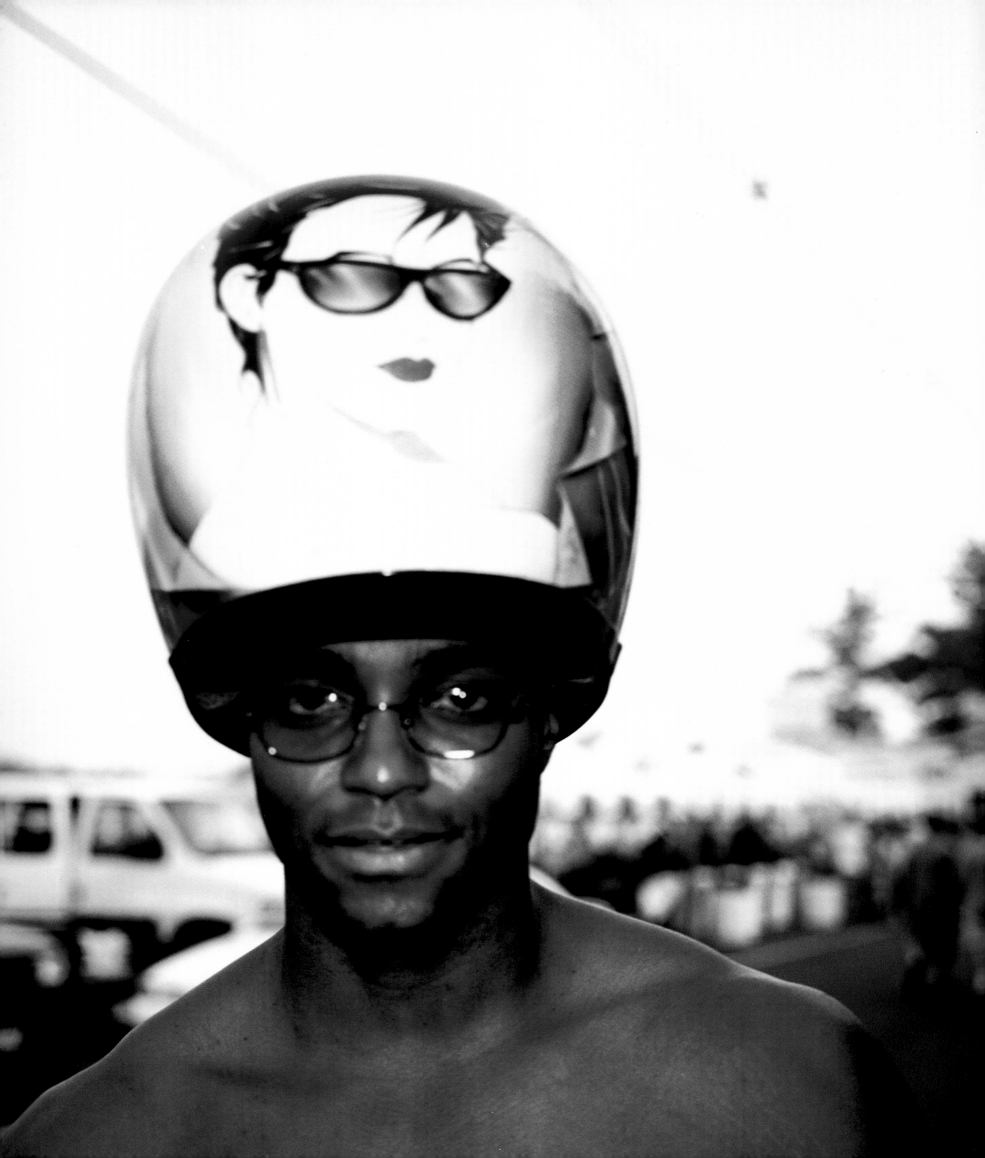

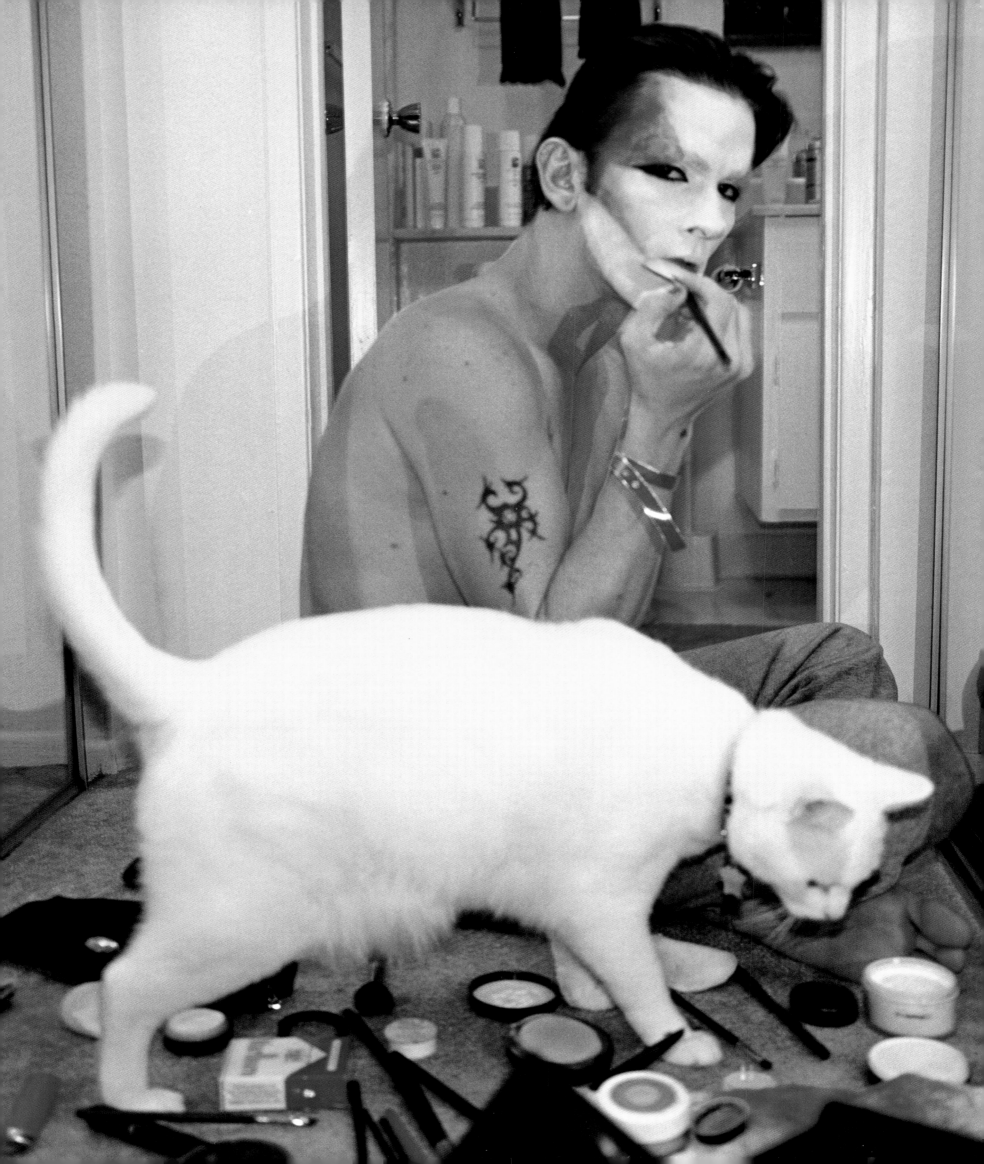

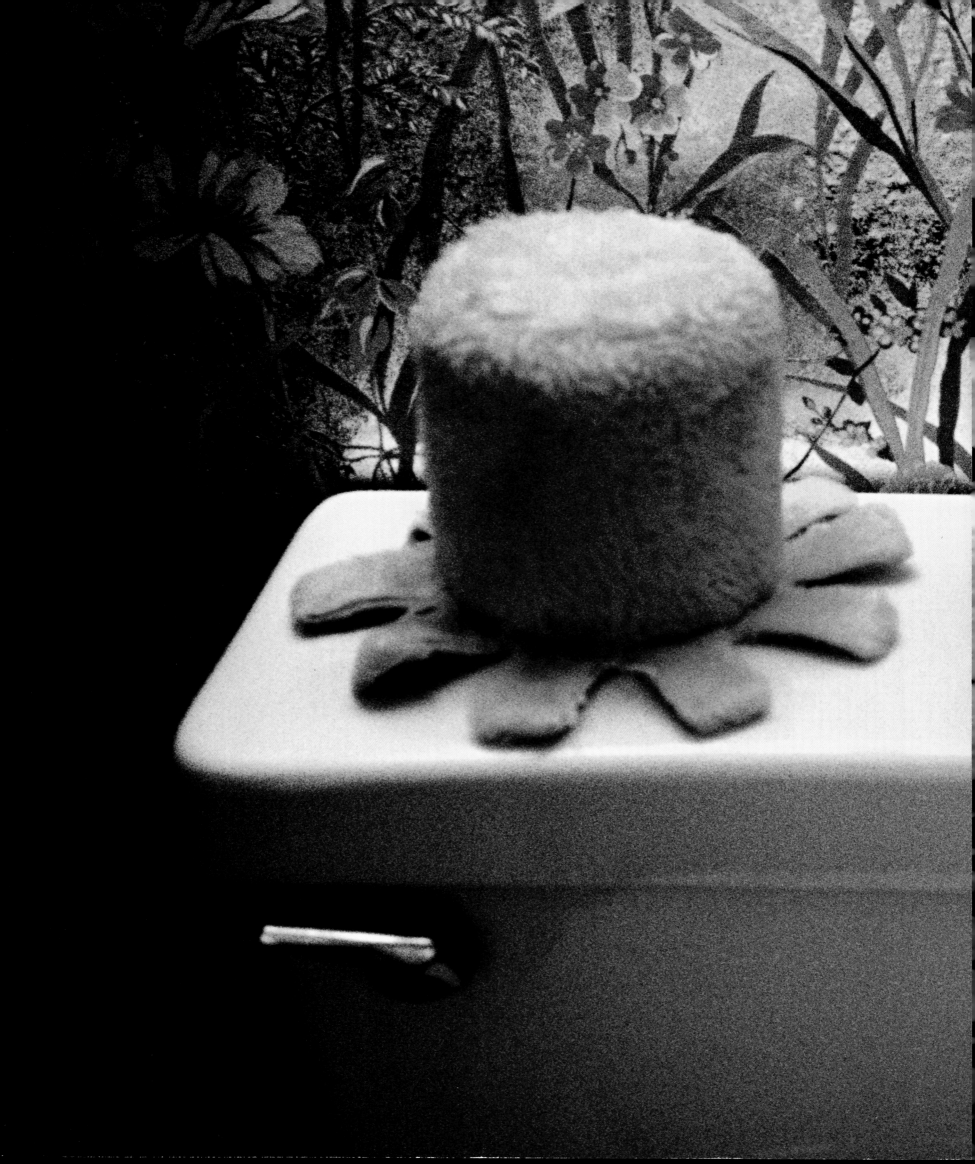

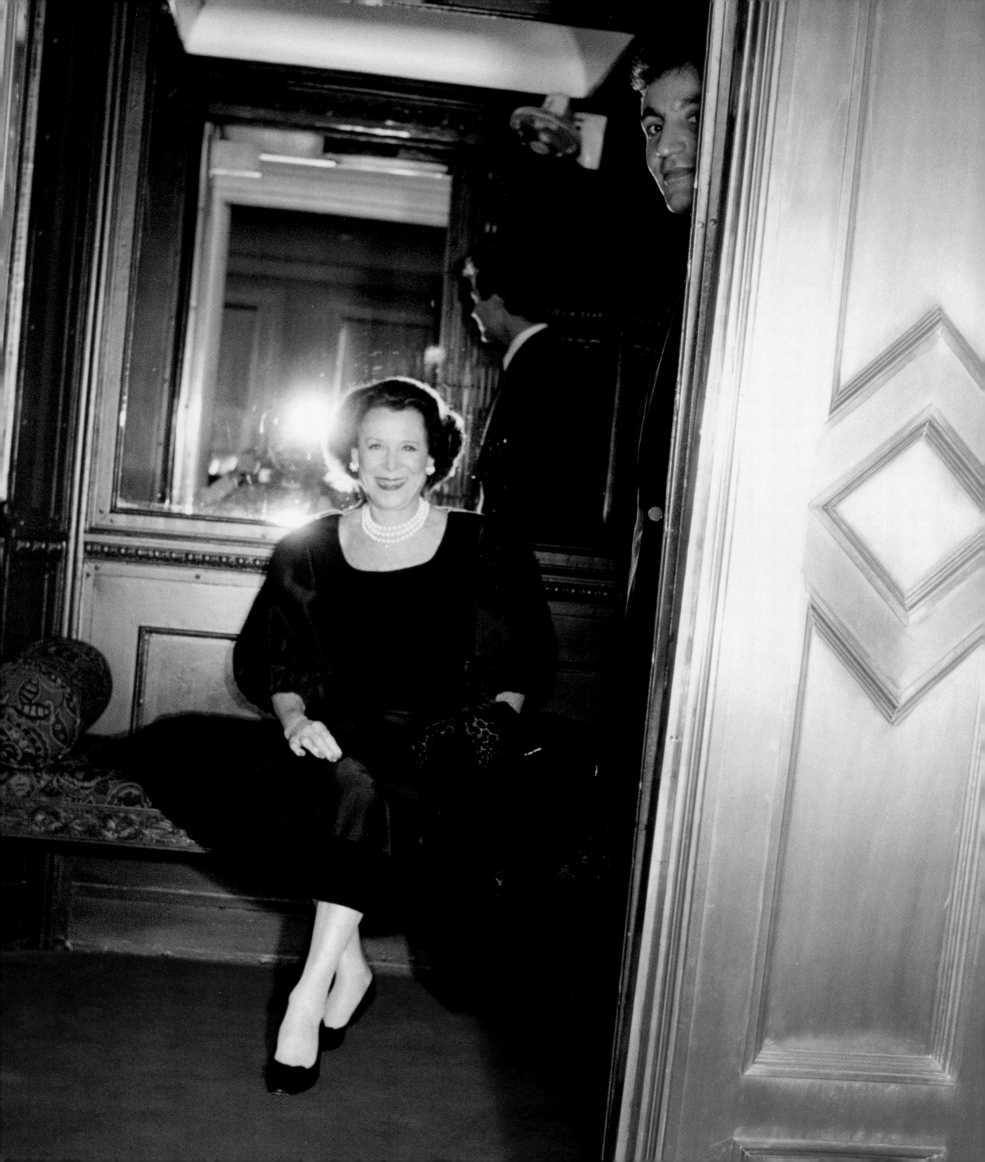

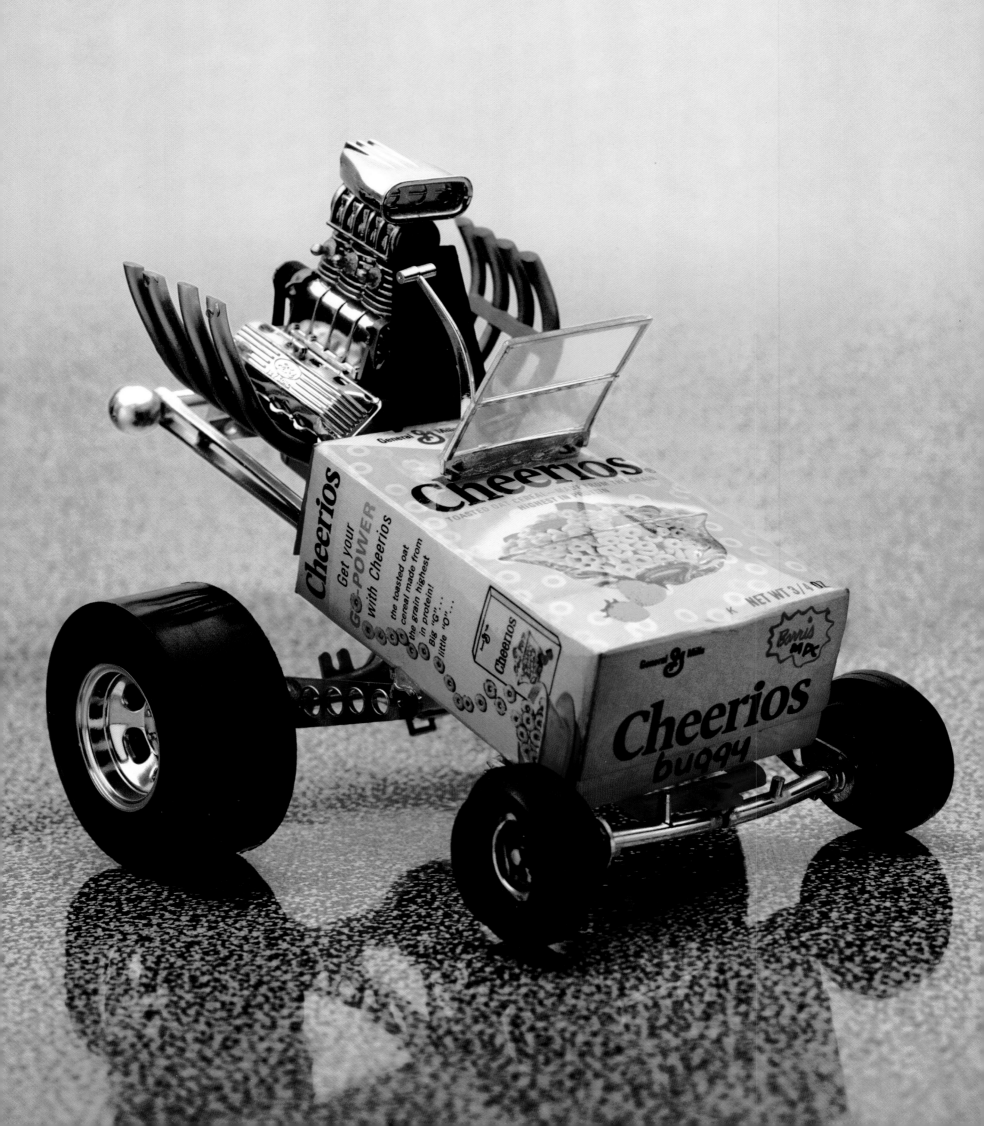

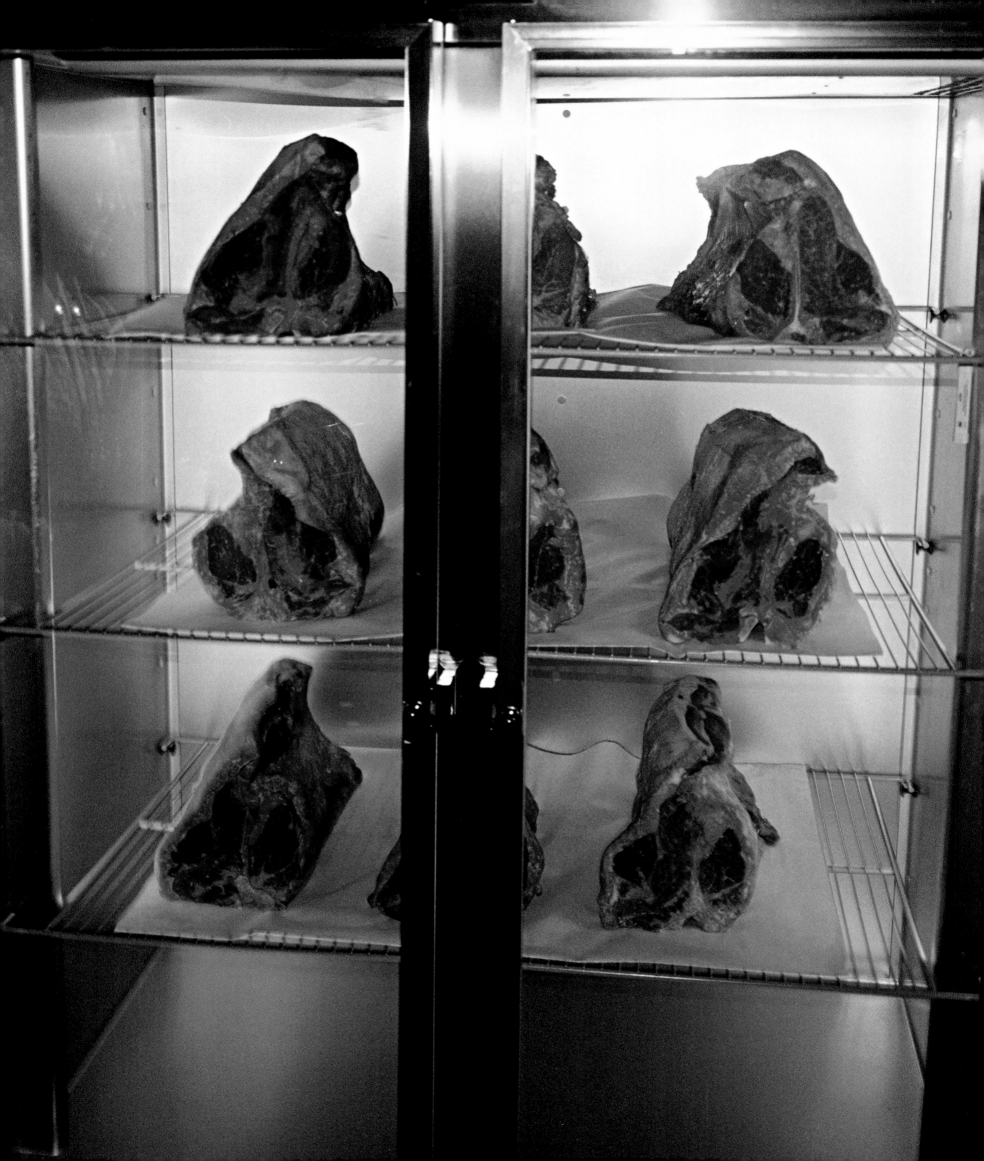

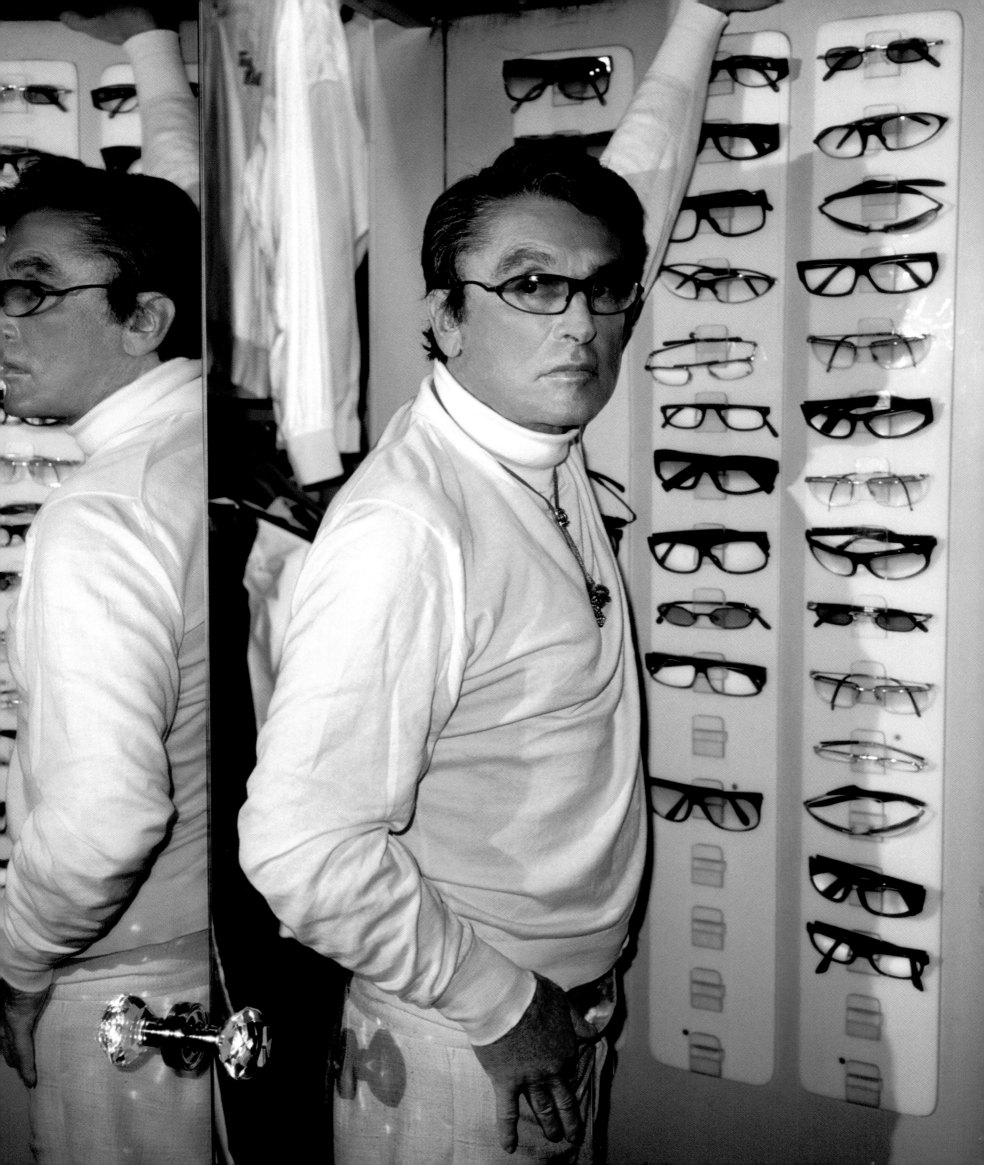

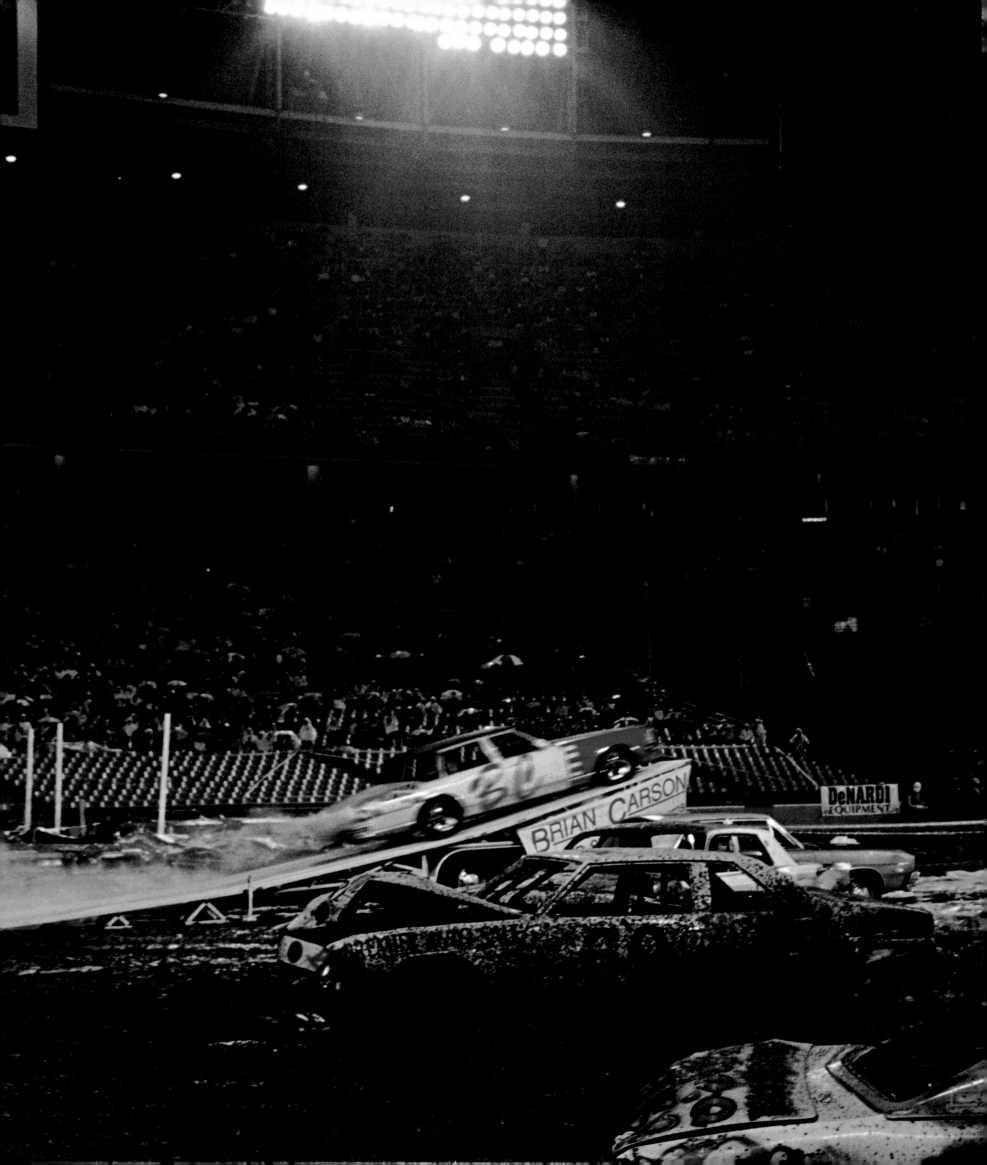

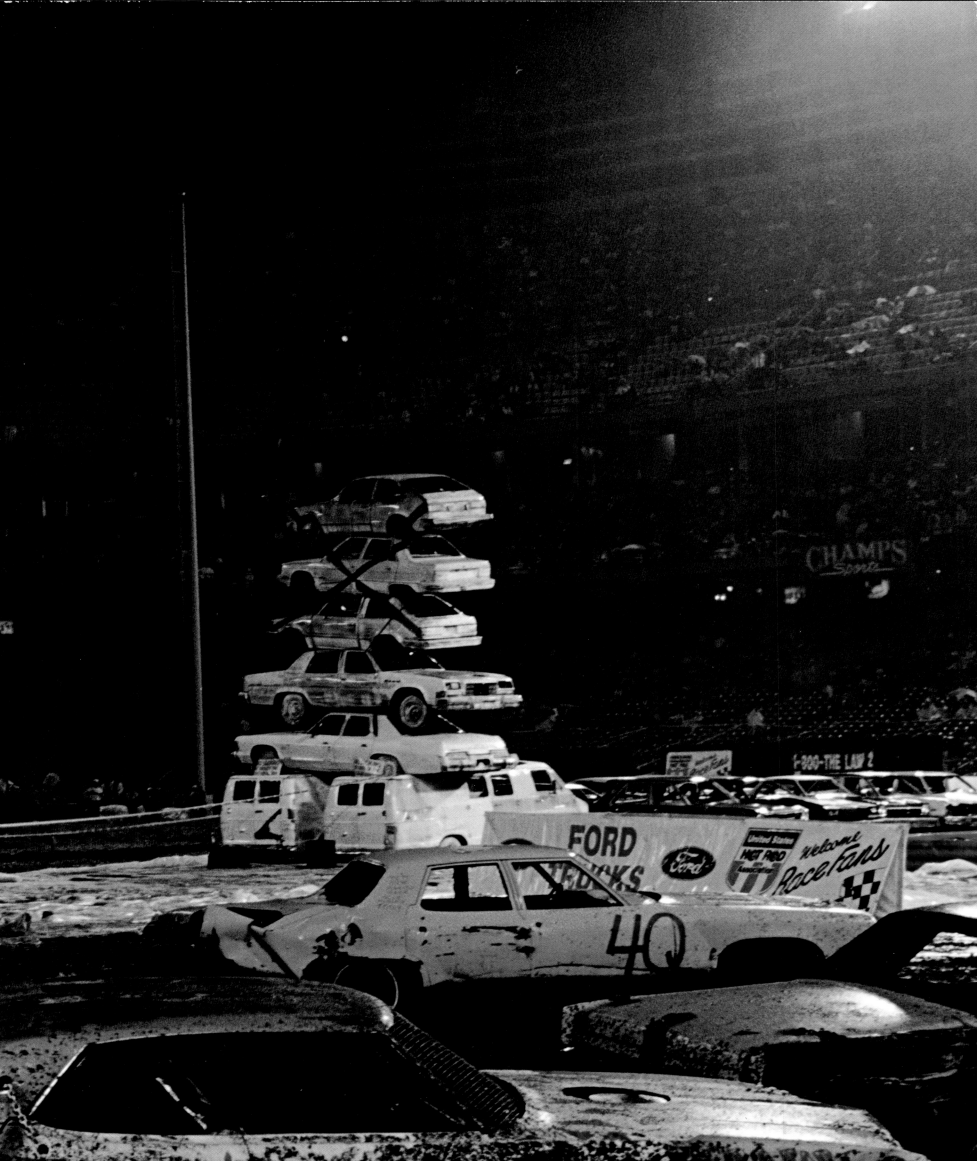

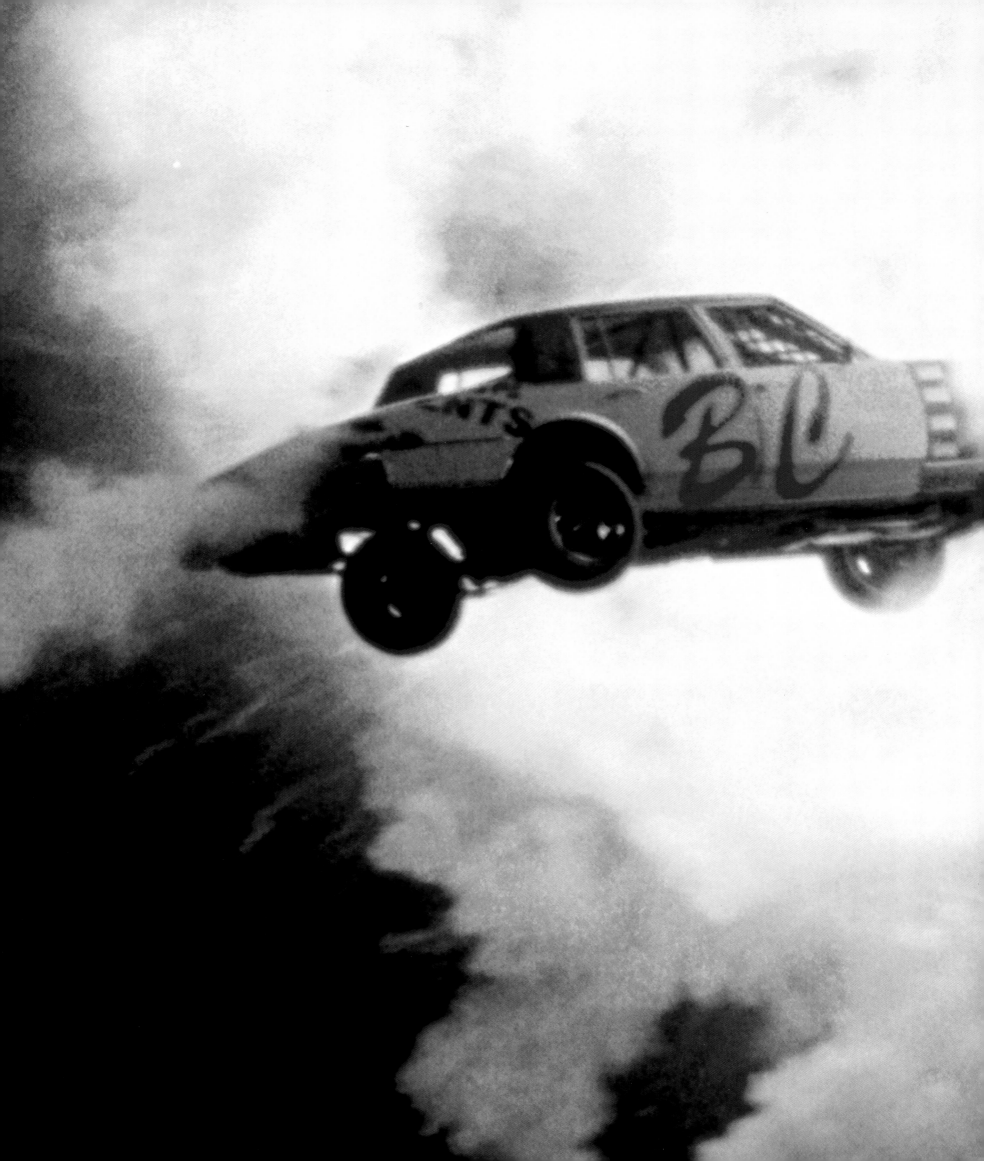

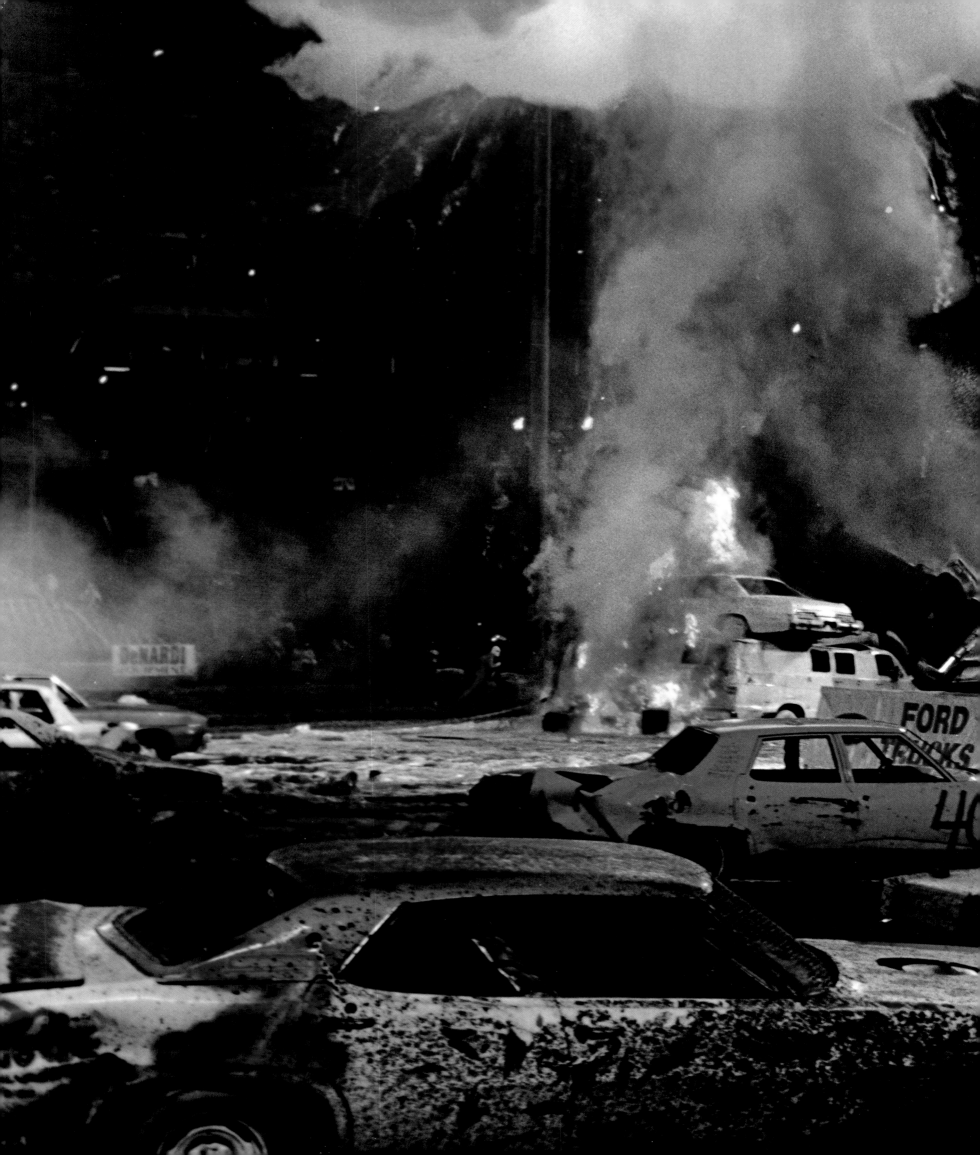

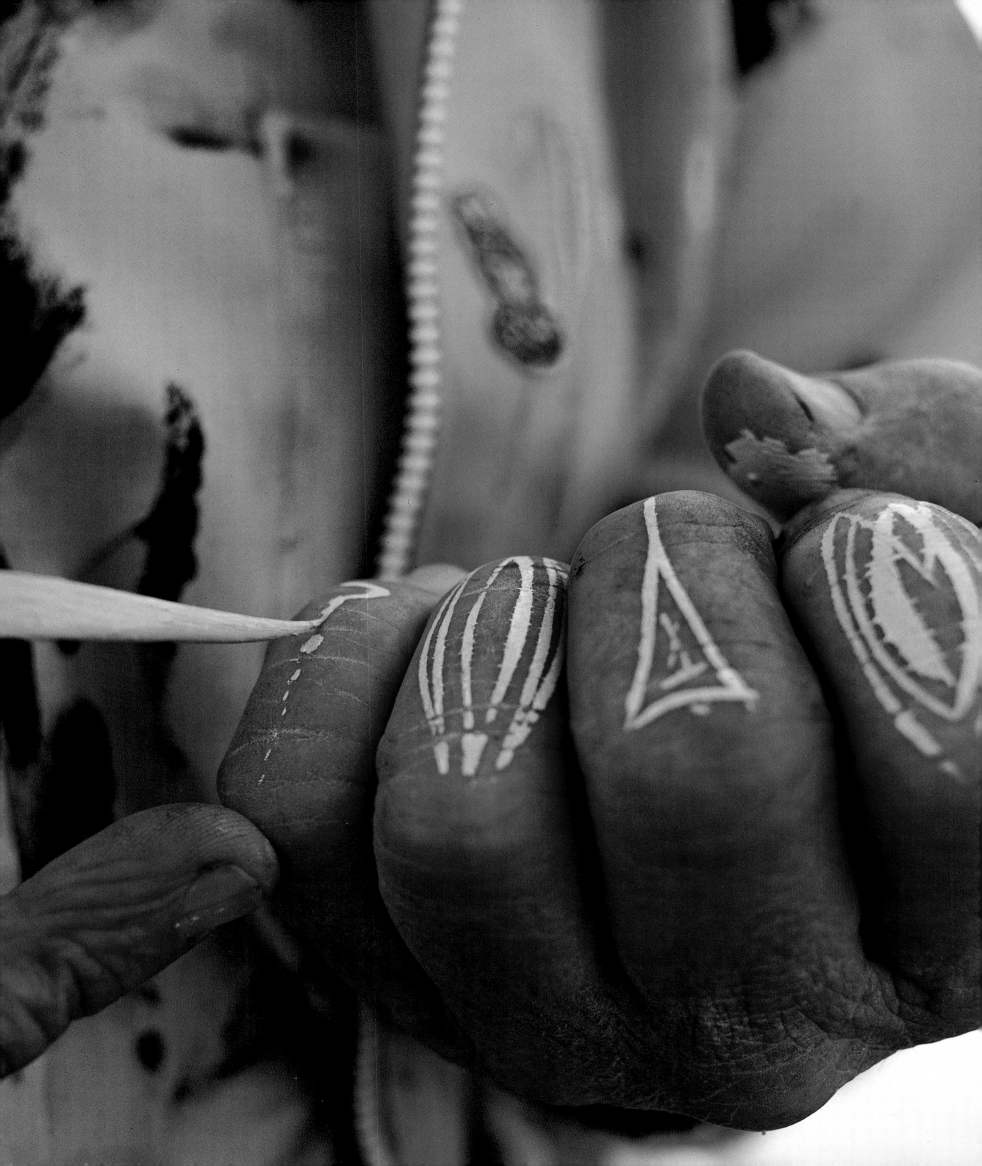

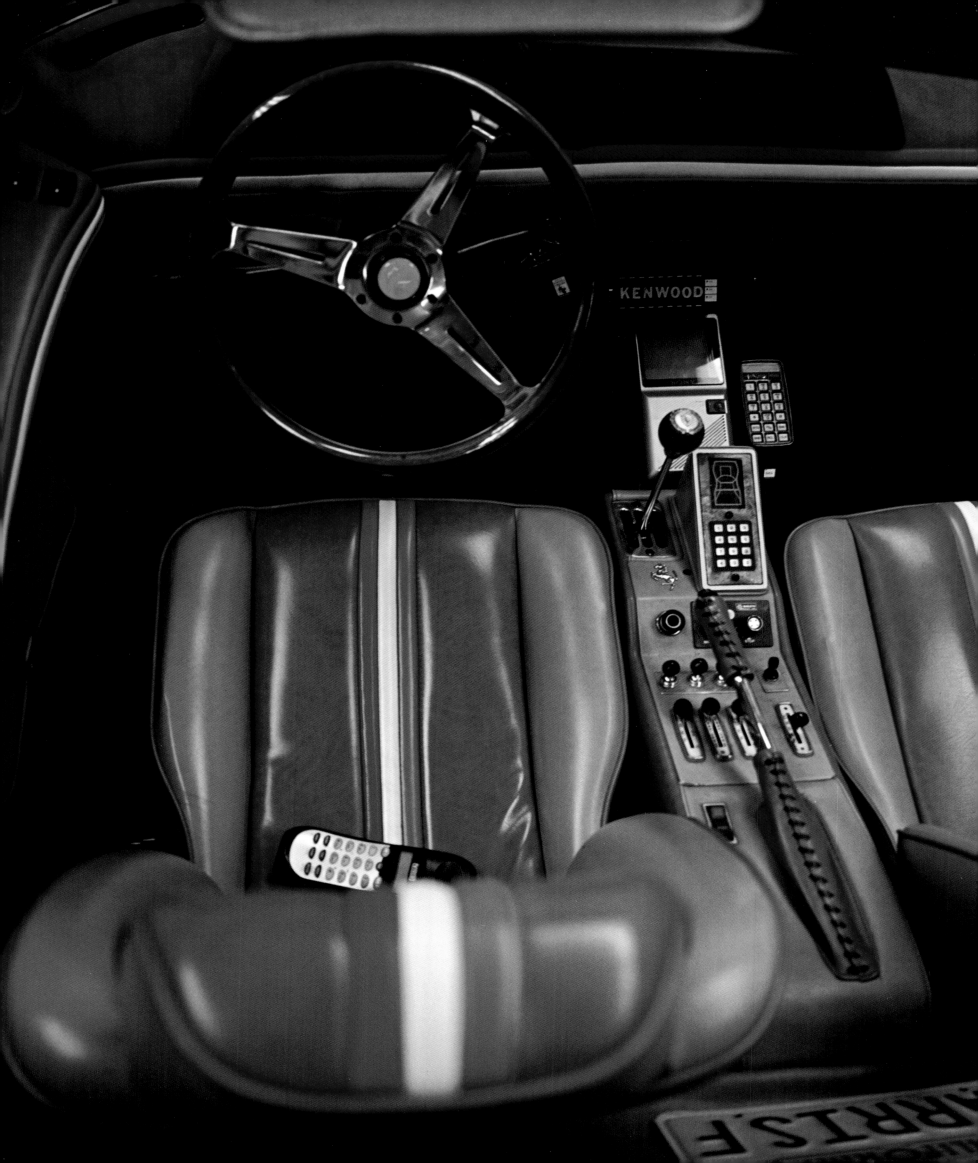

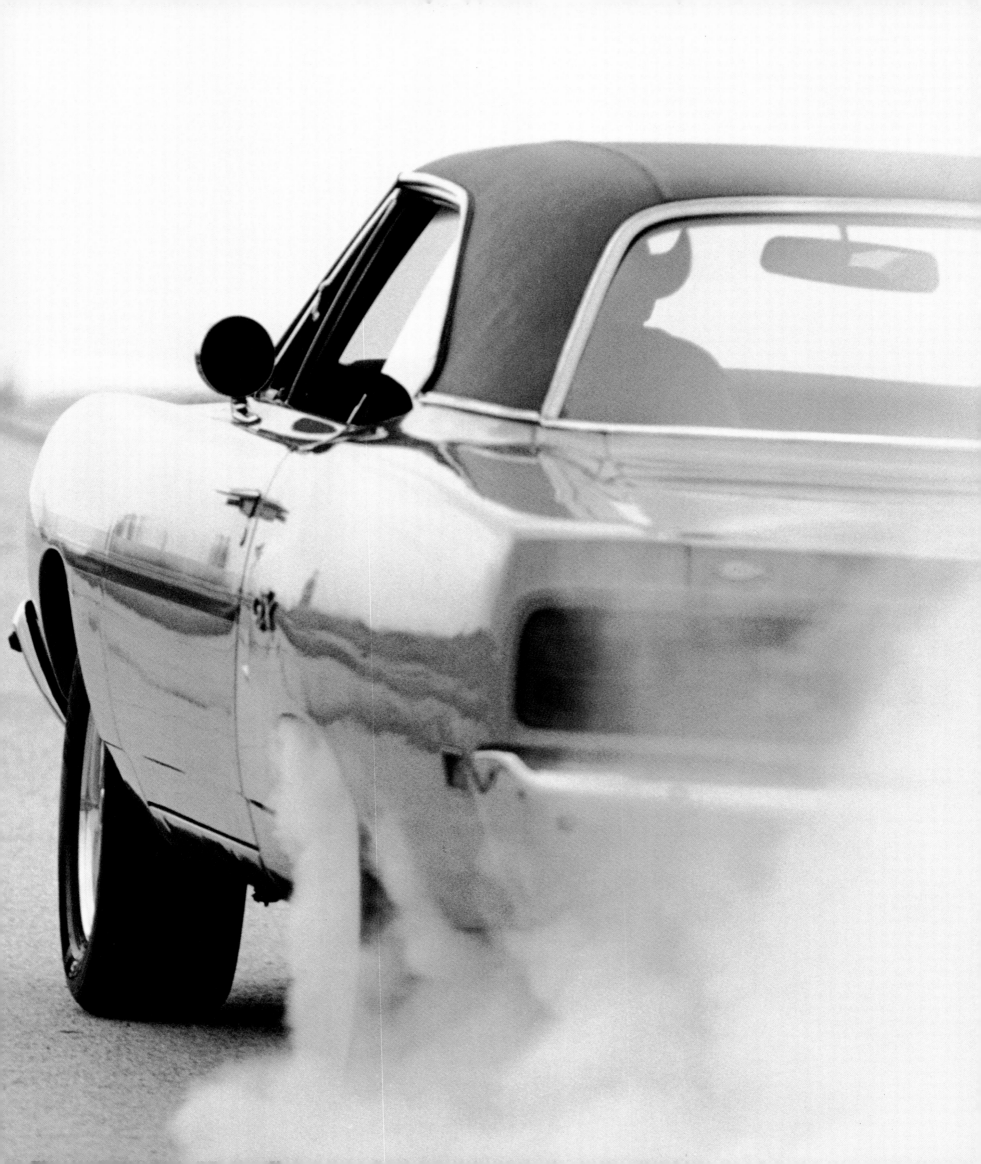

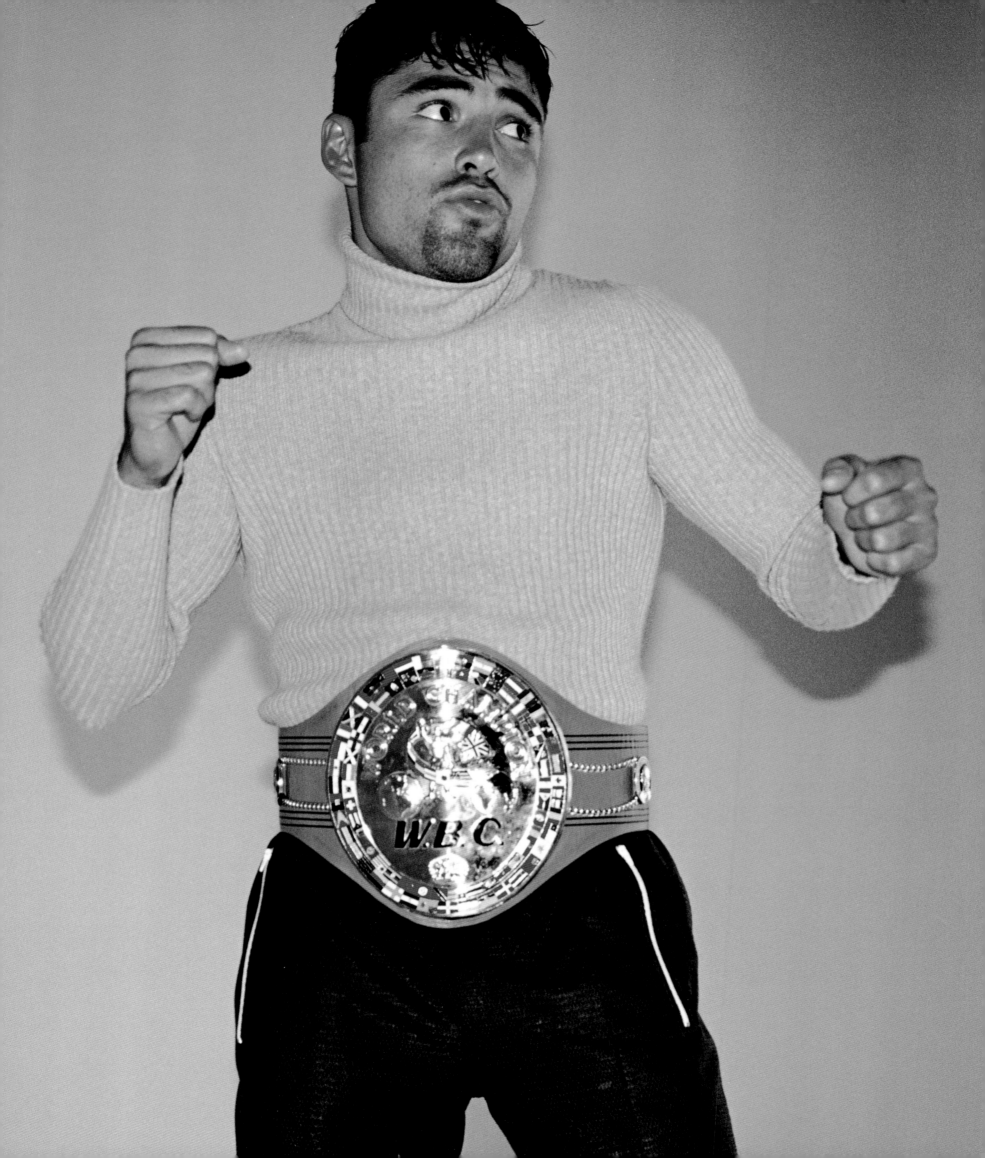

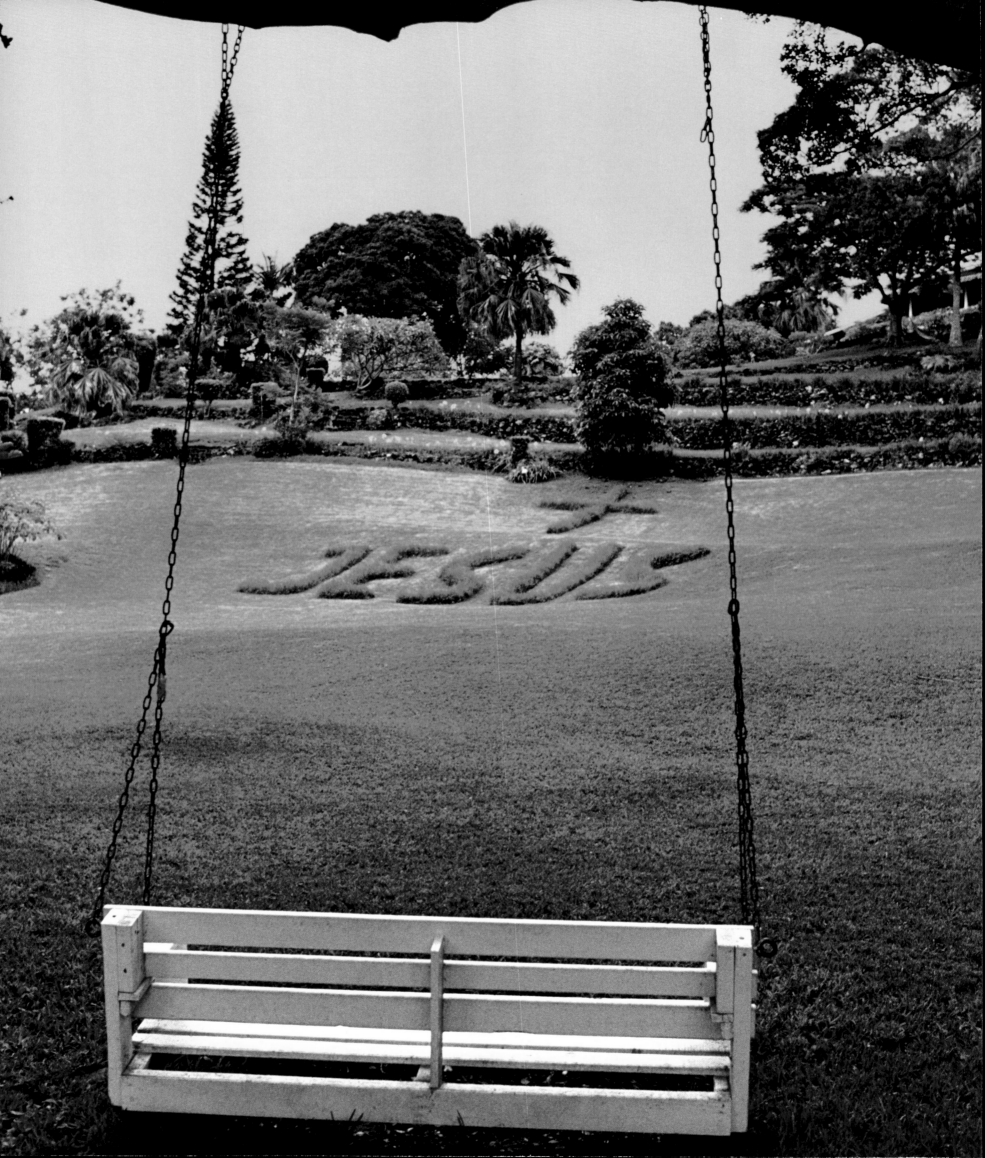

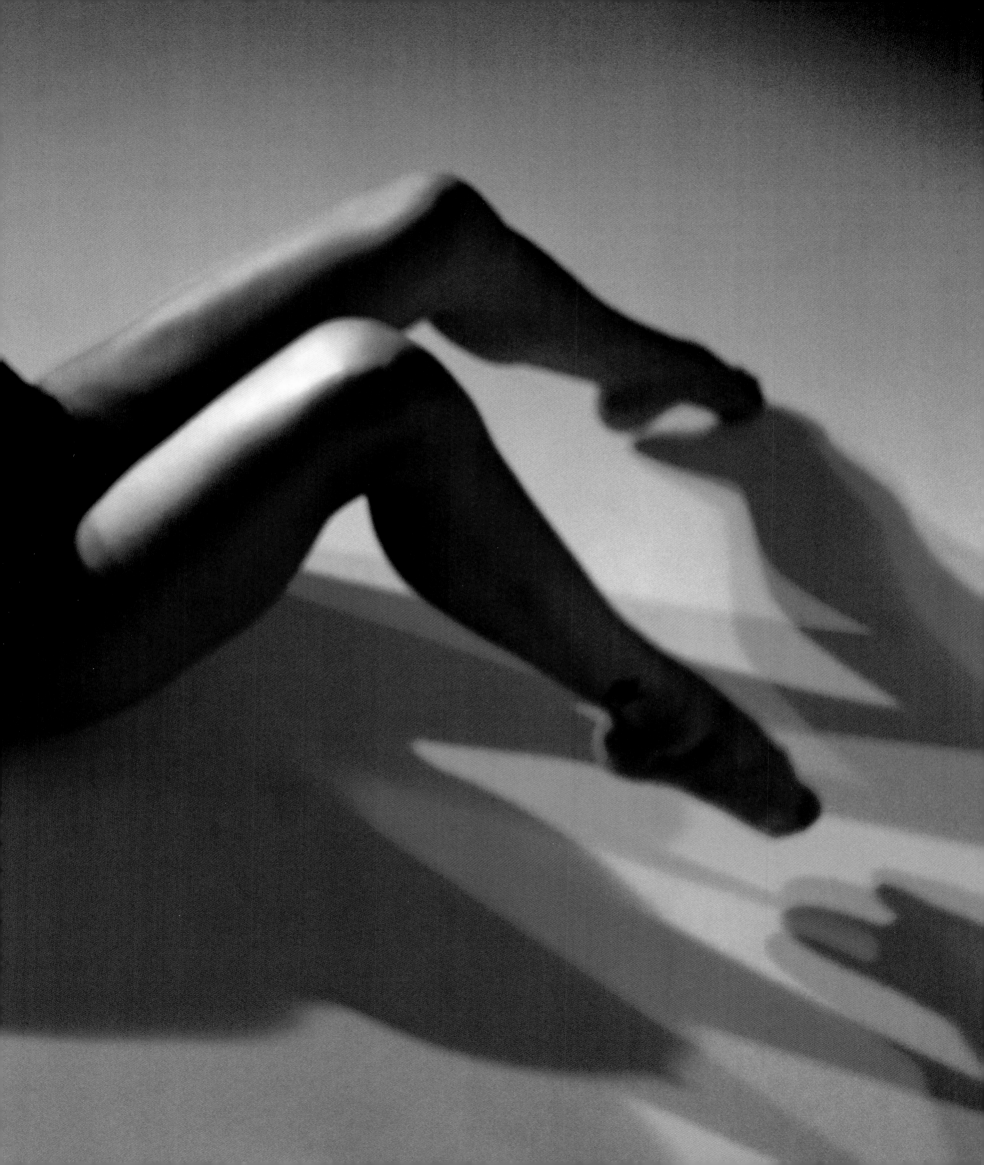

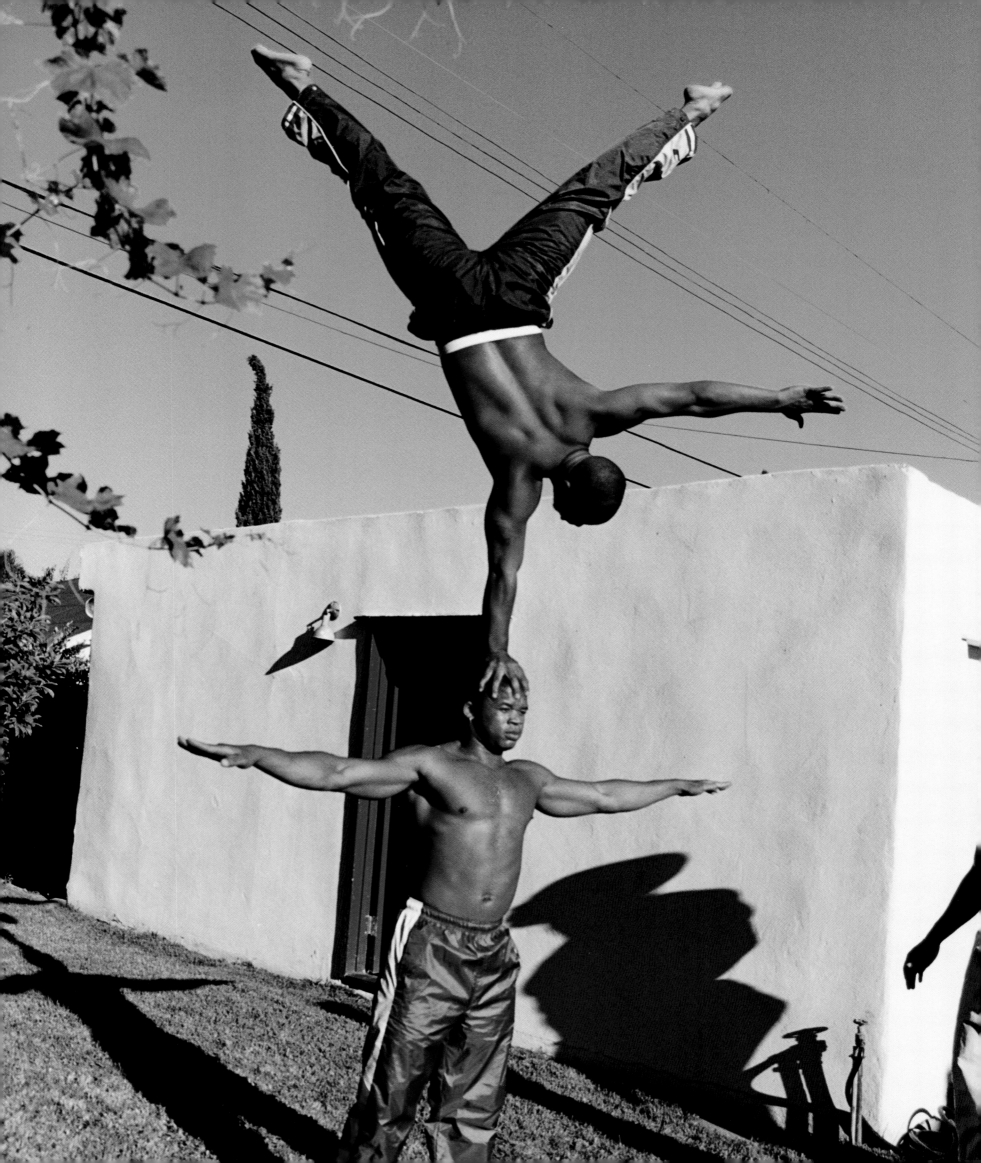

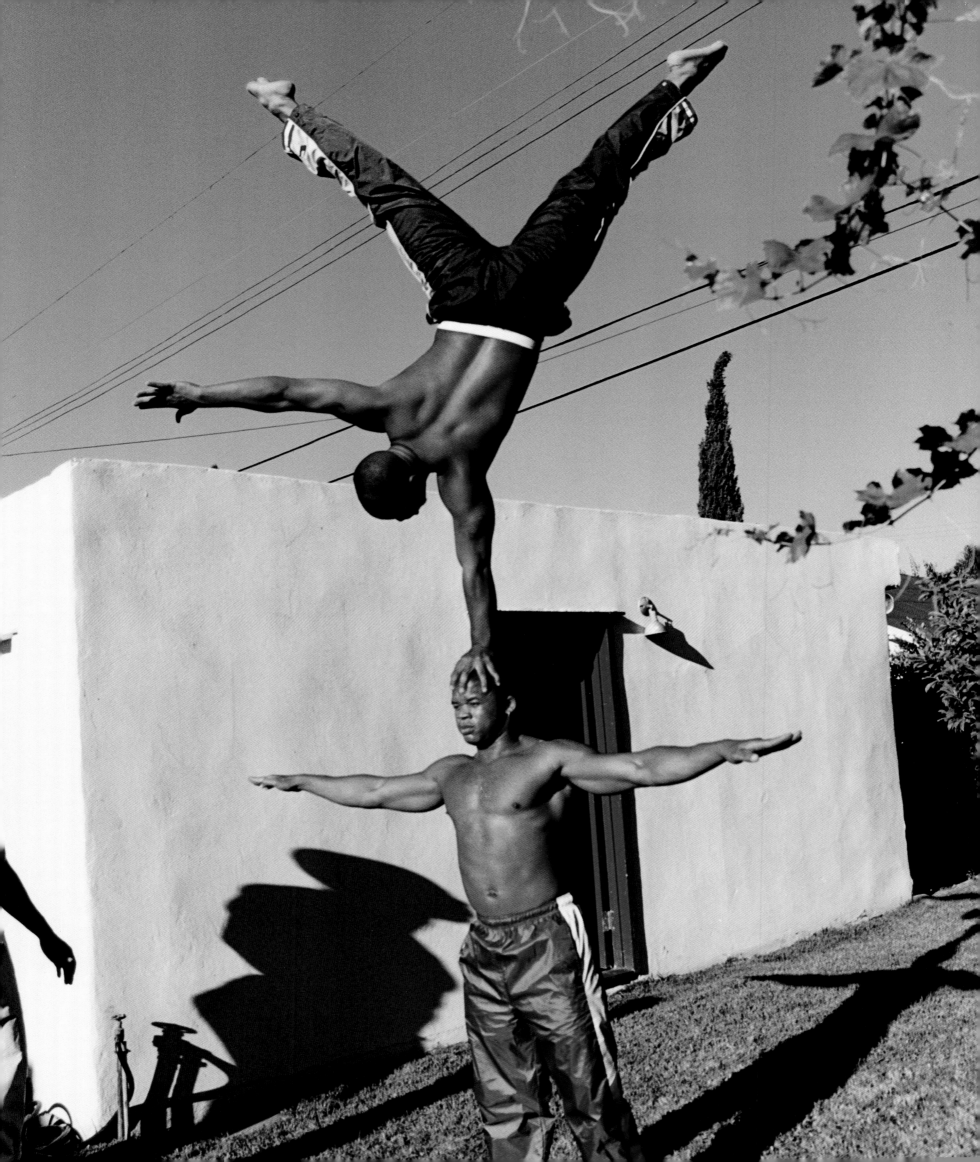

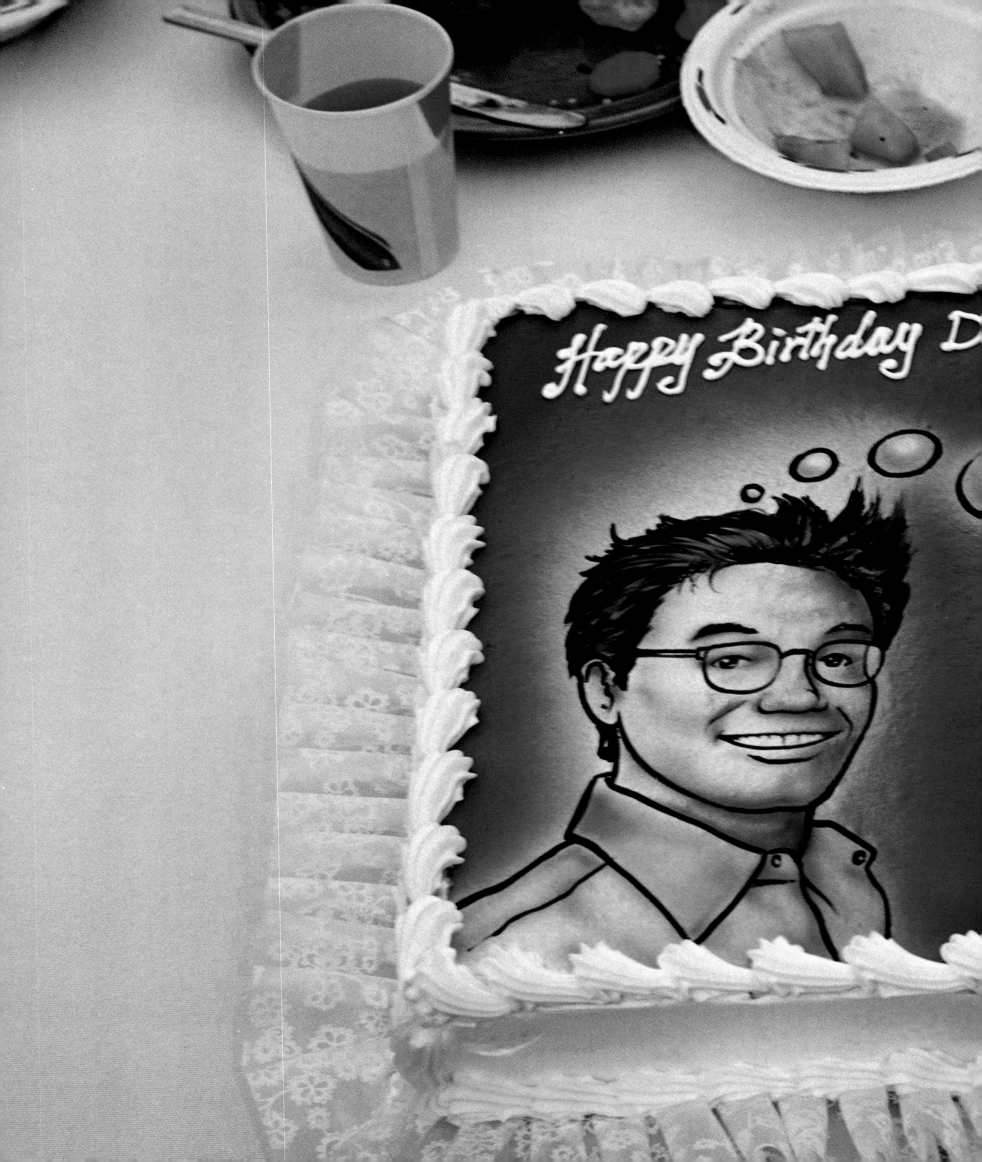

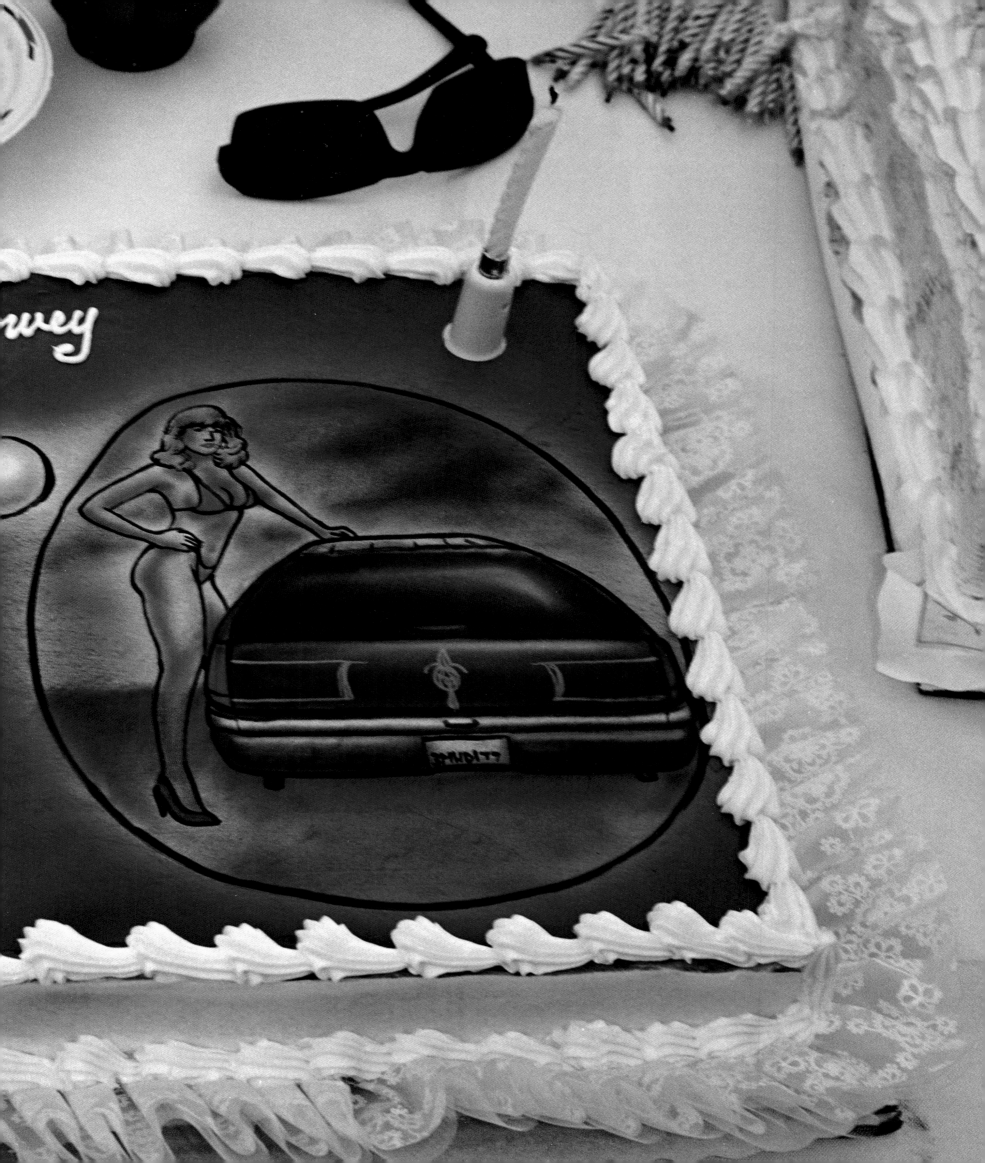

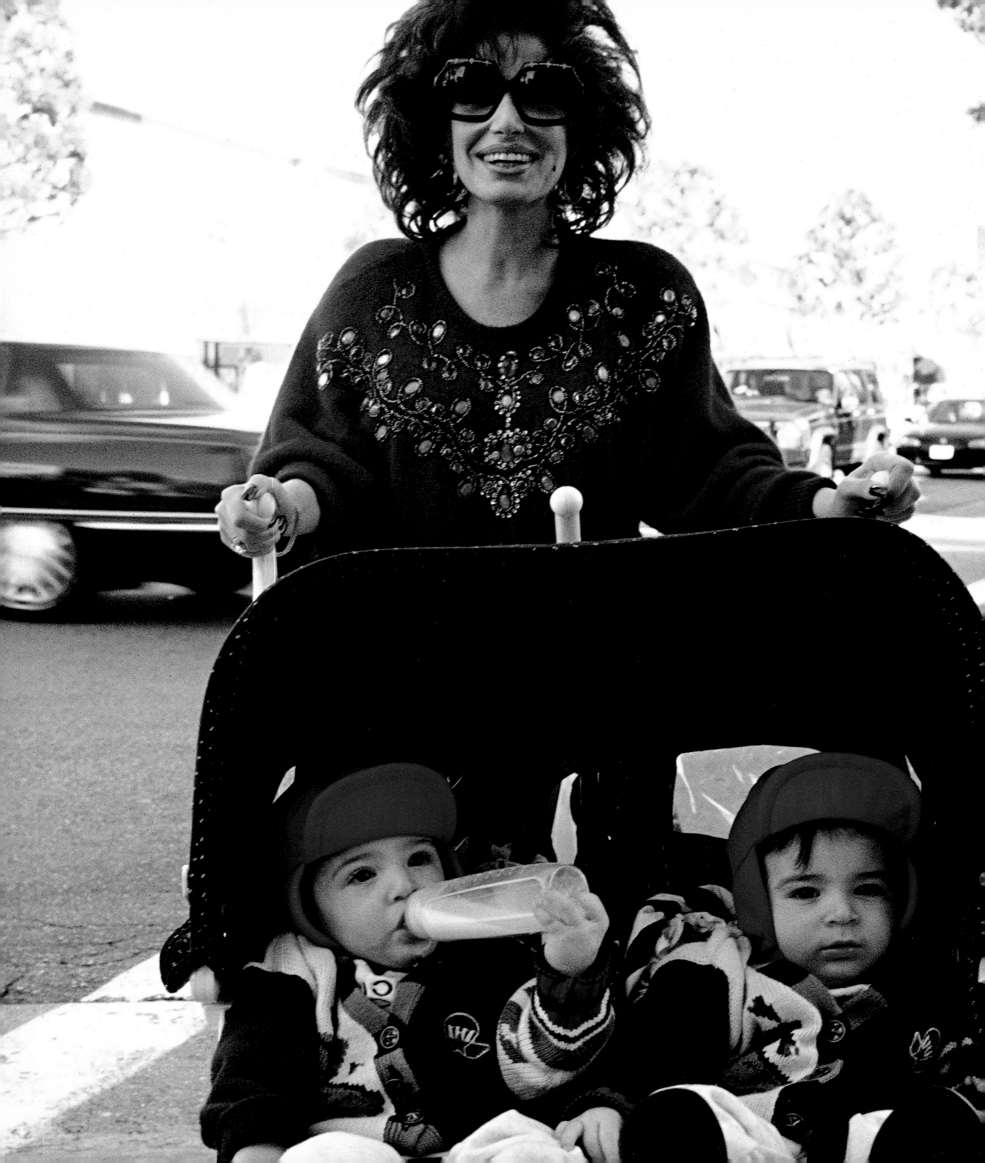

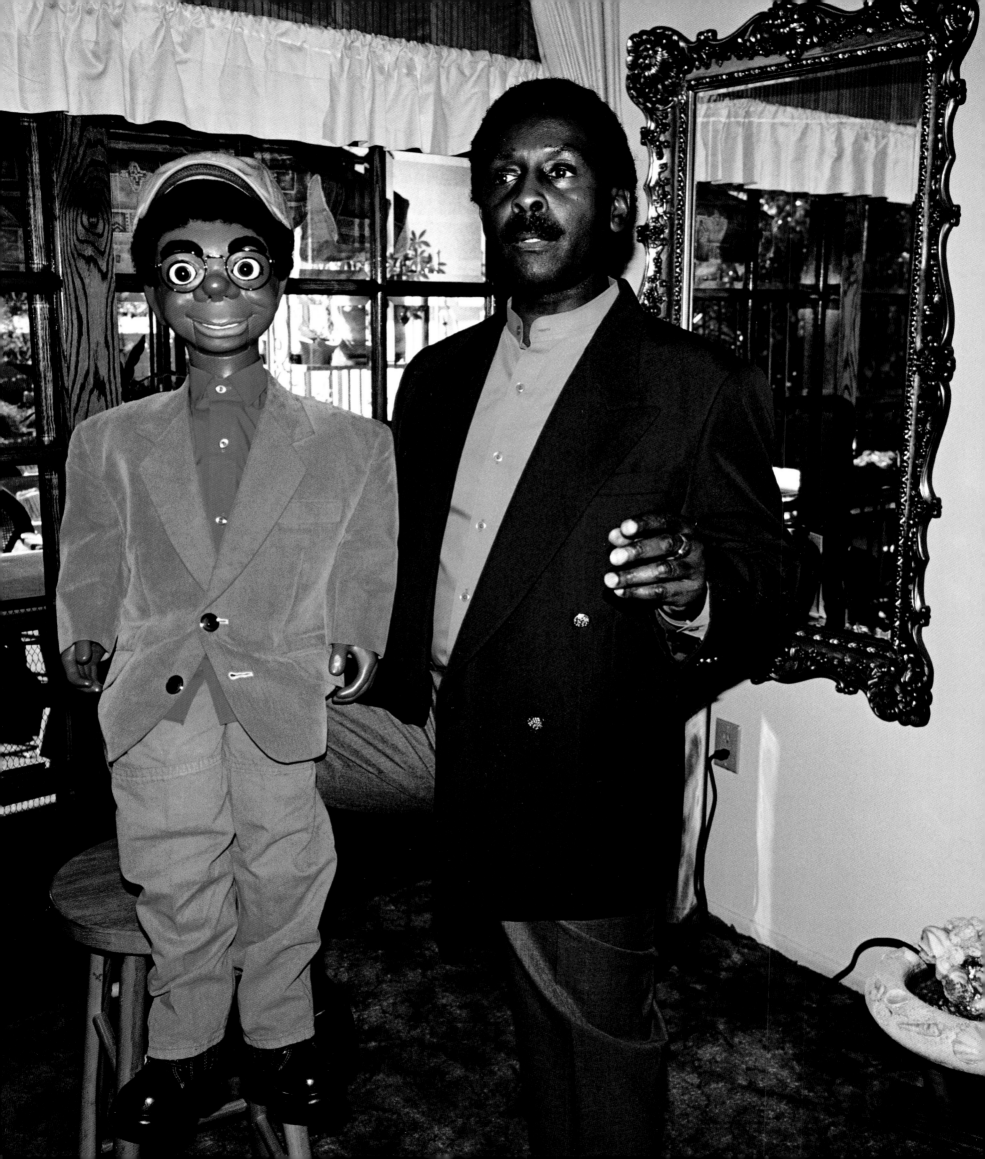

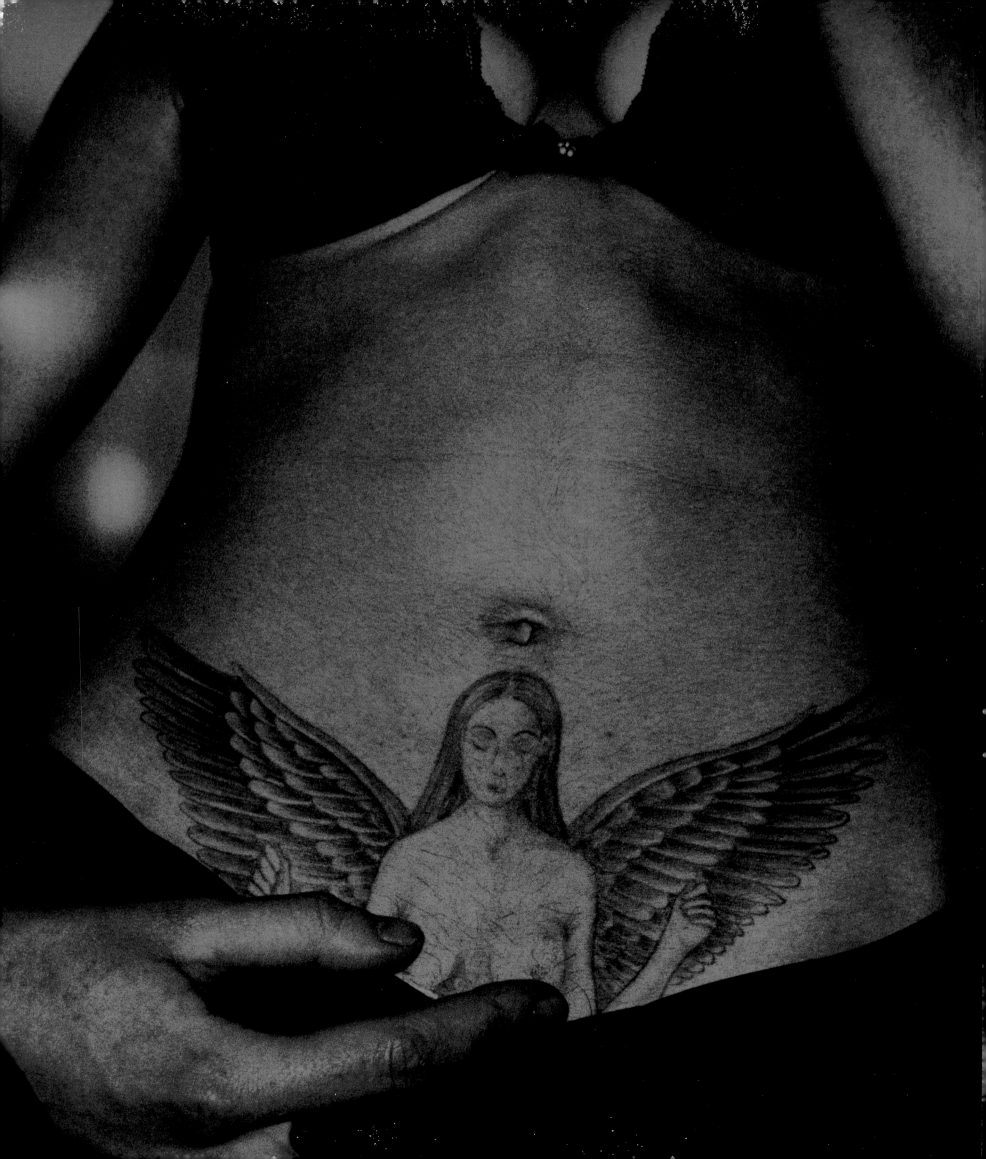

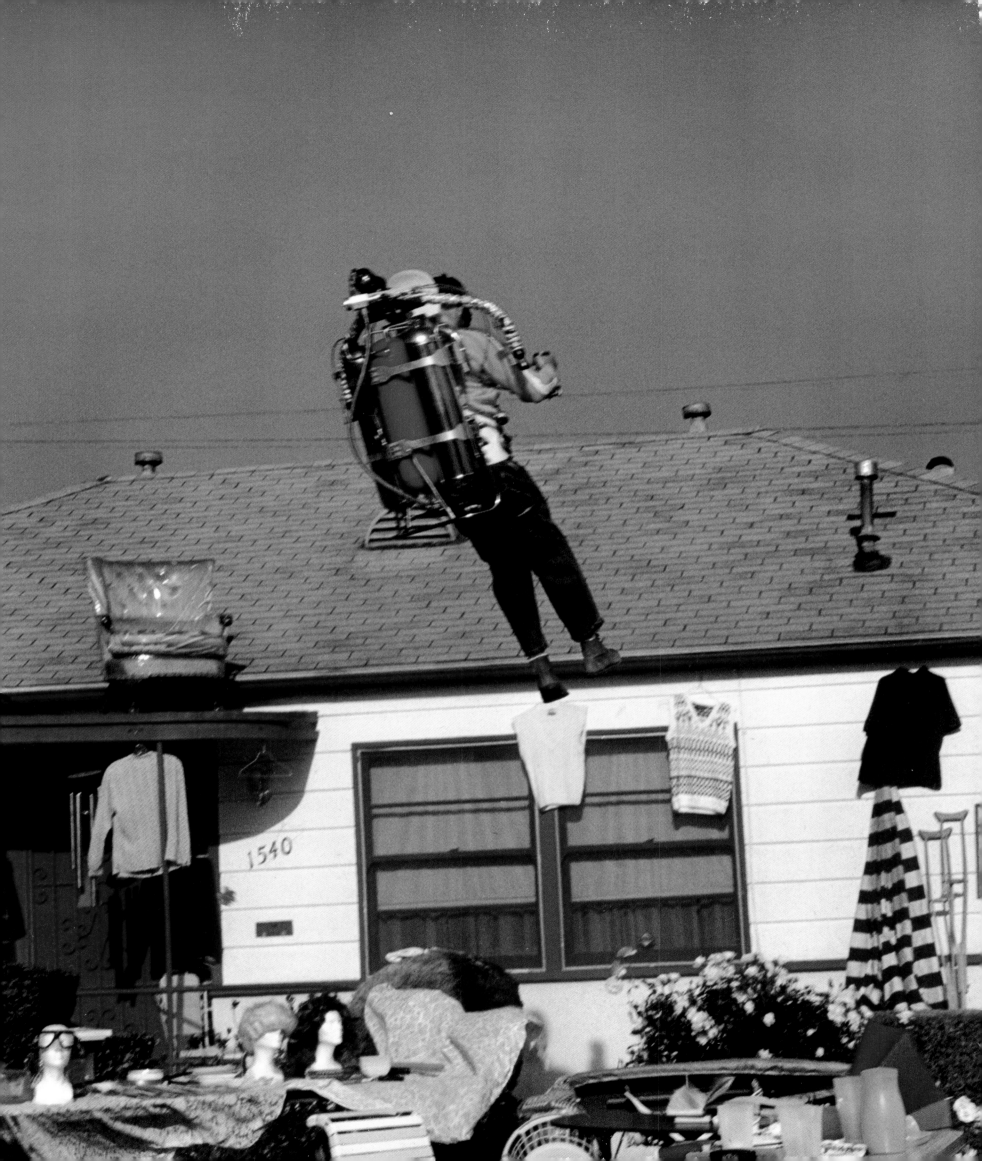

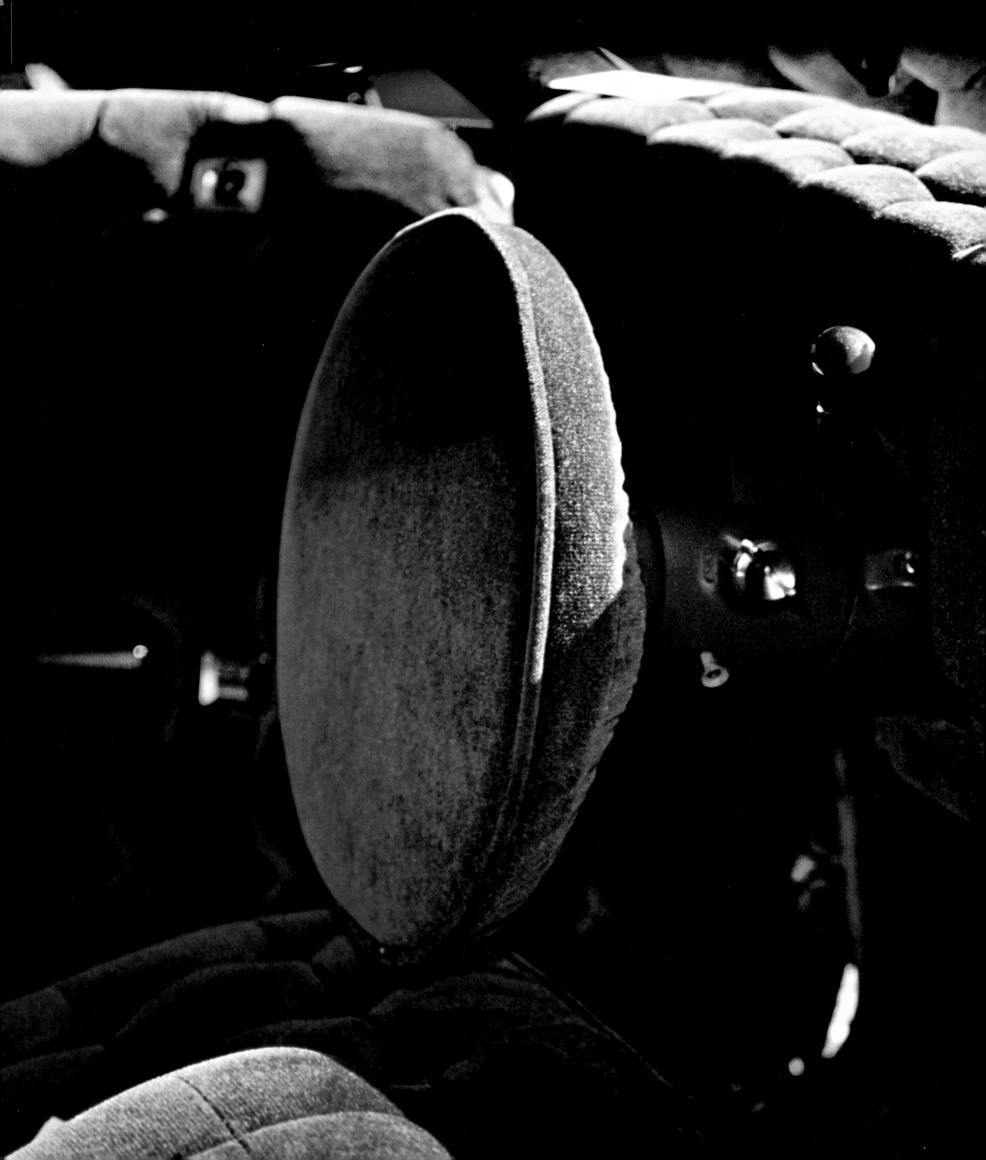

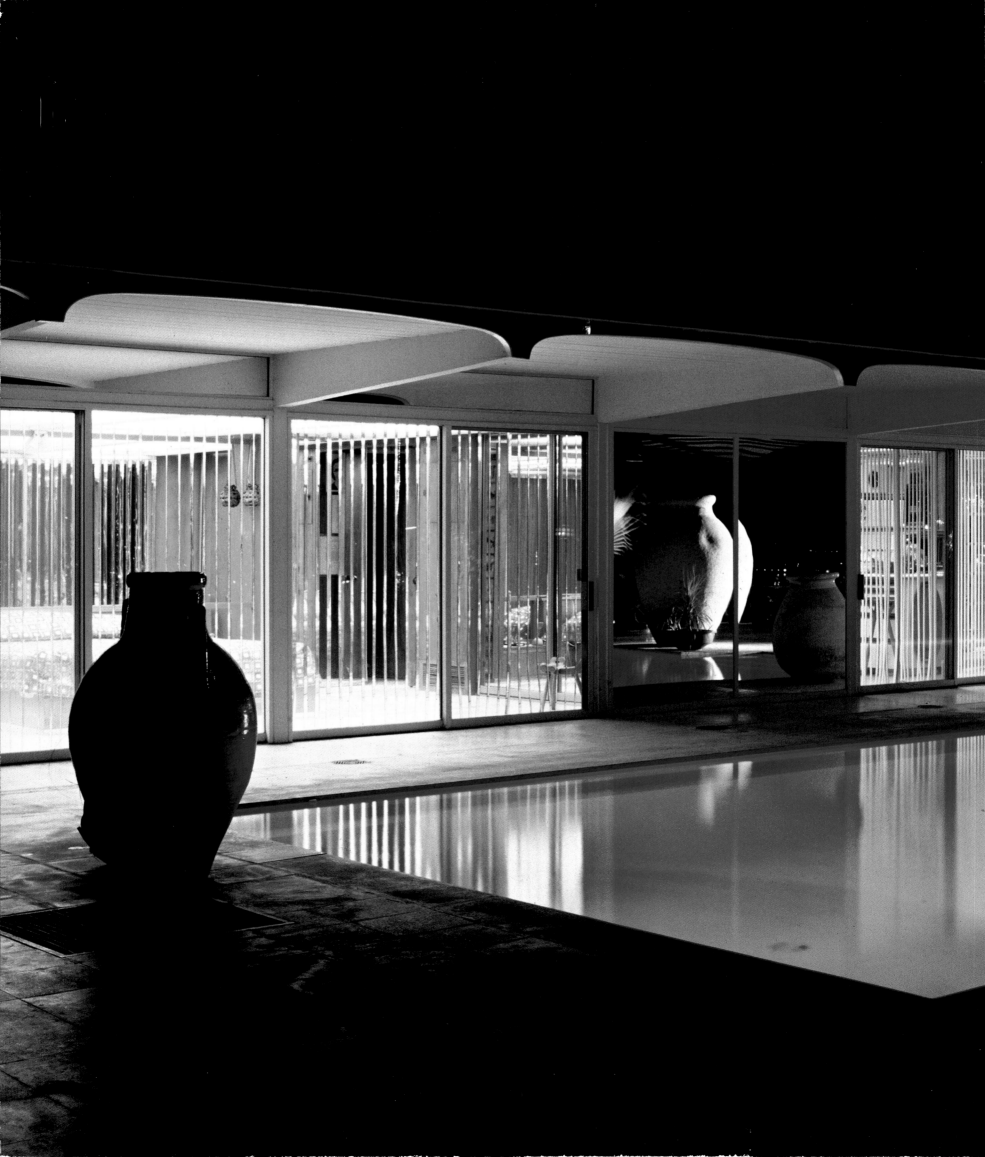

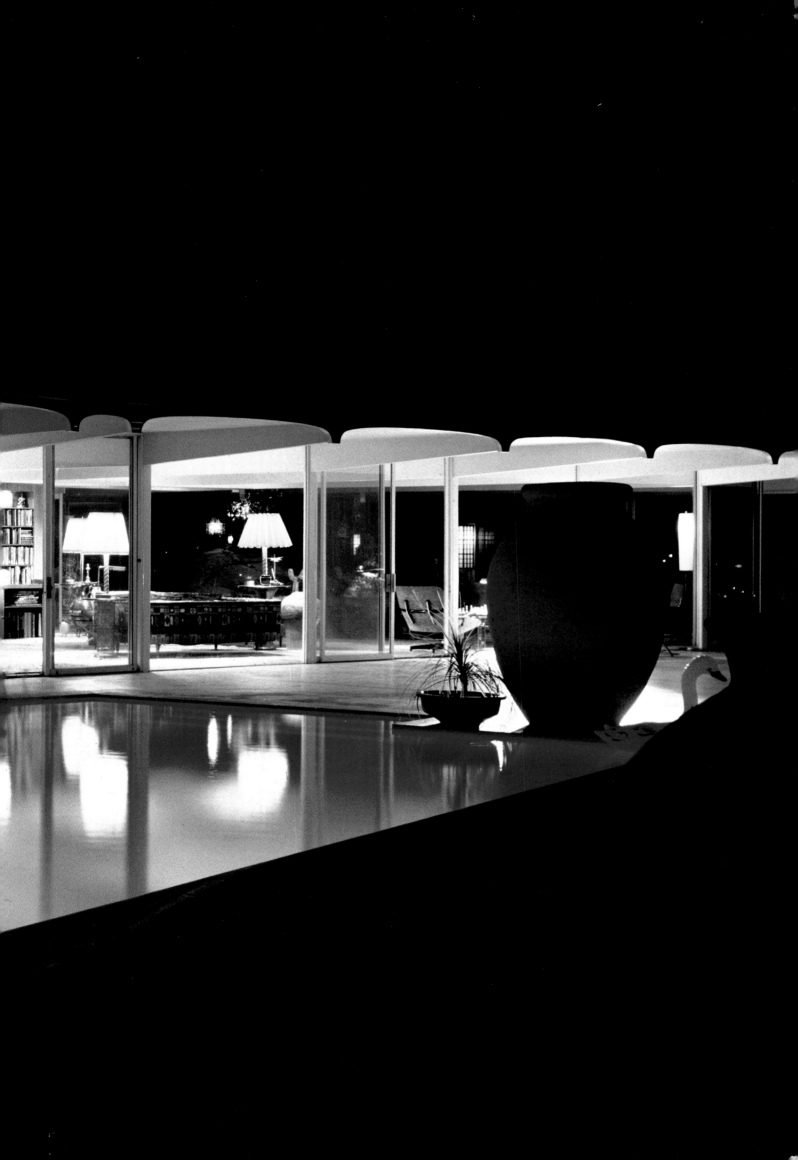

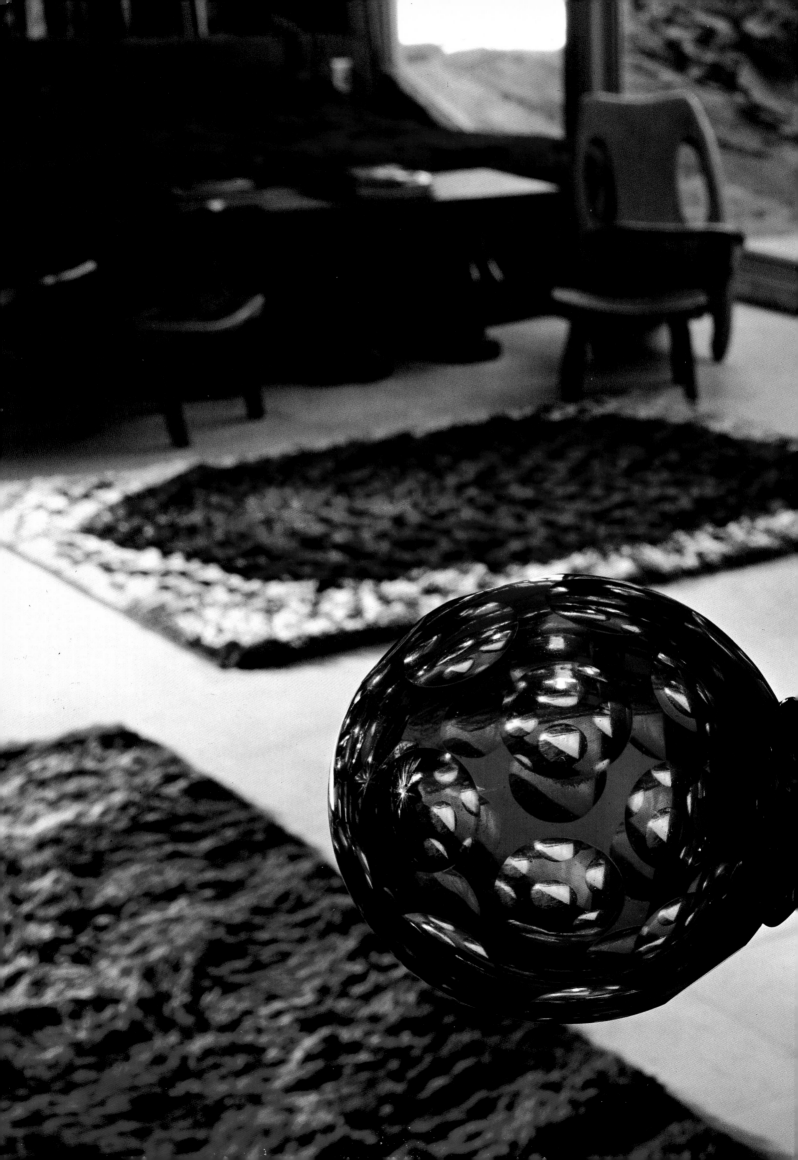

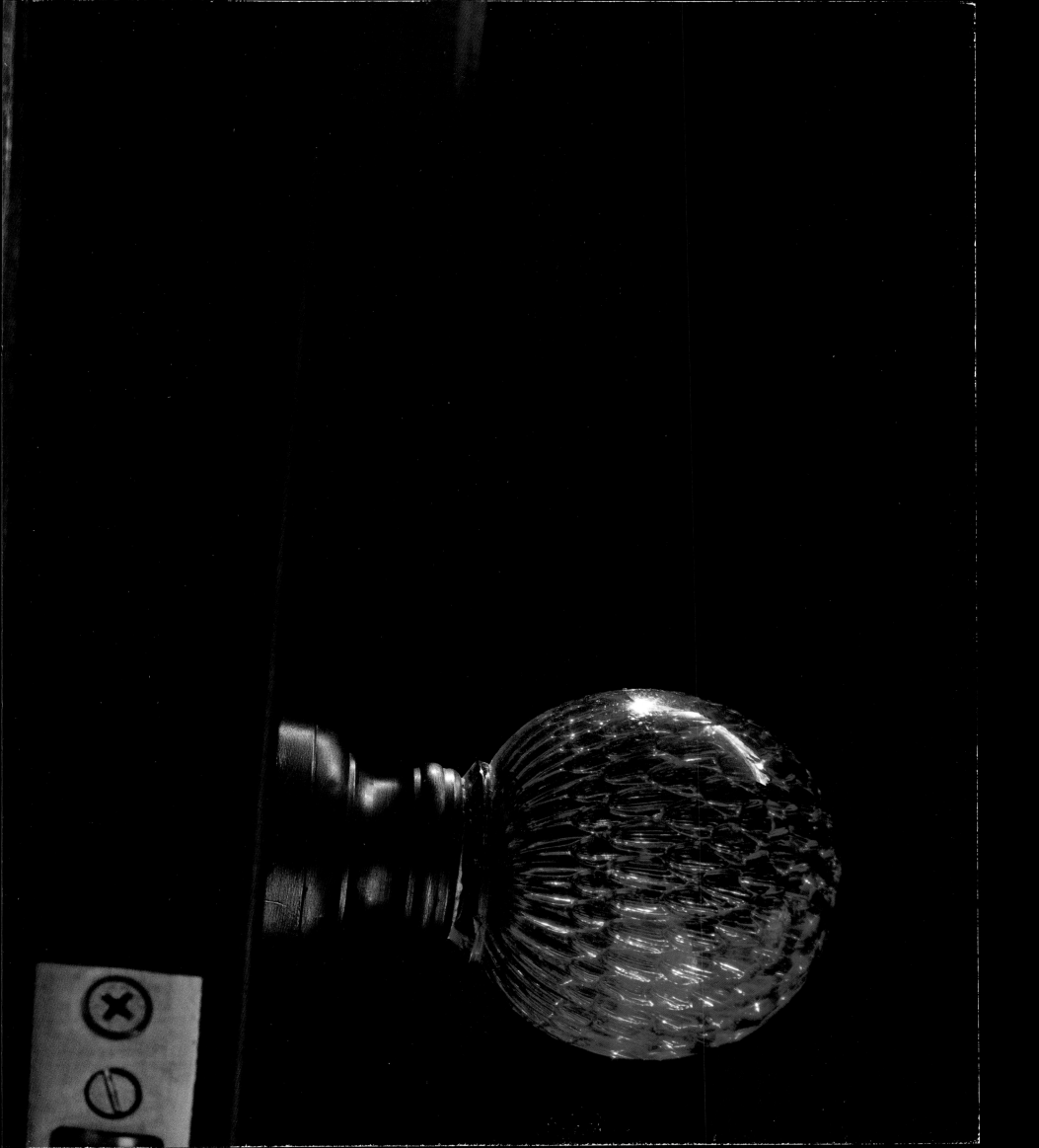

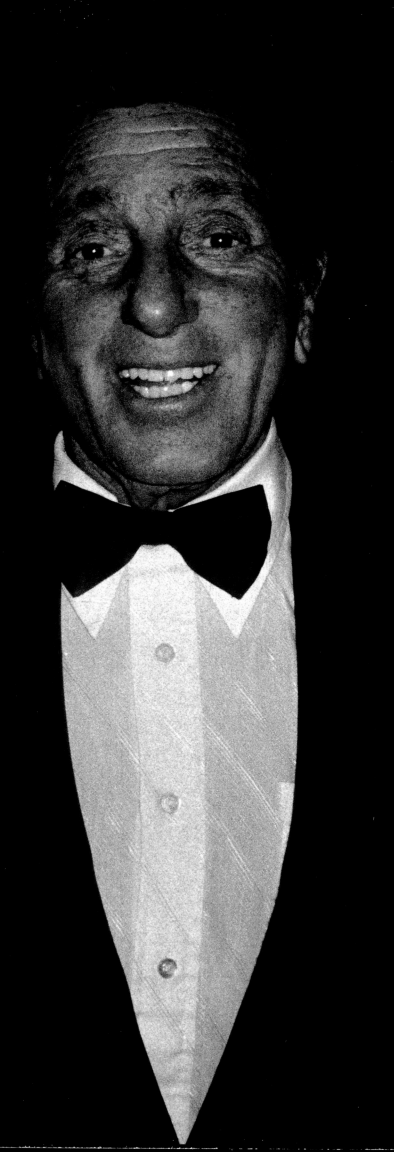

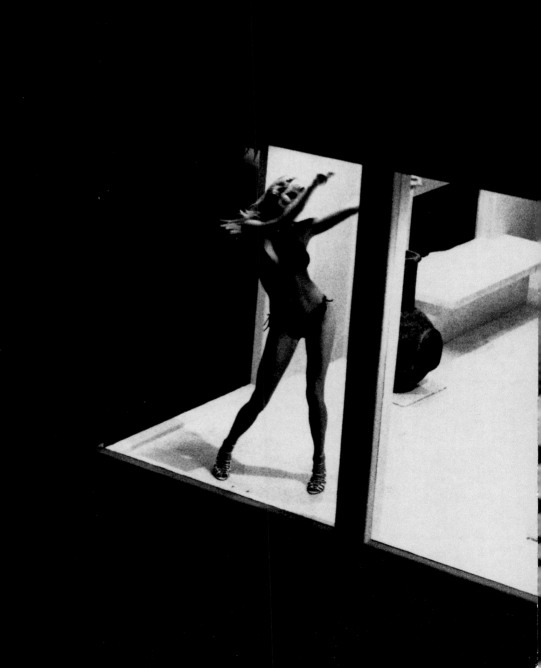

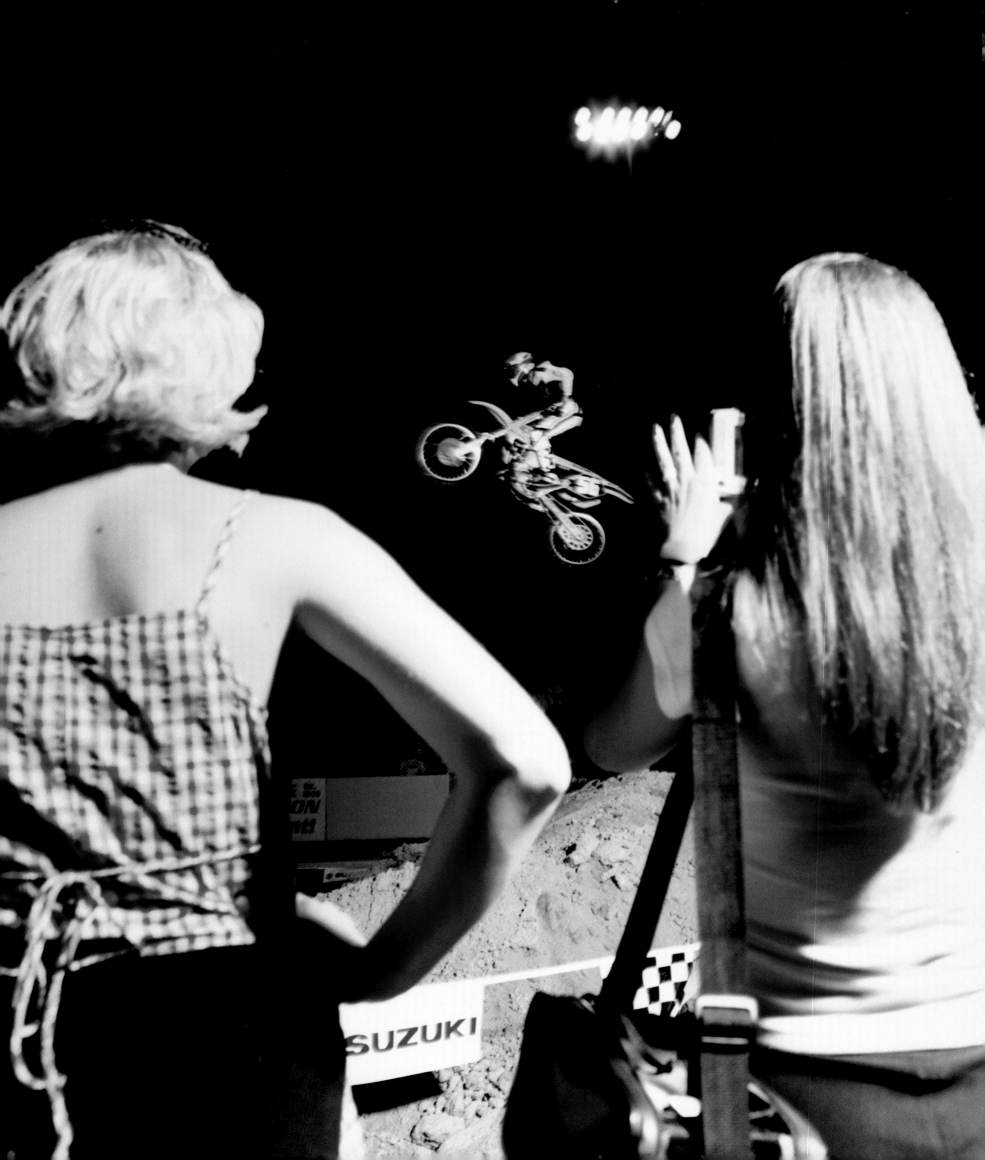

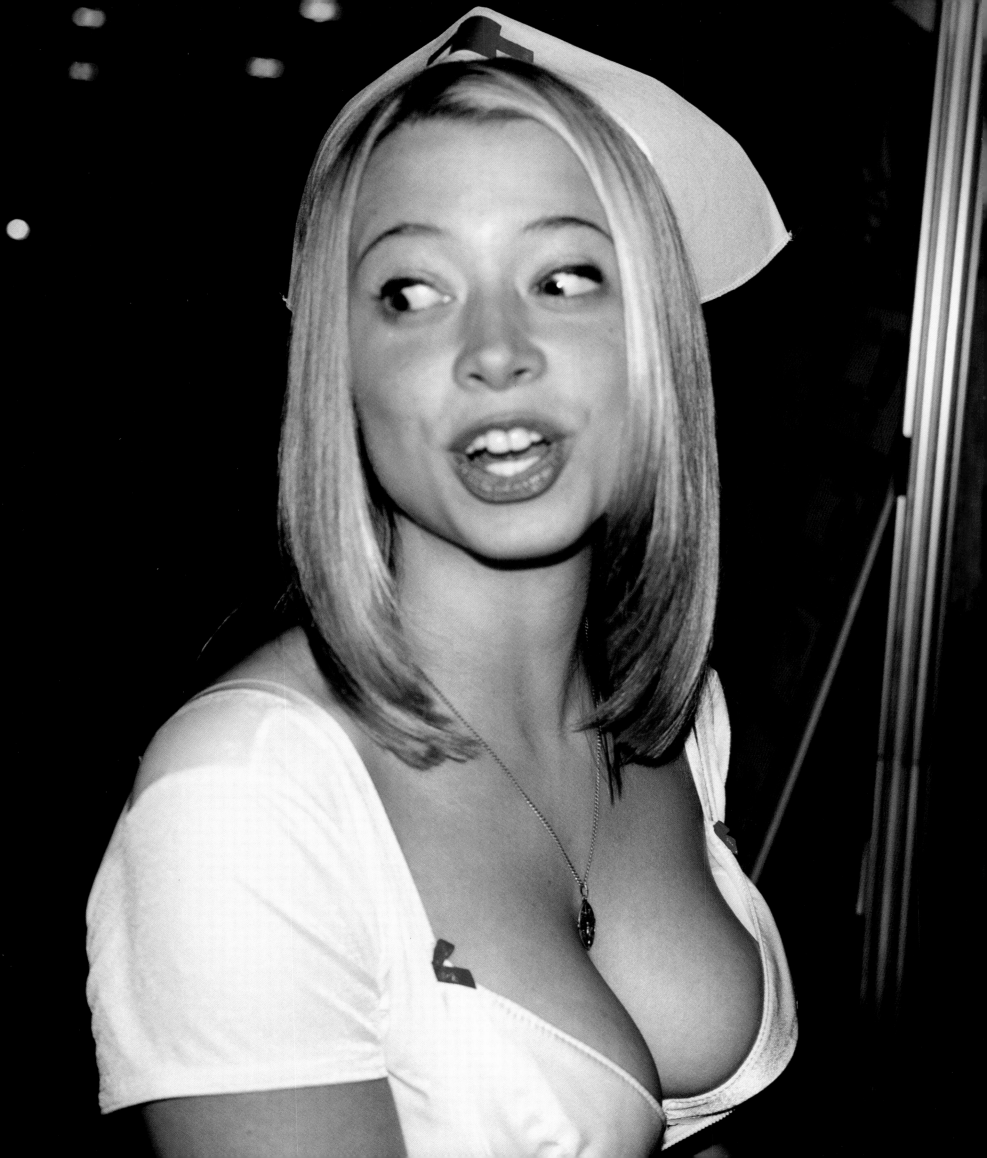

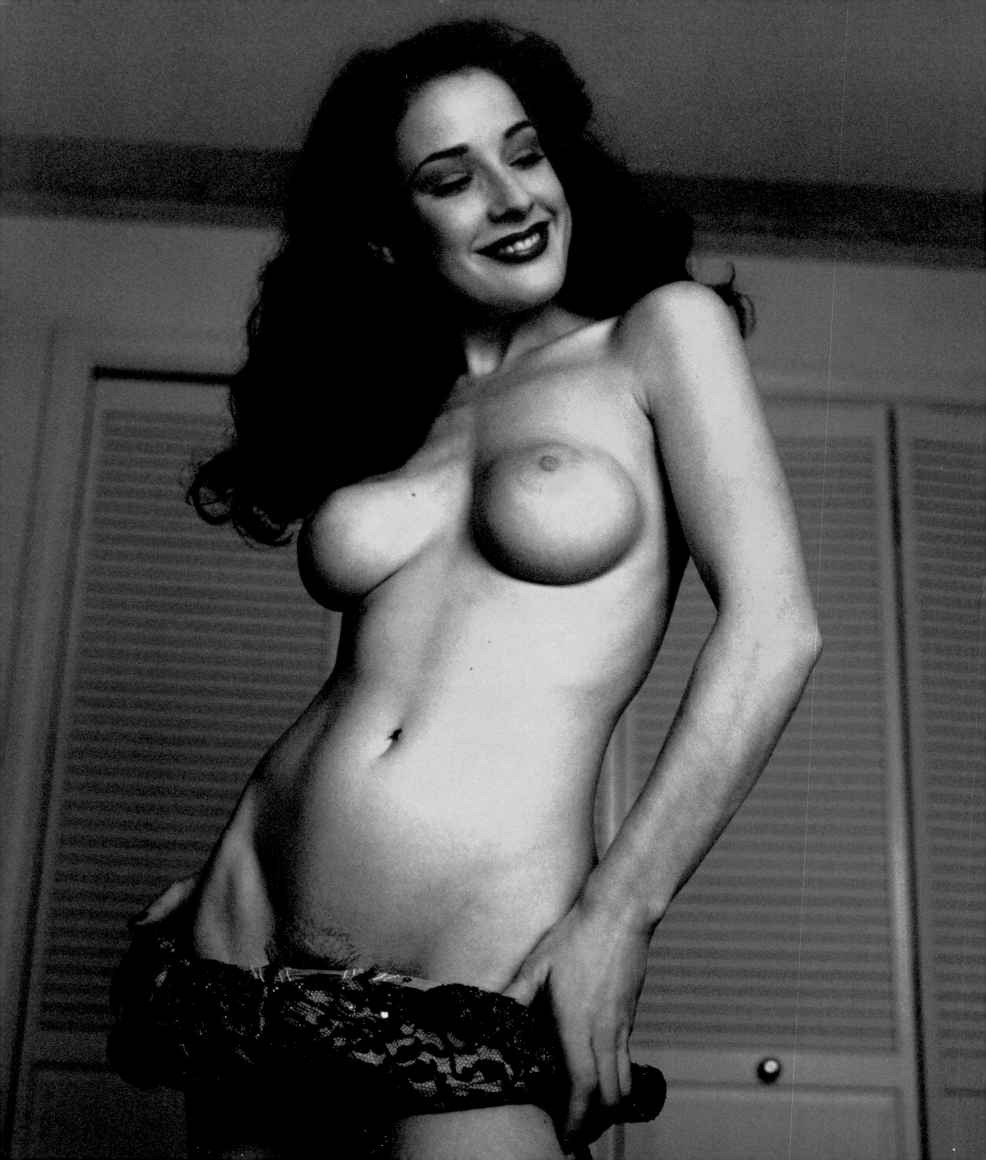

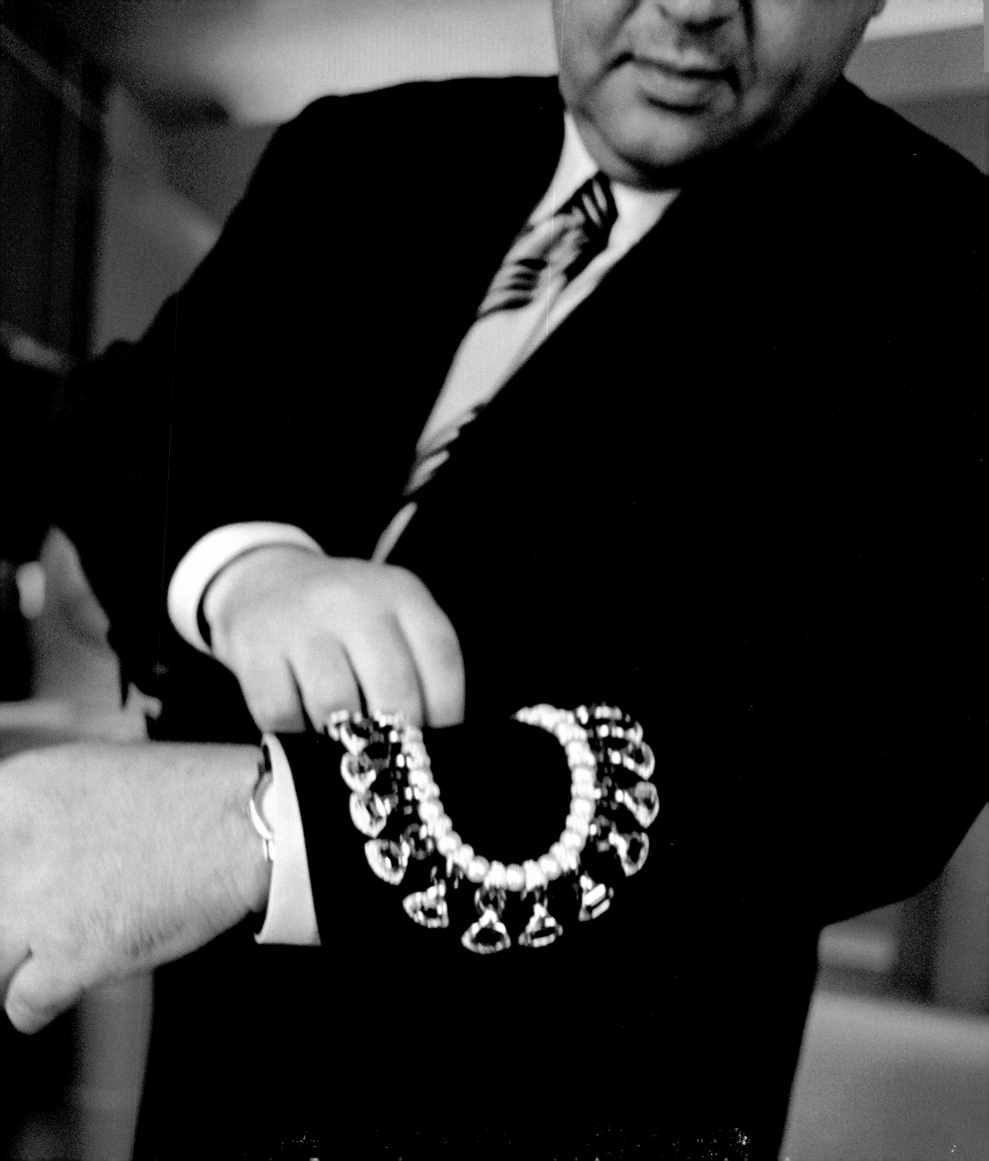

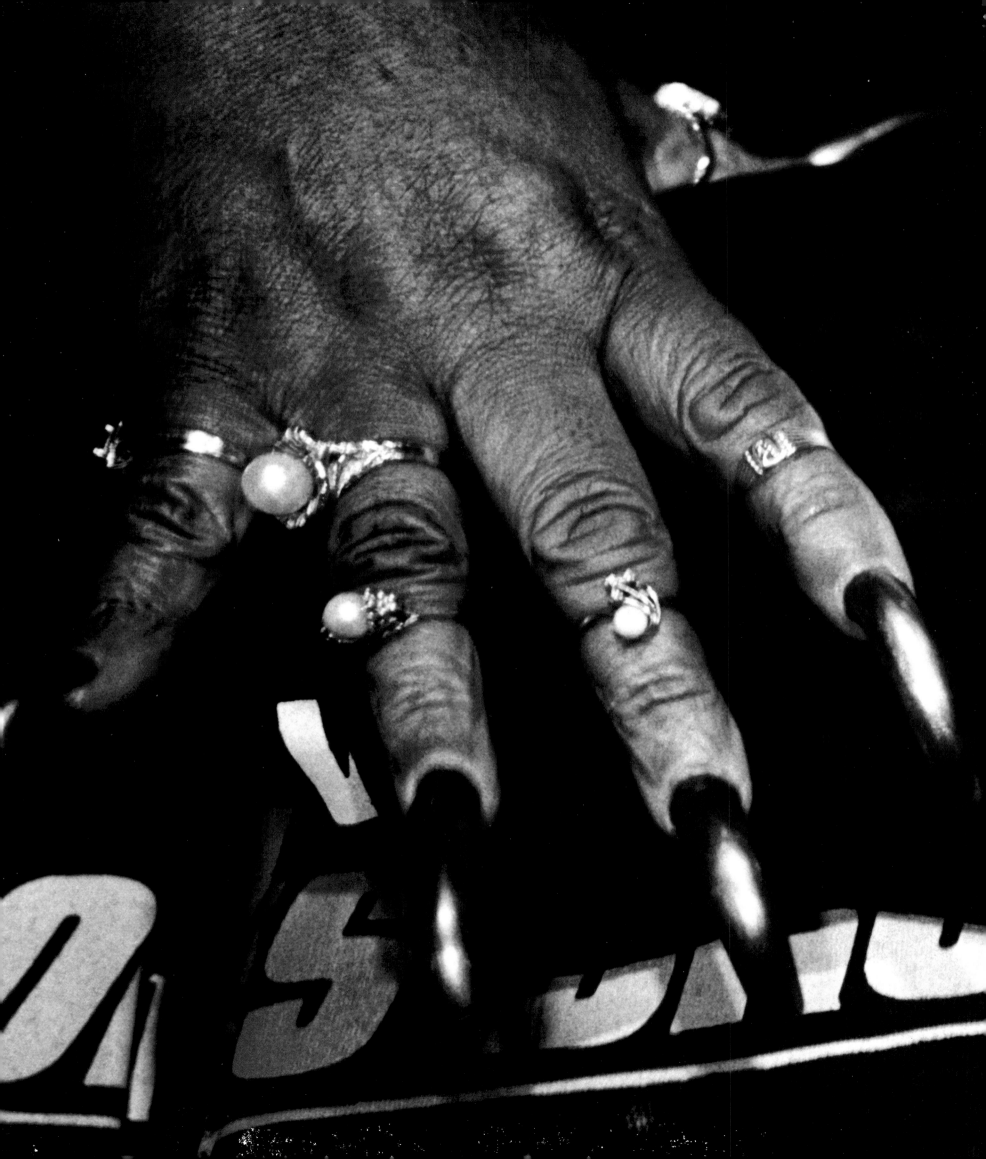

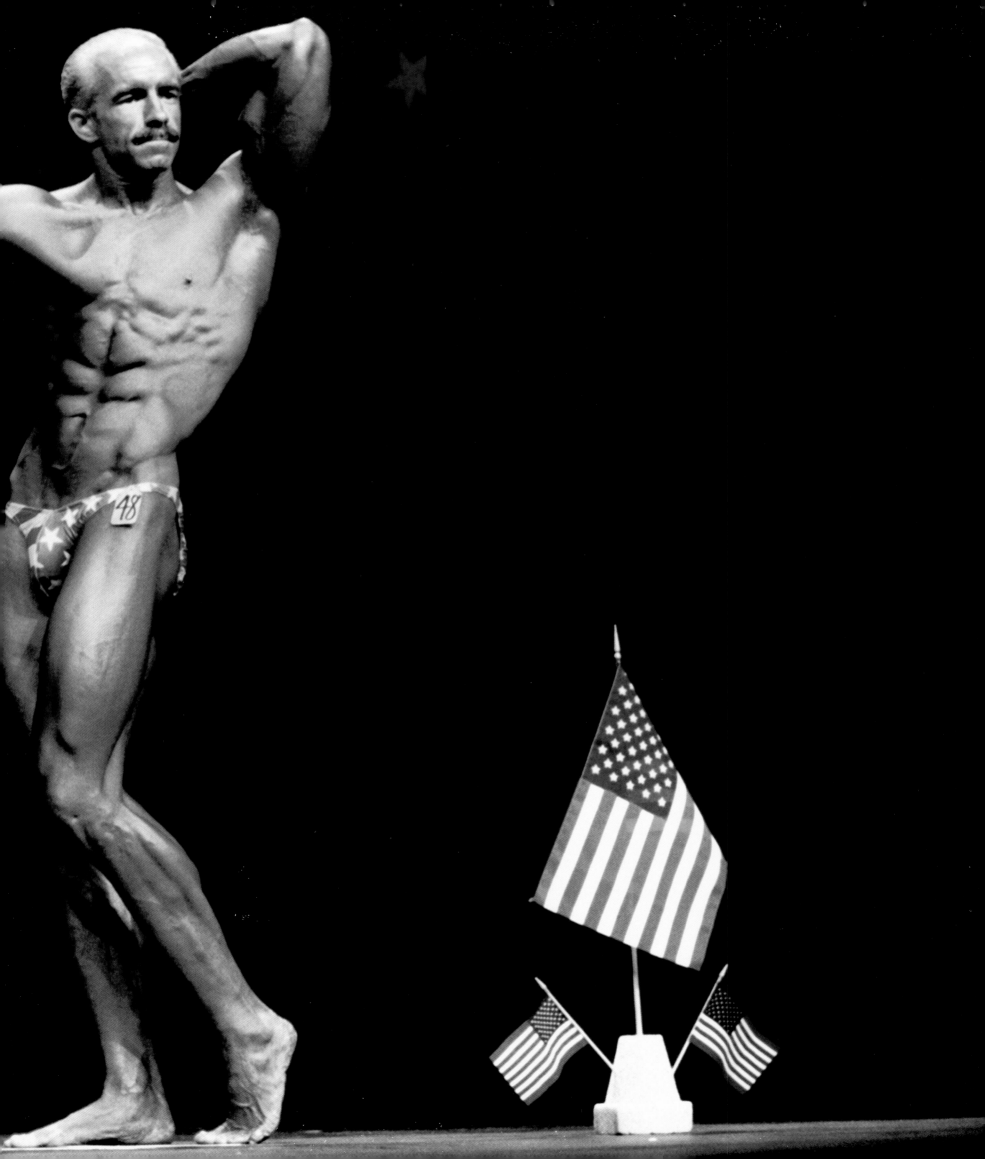

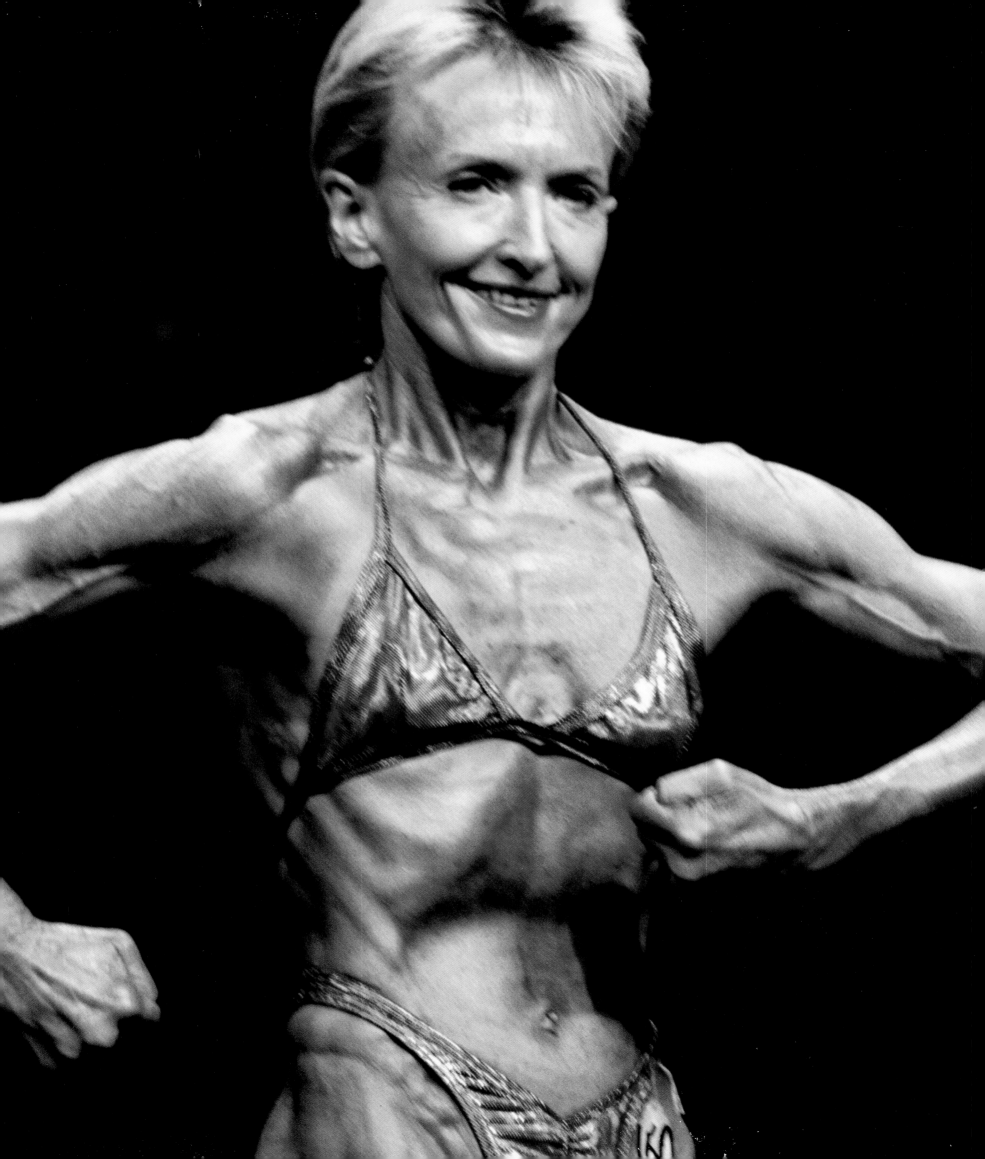

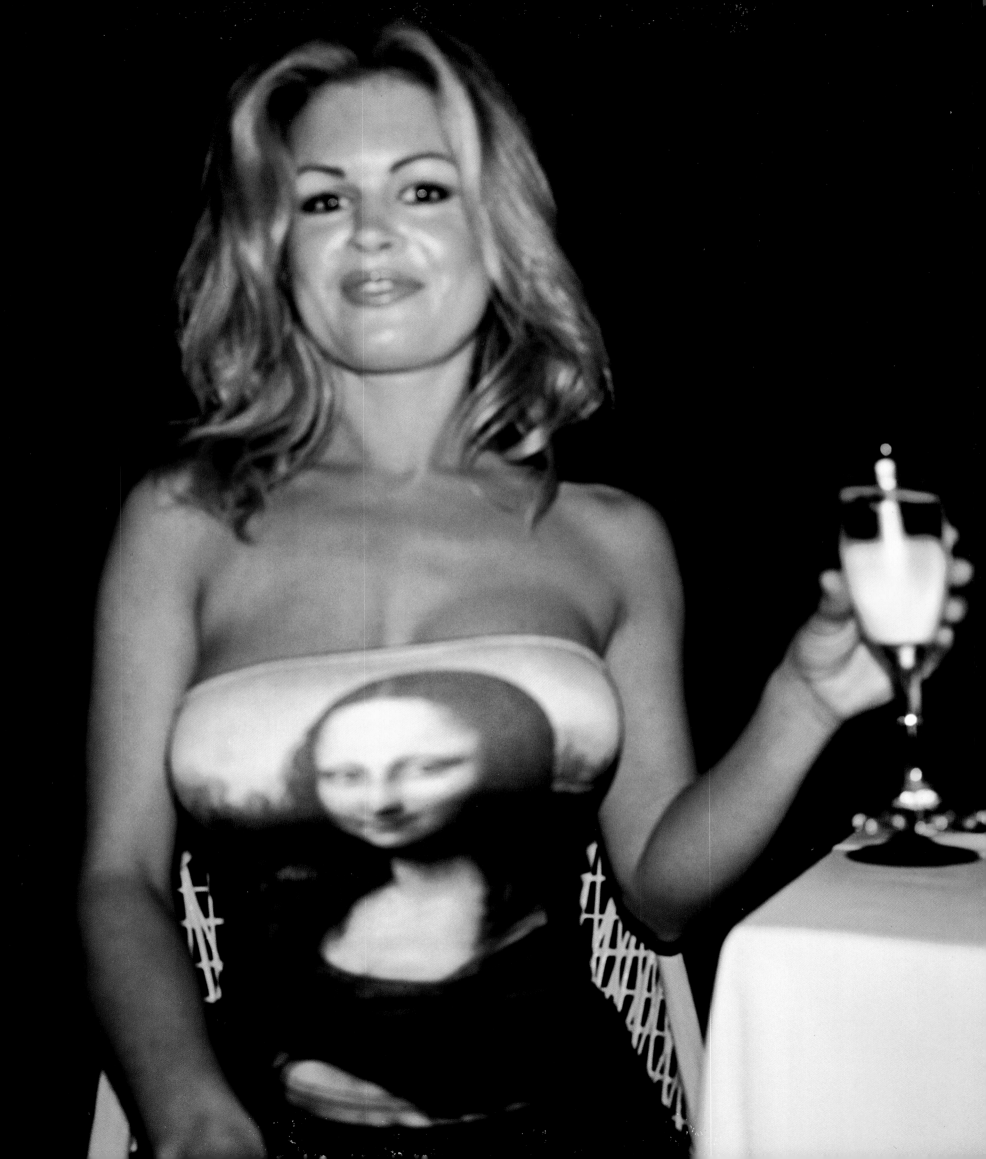

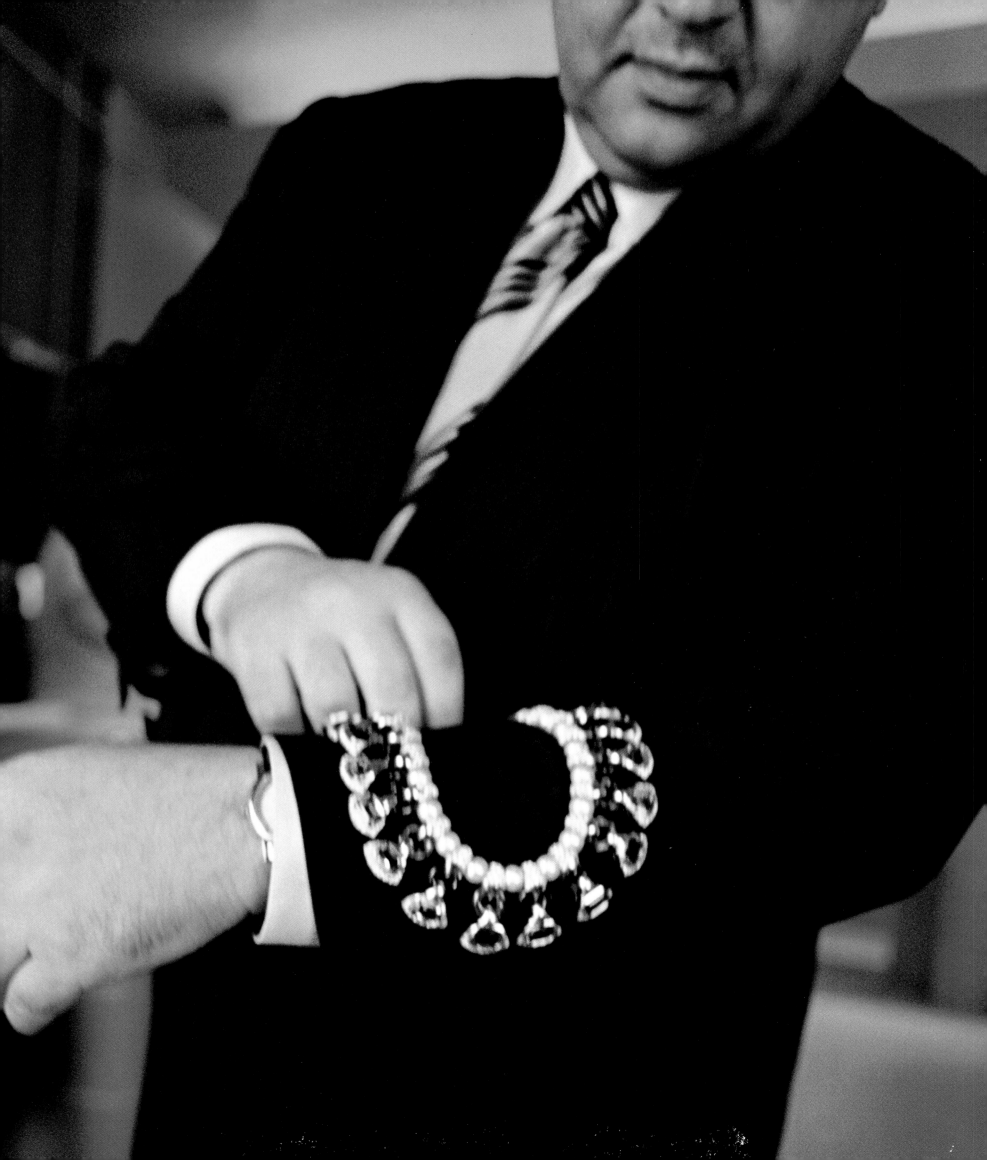

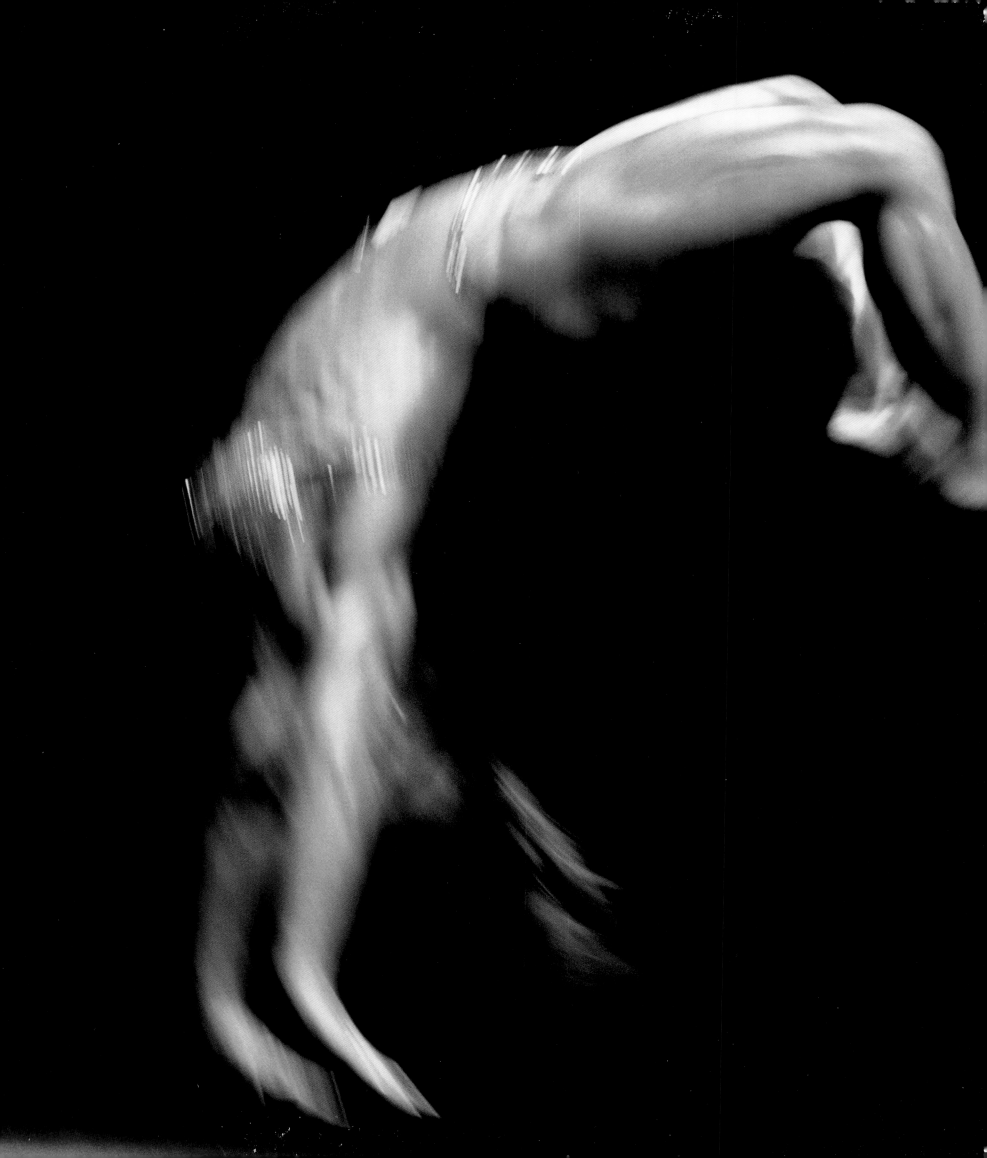

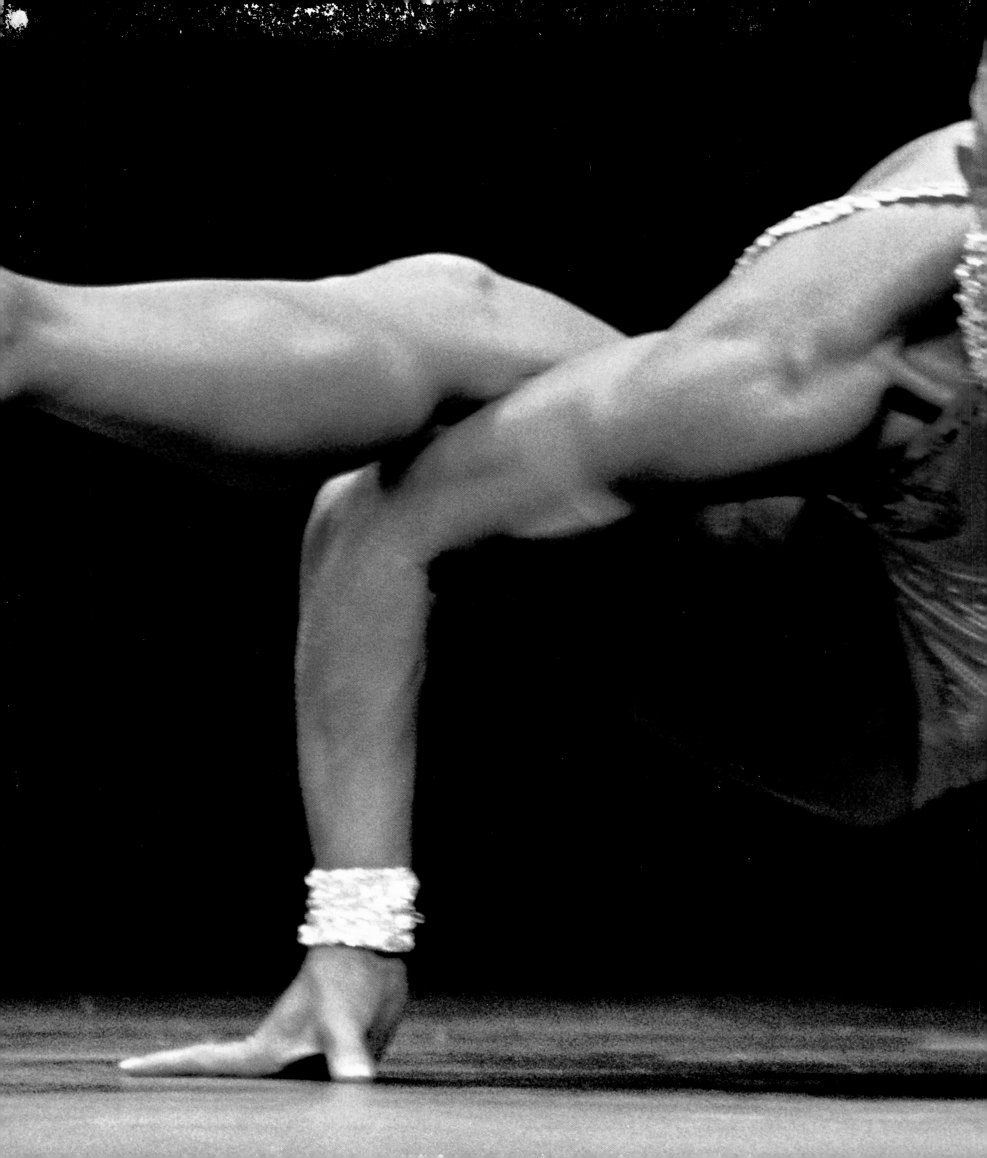

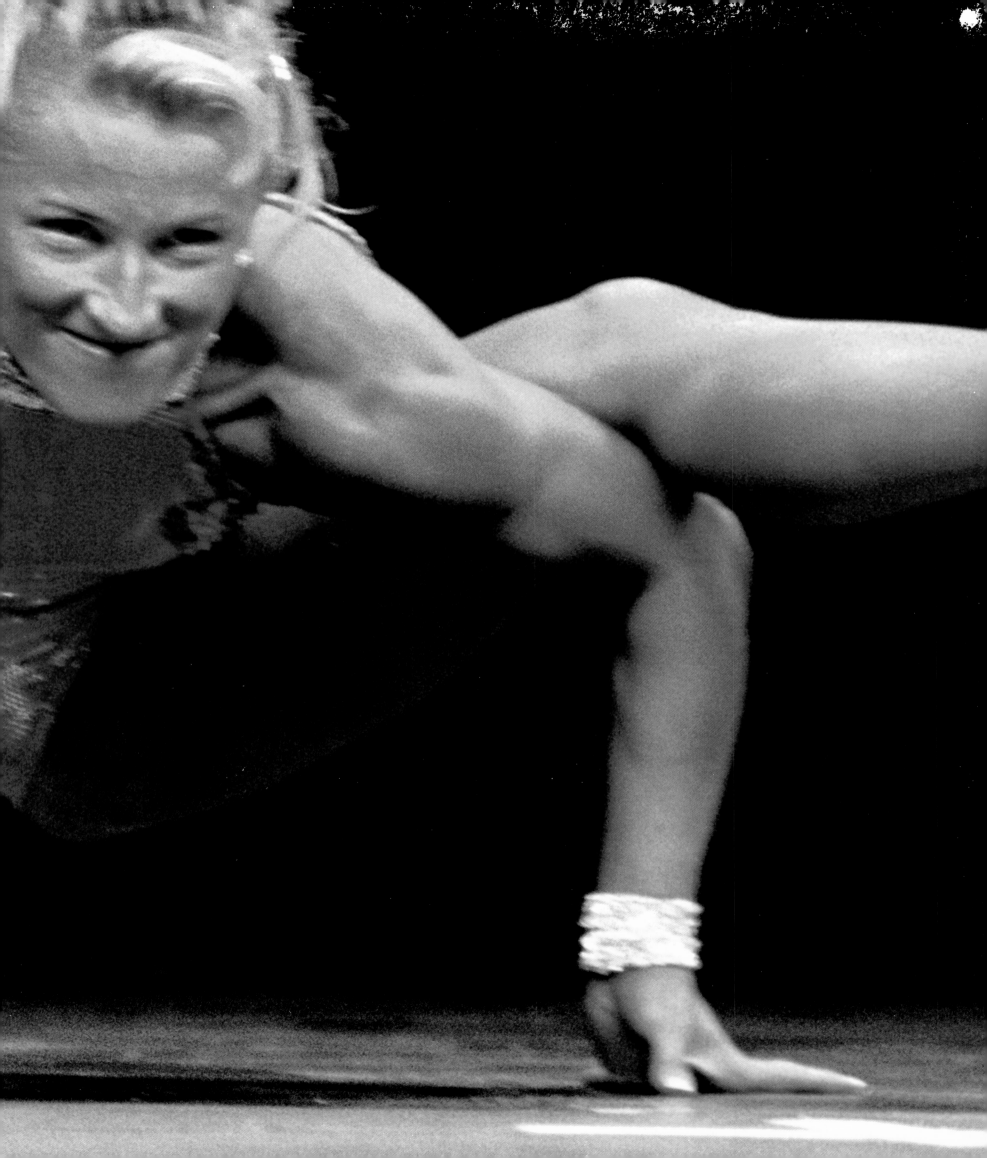

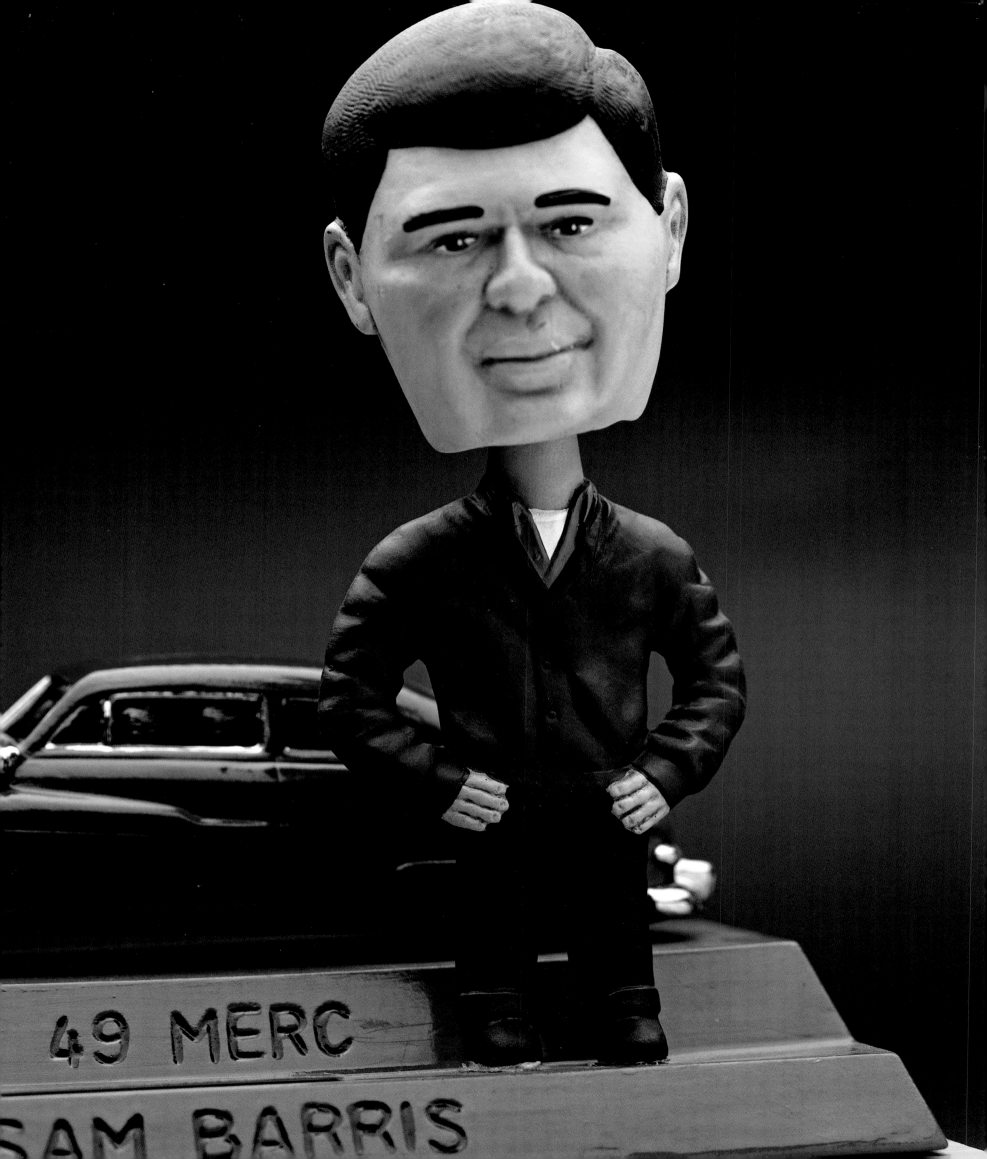

49 MERC

SAM BARRIS

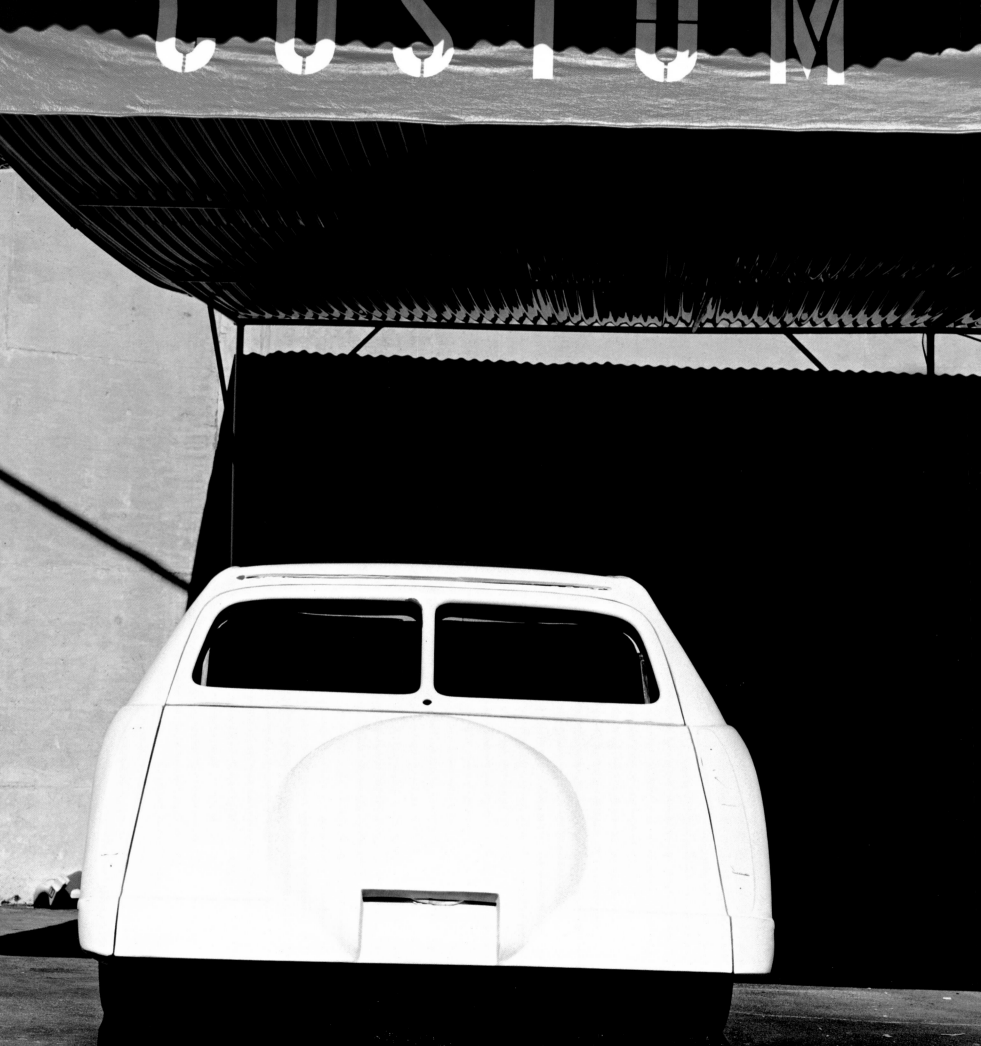

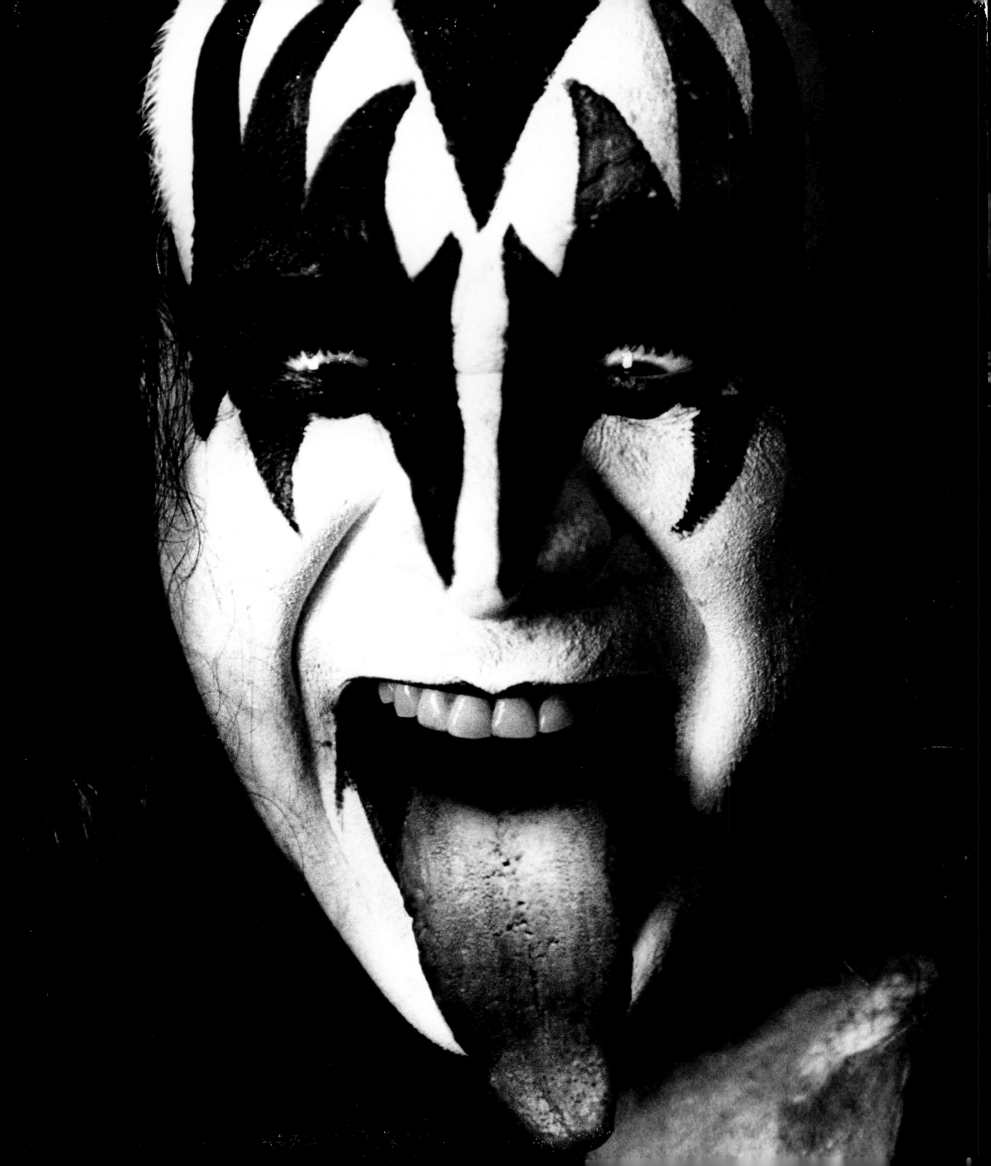

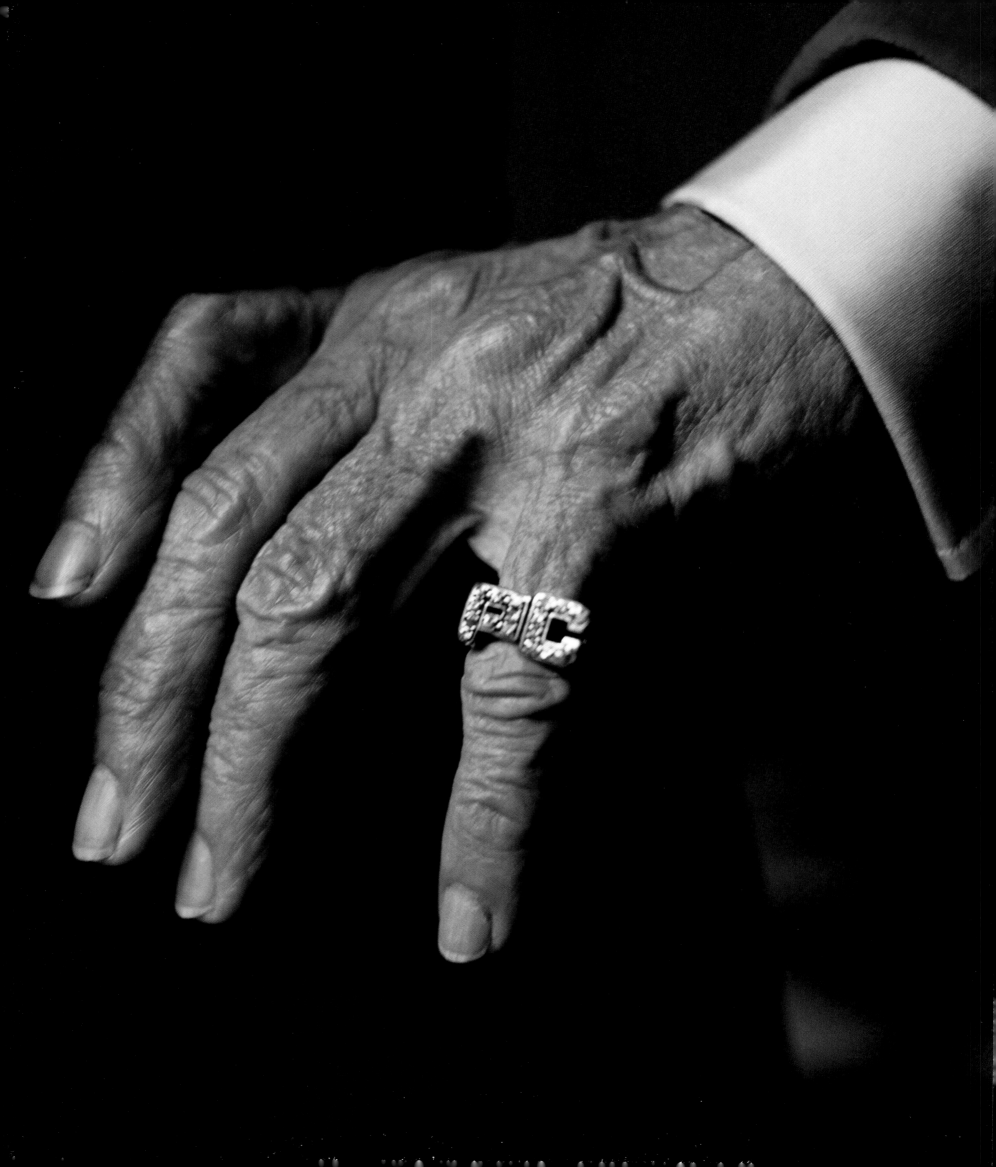

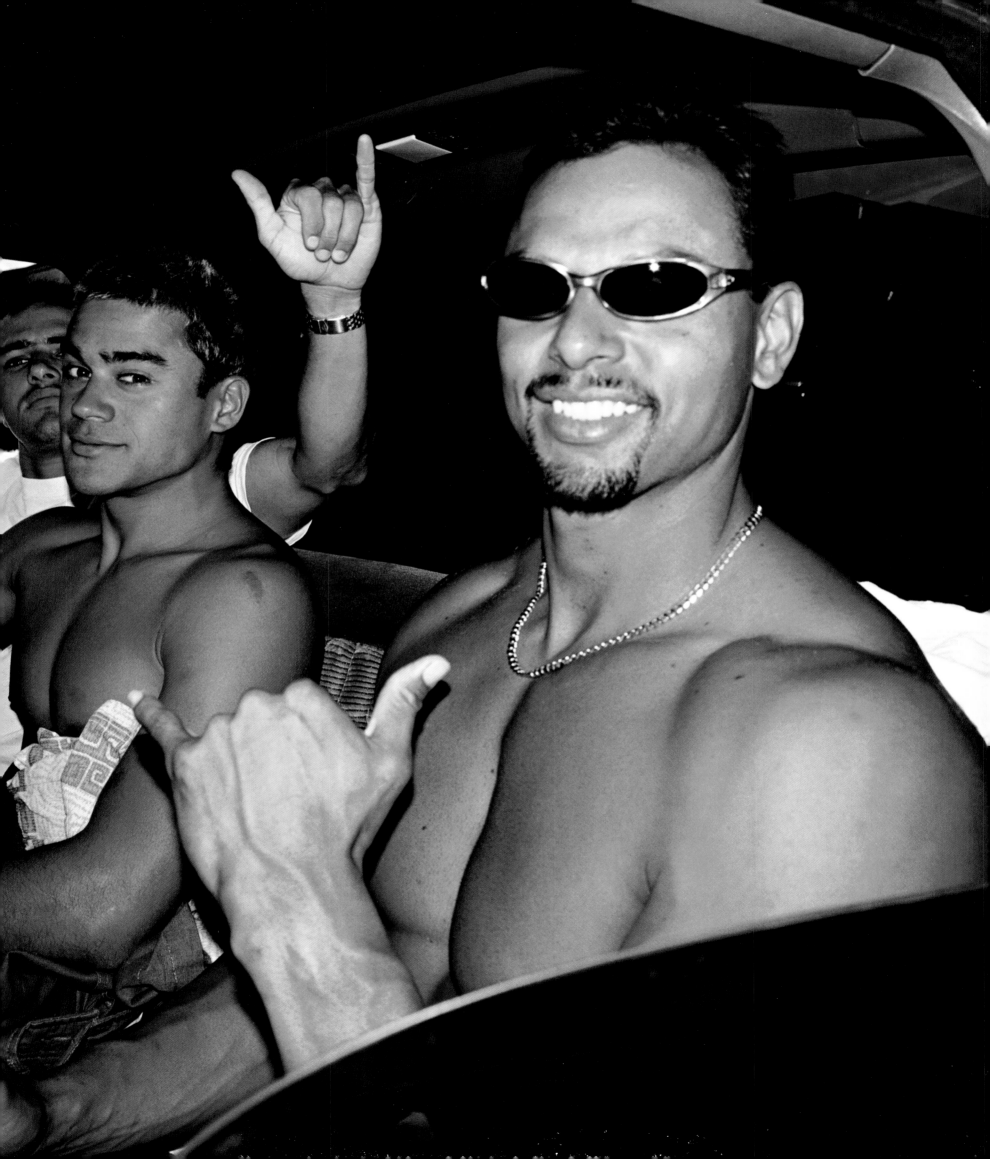

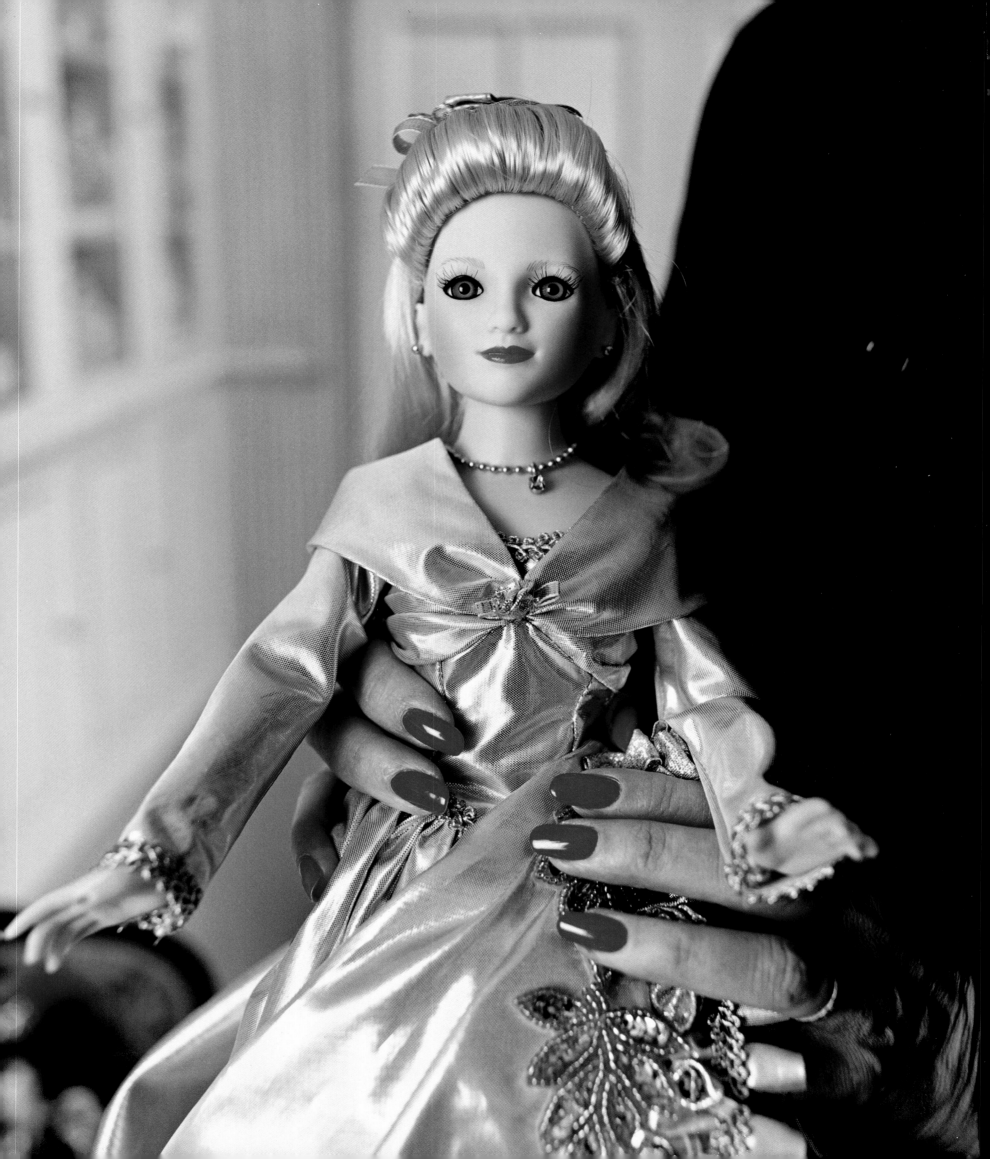

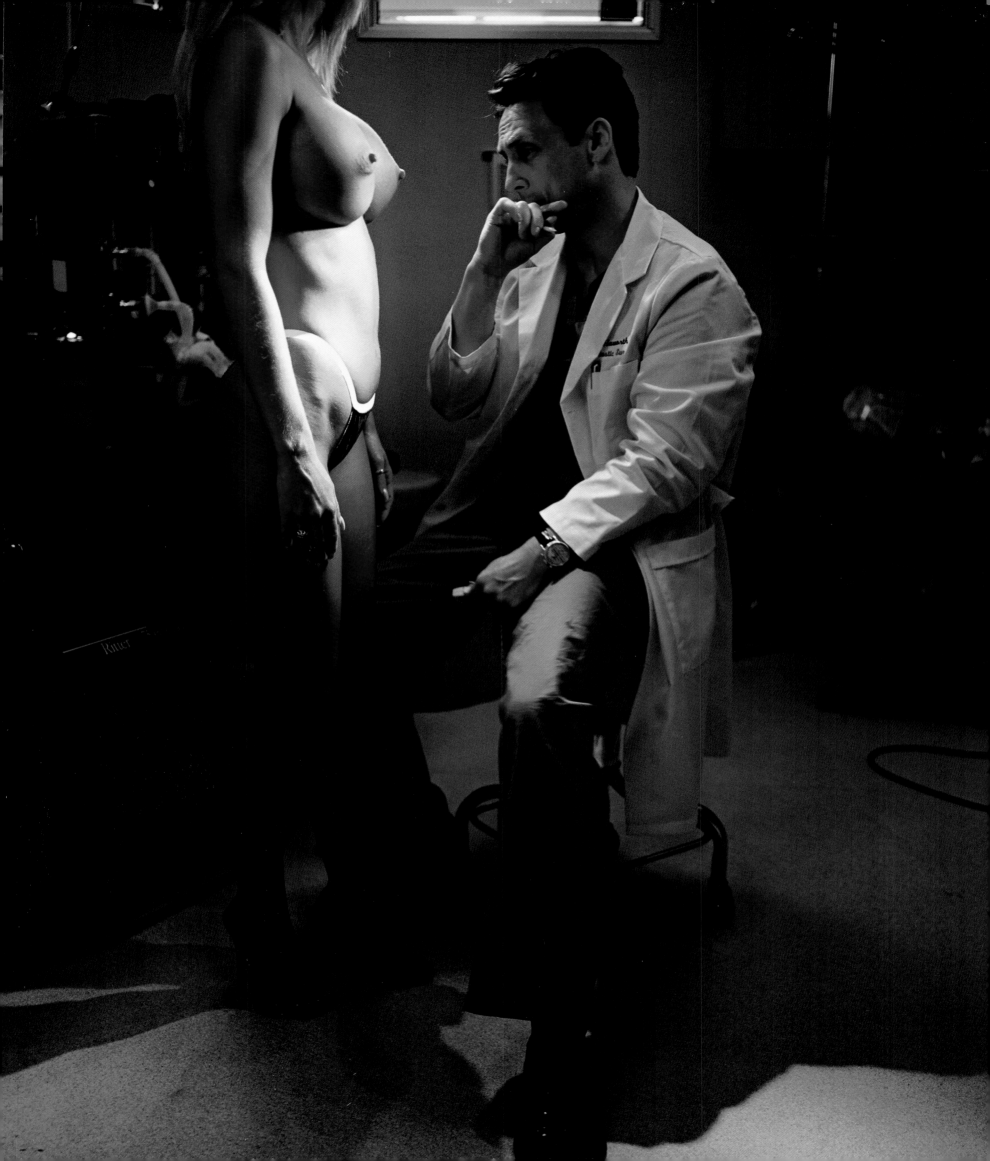

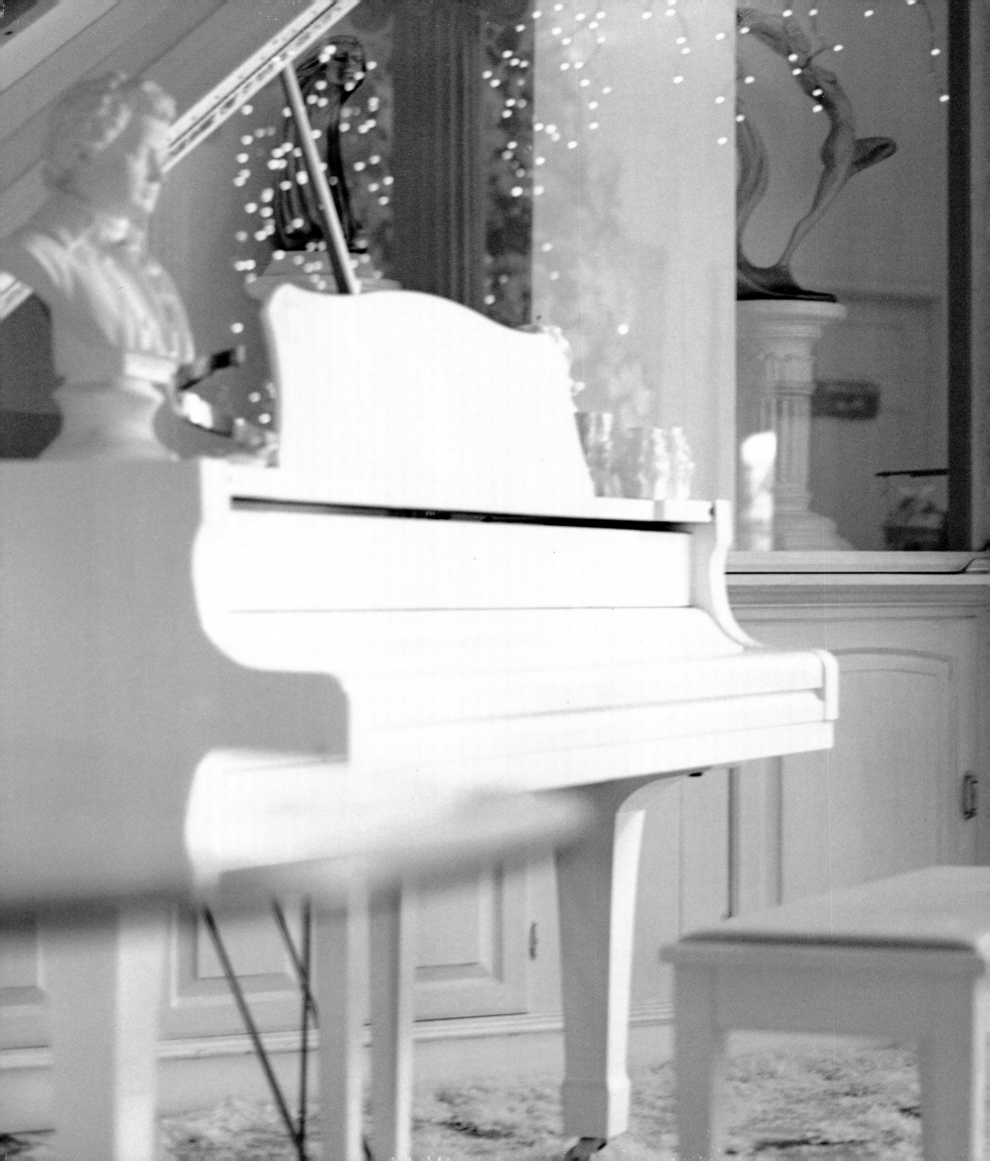

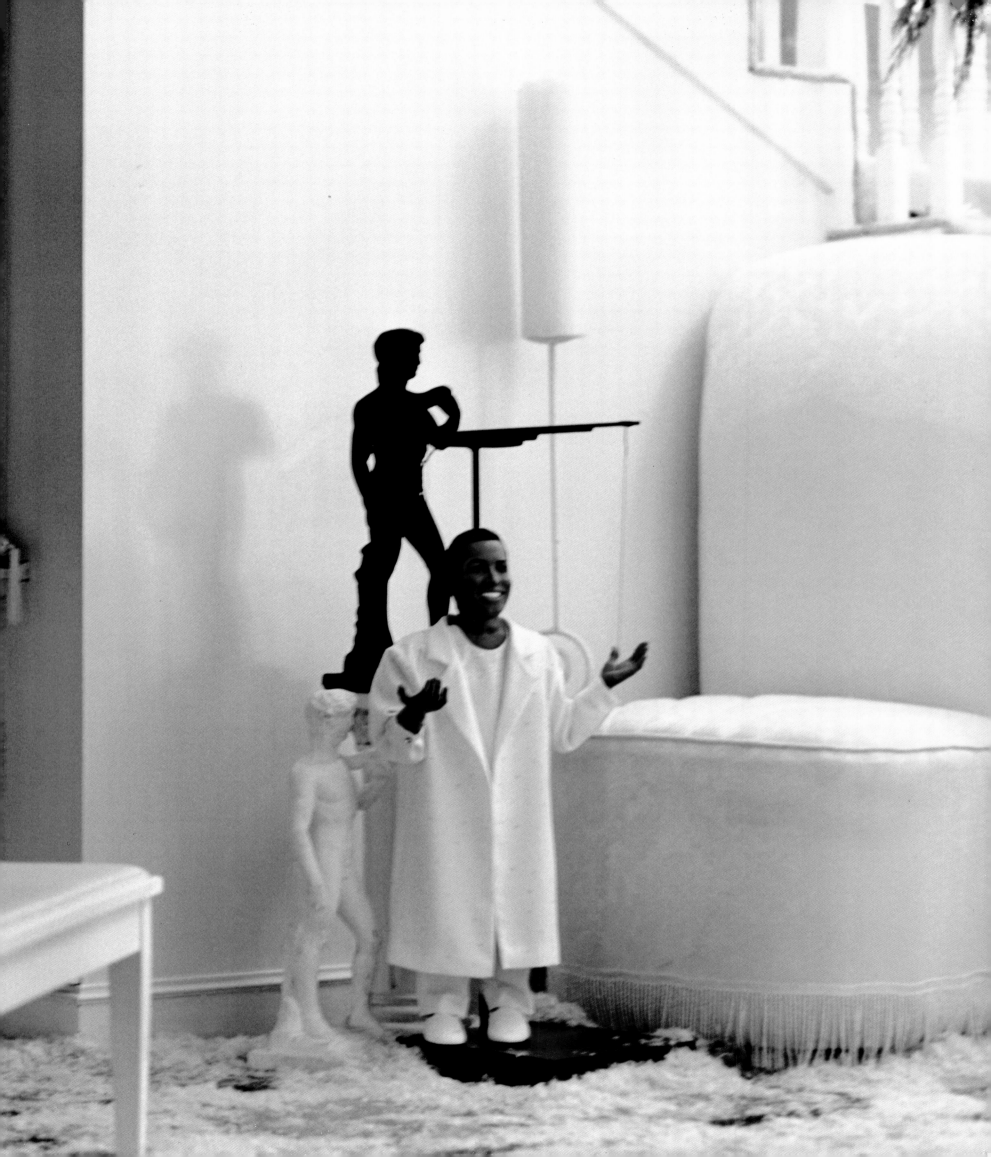

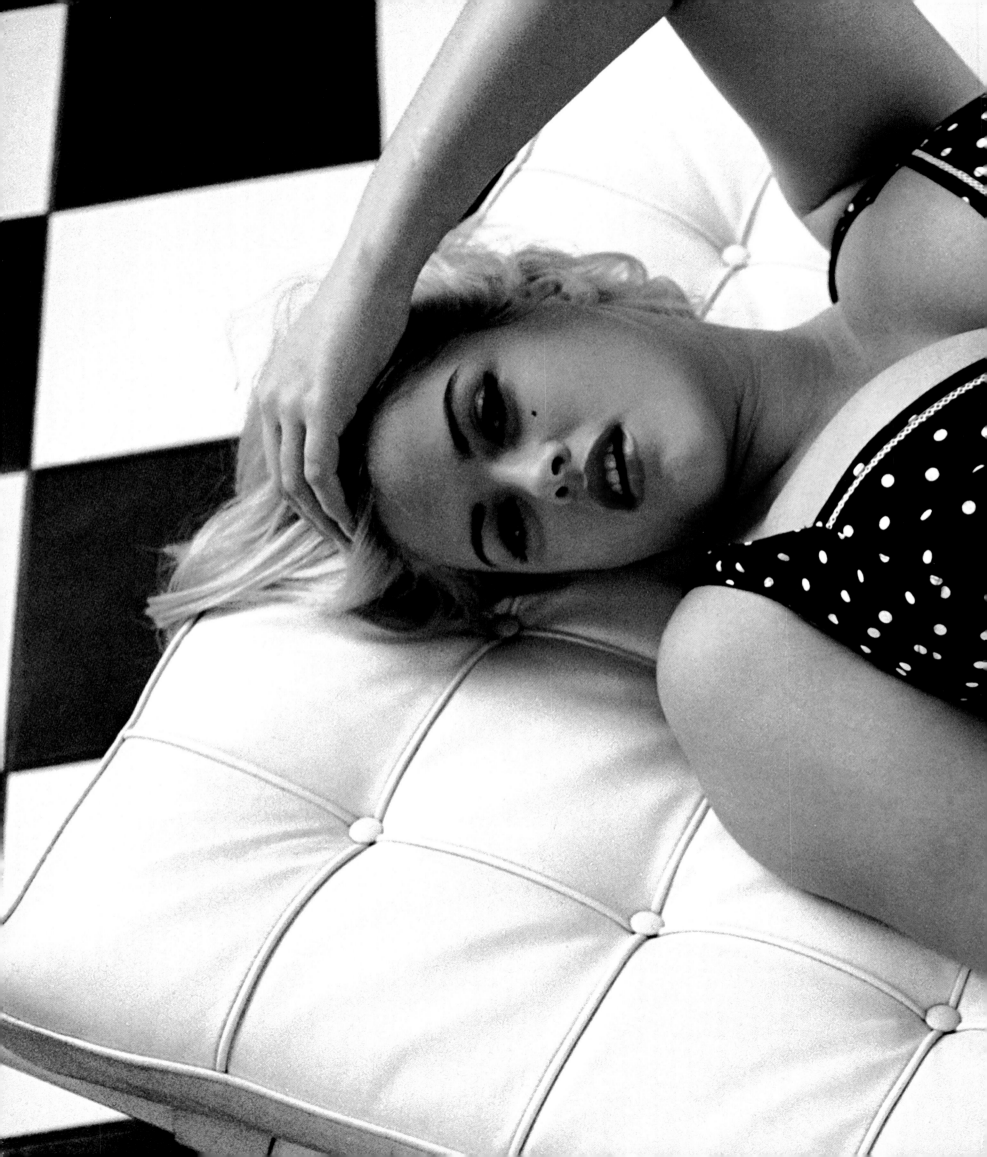

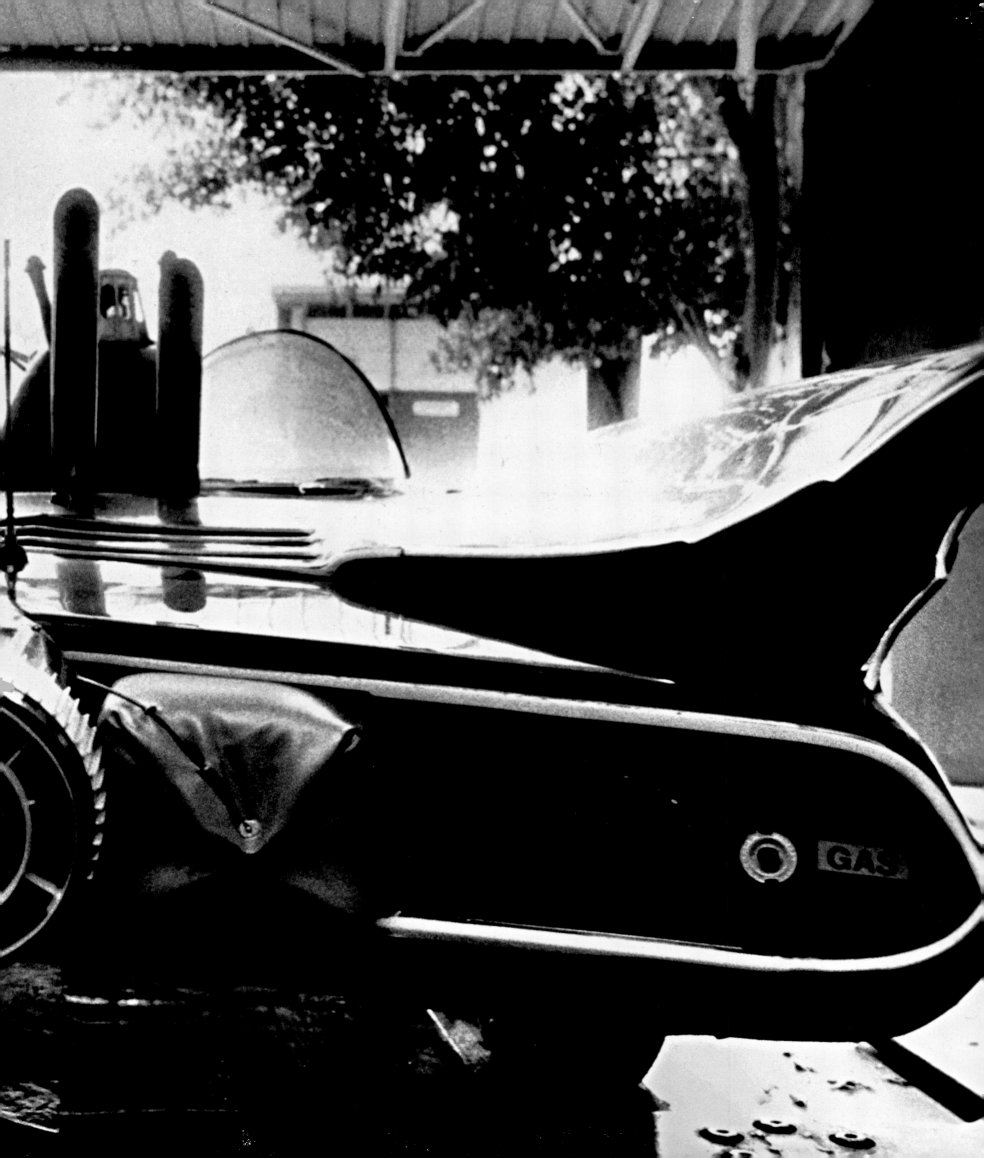

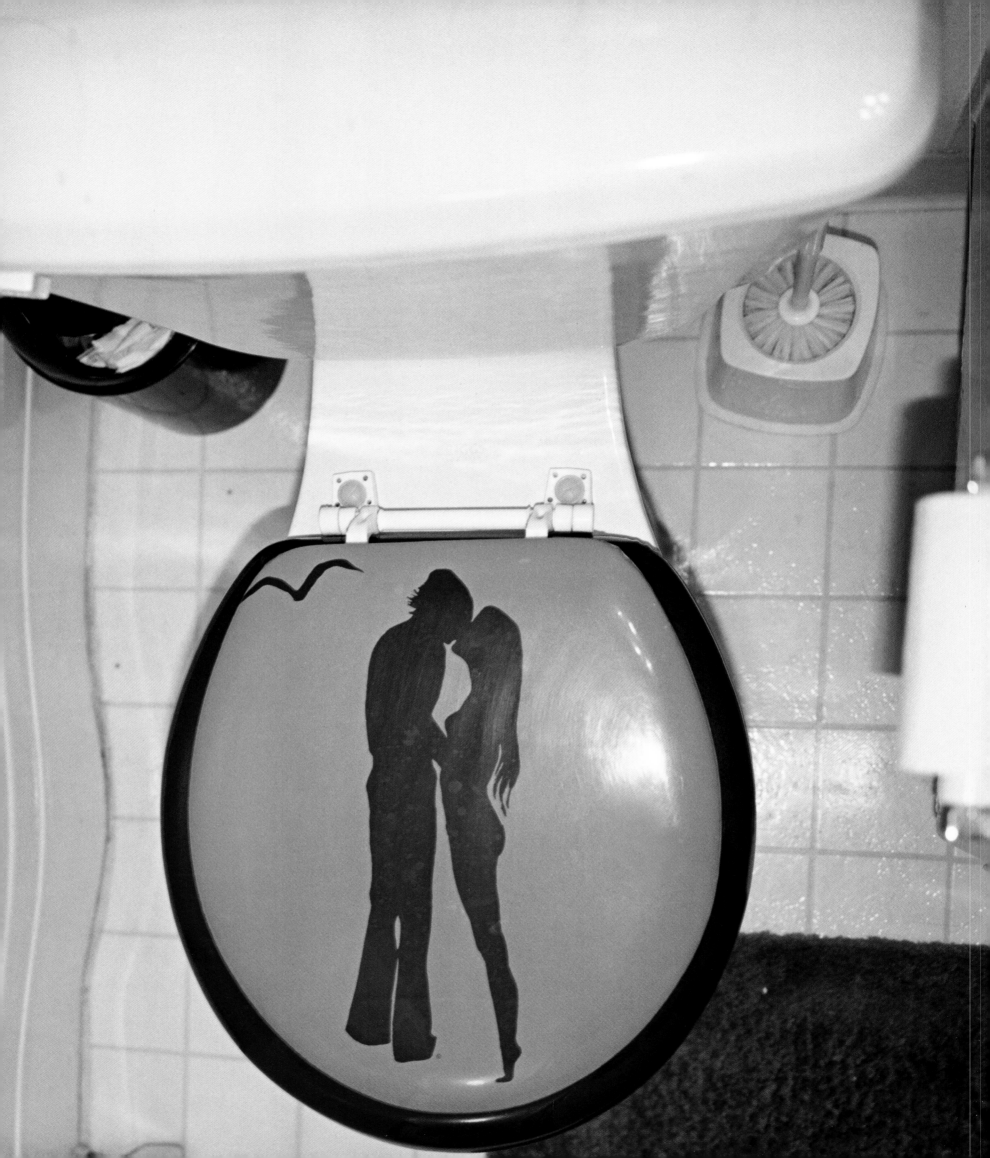

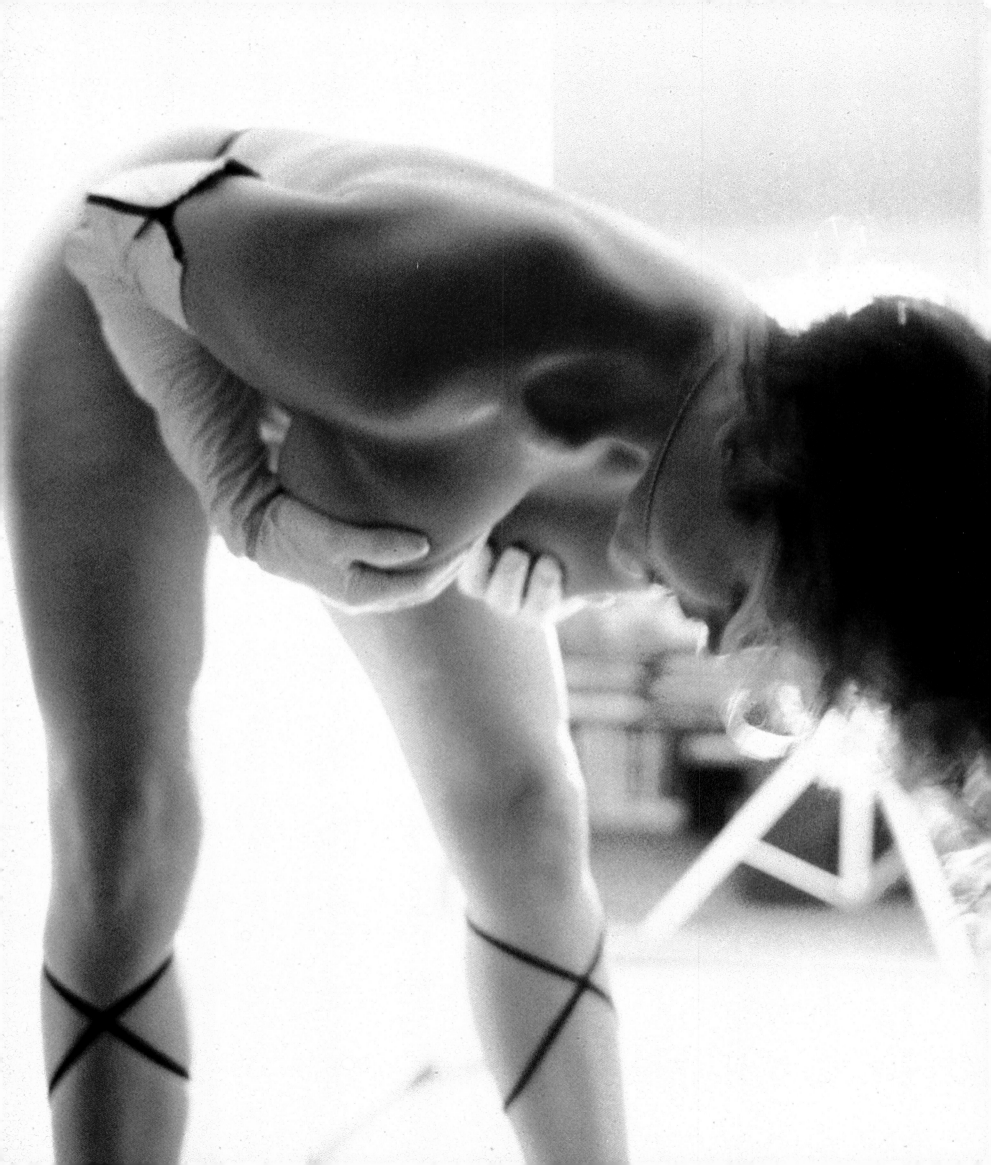

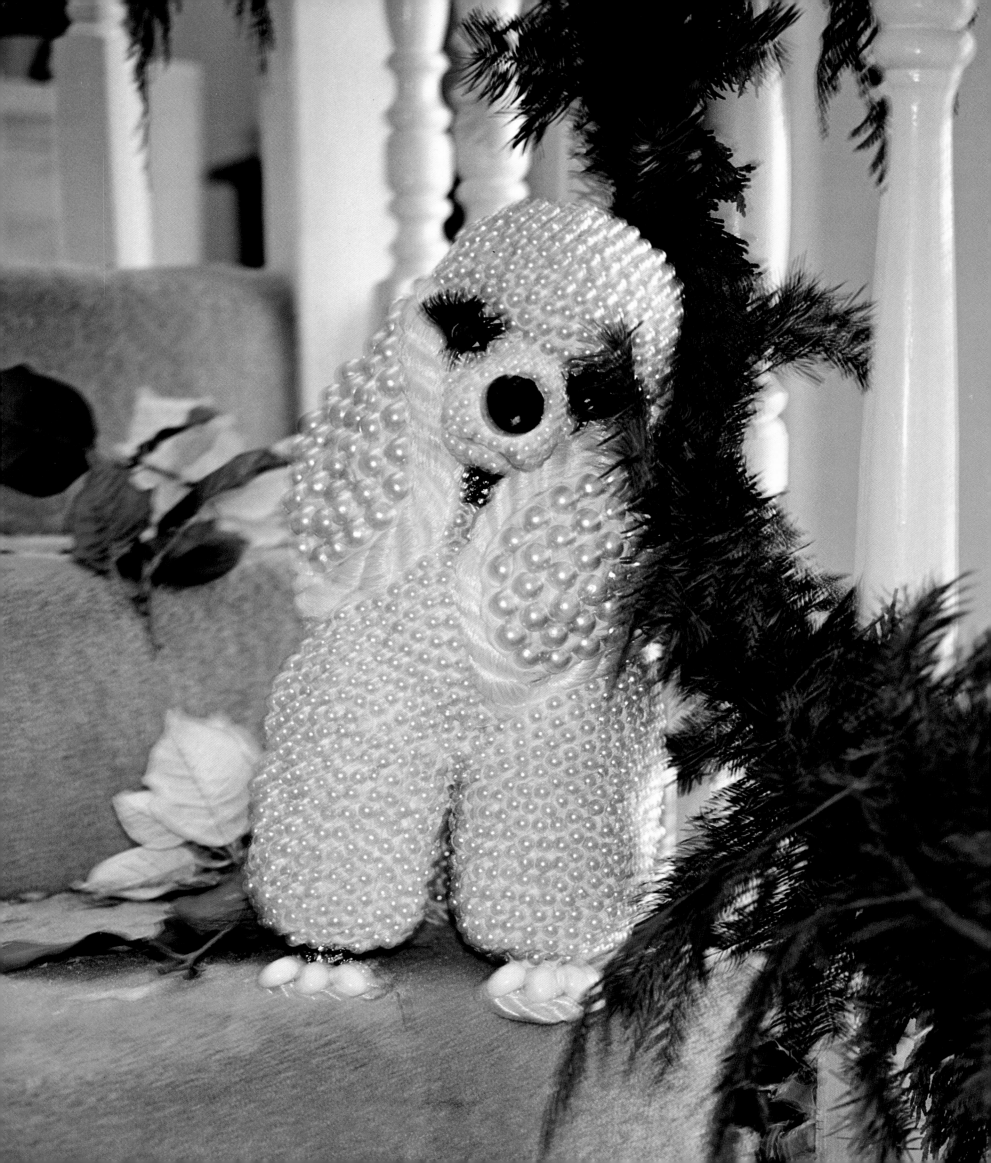

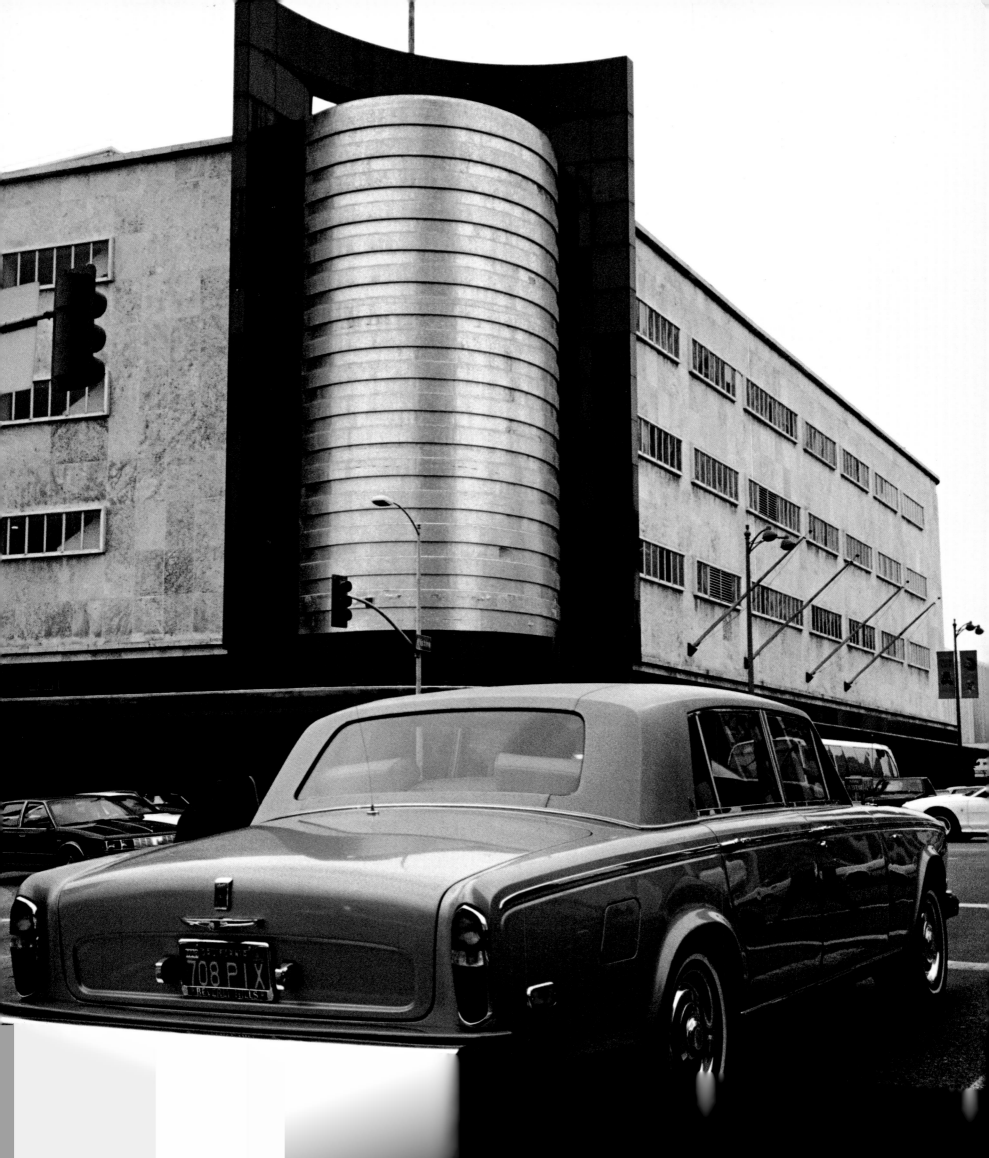

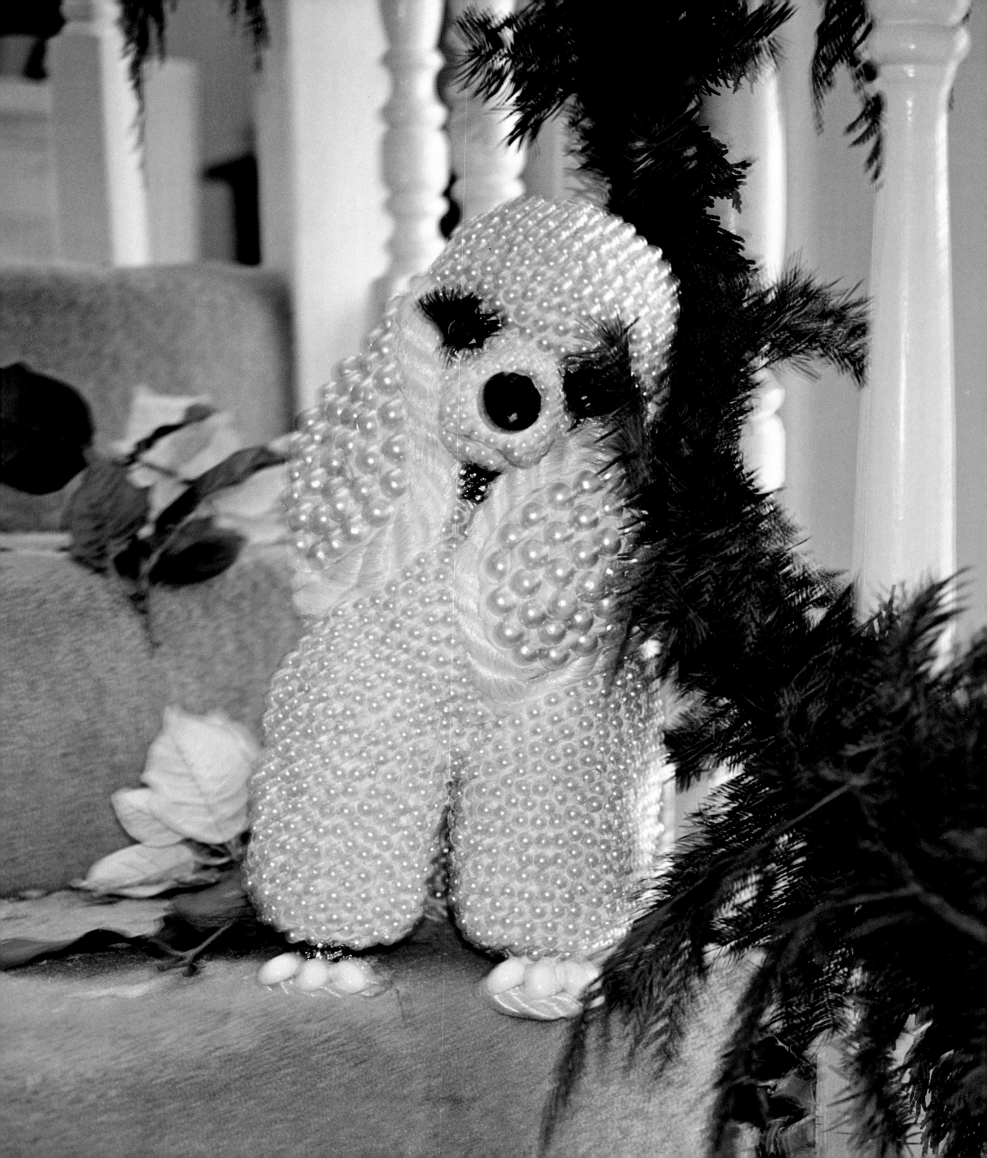

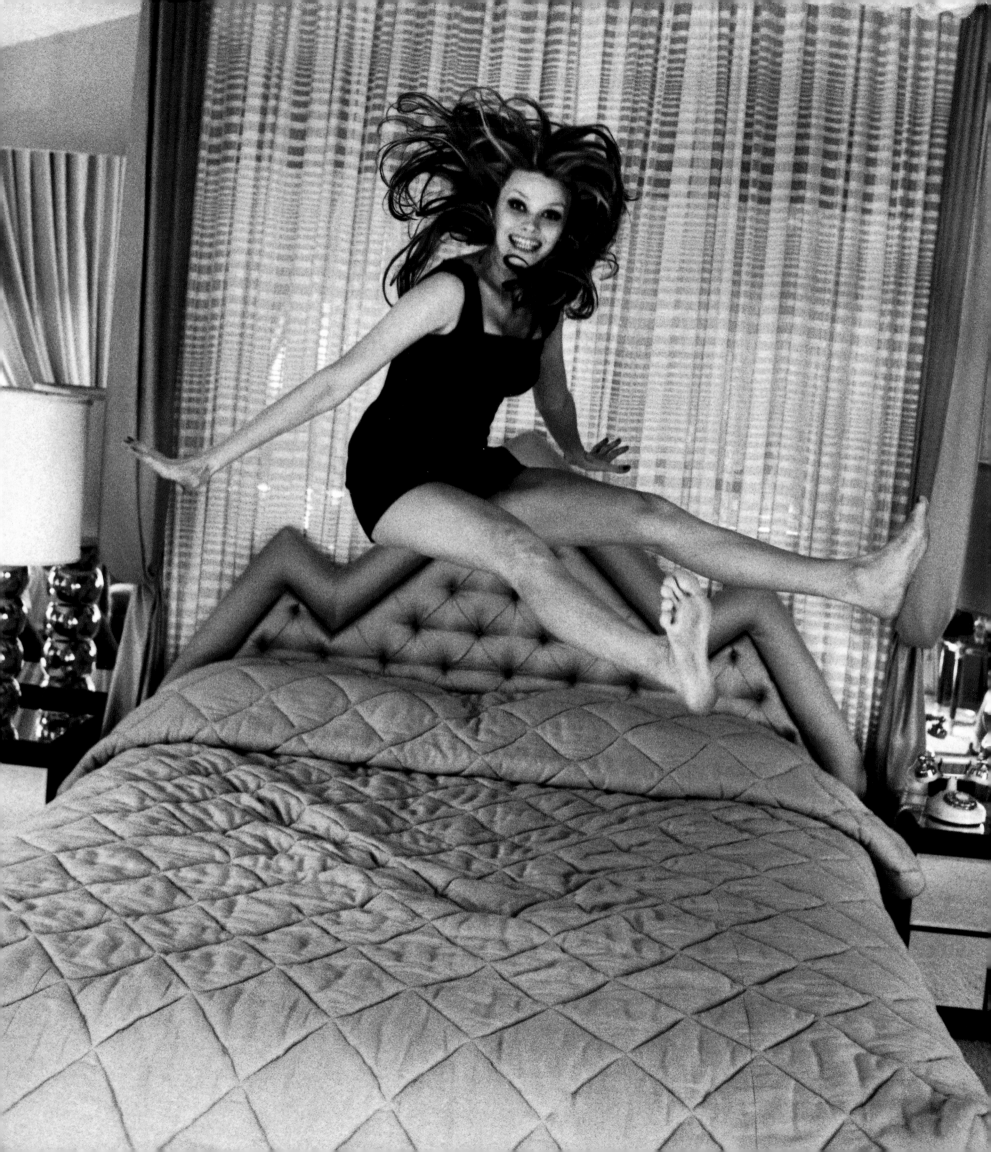

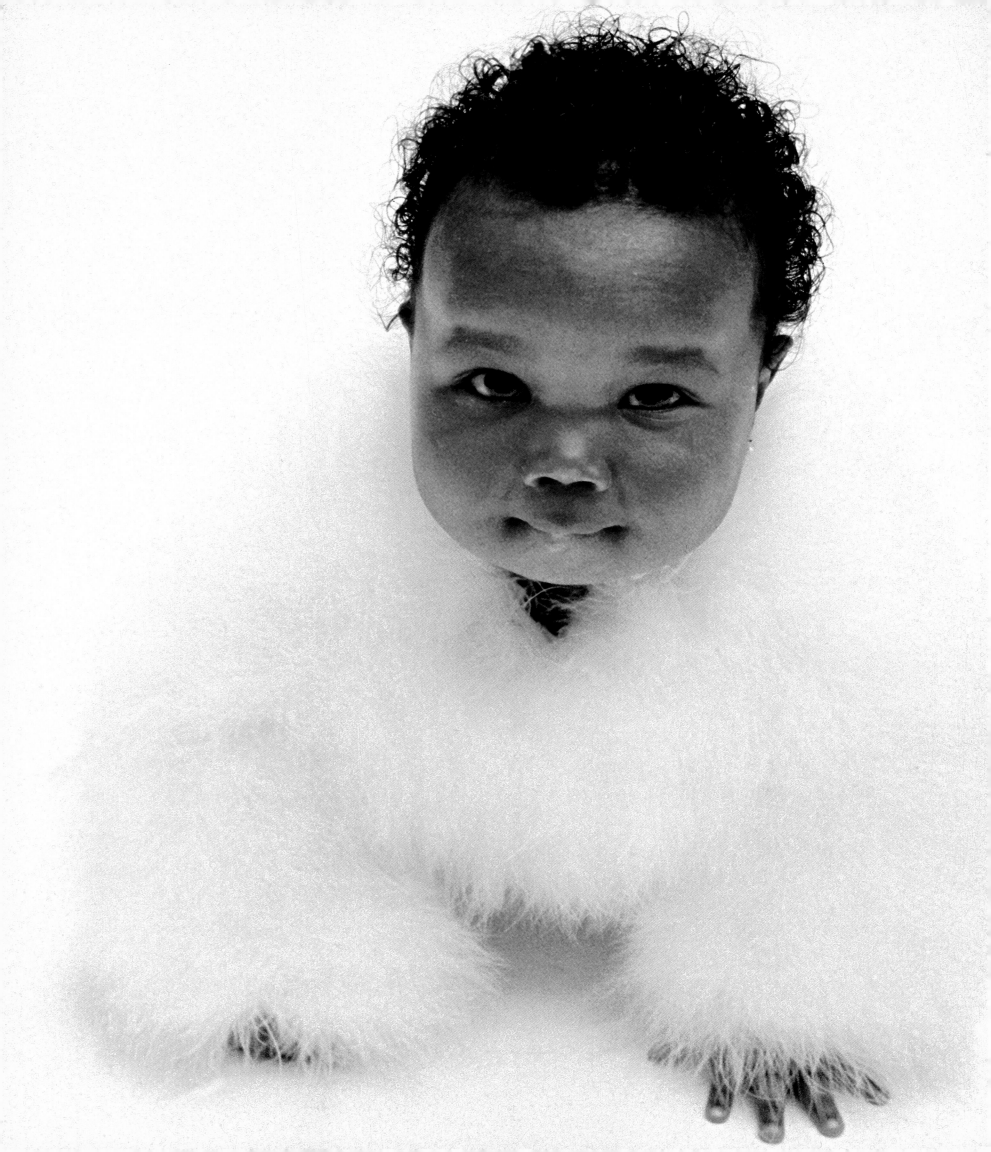

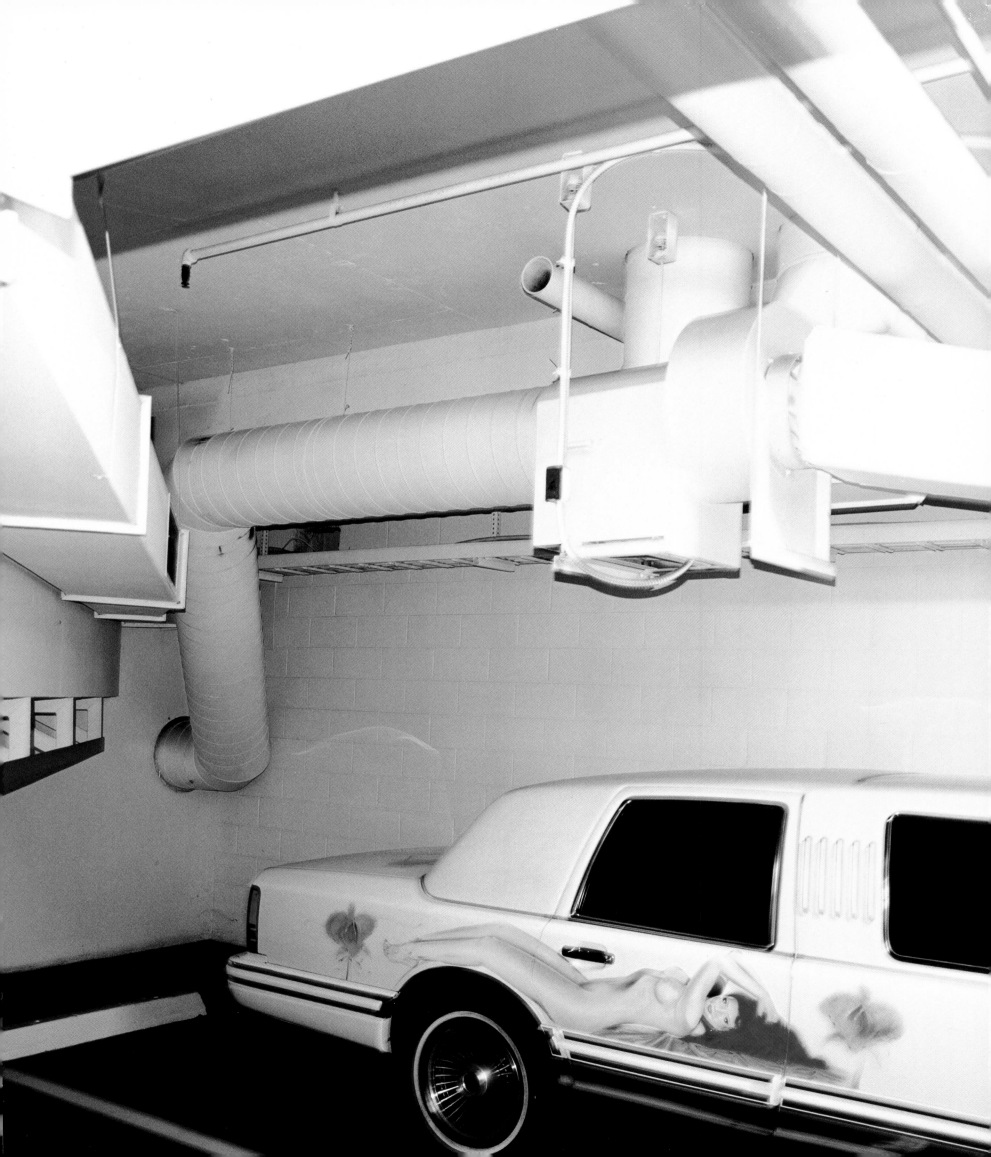

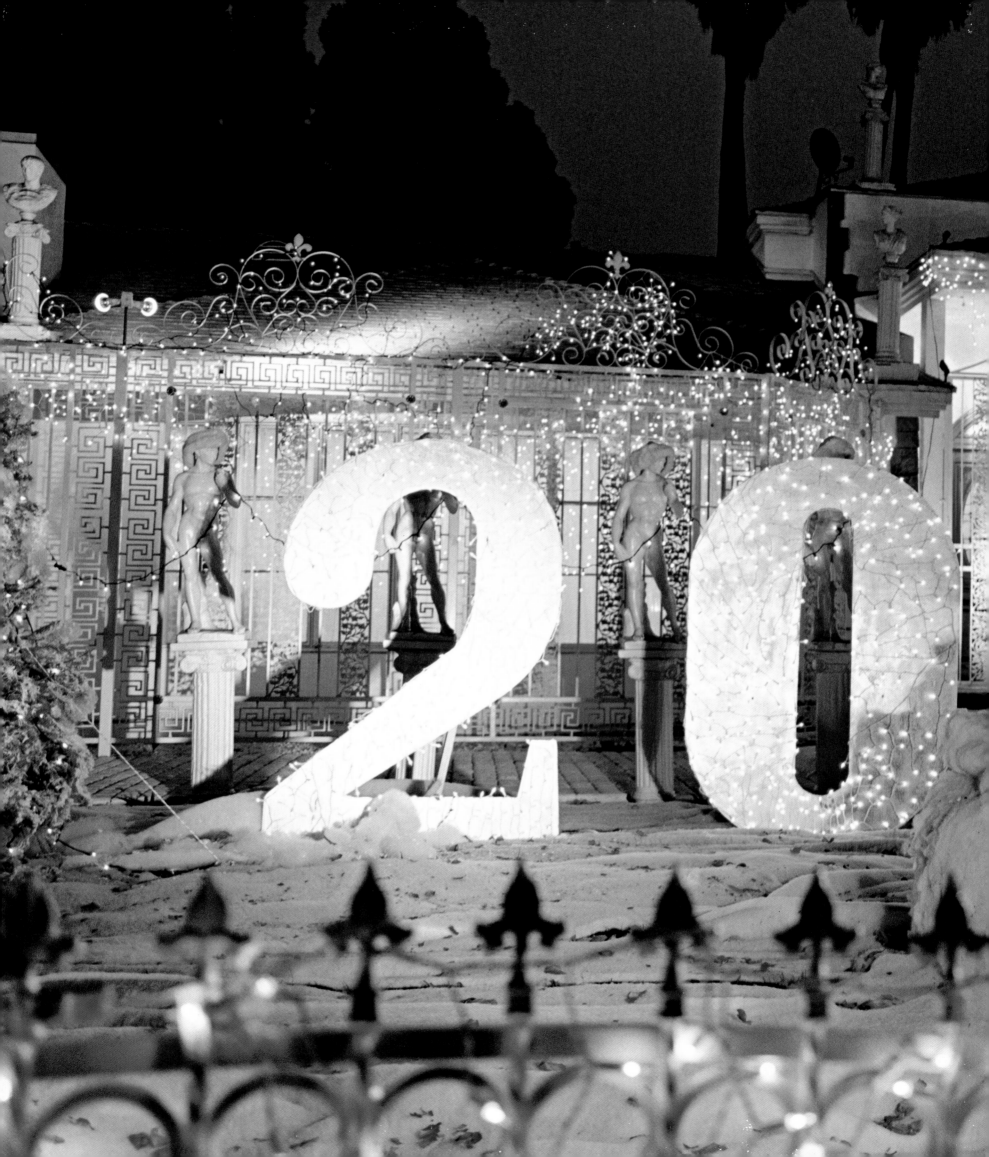

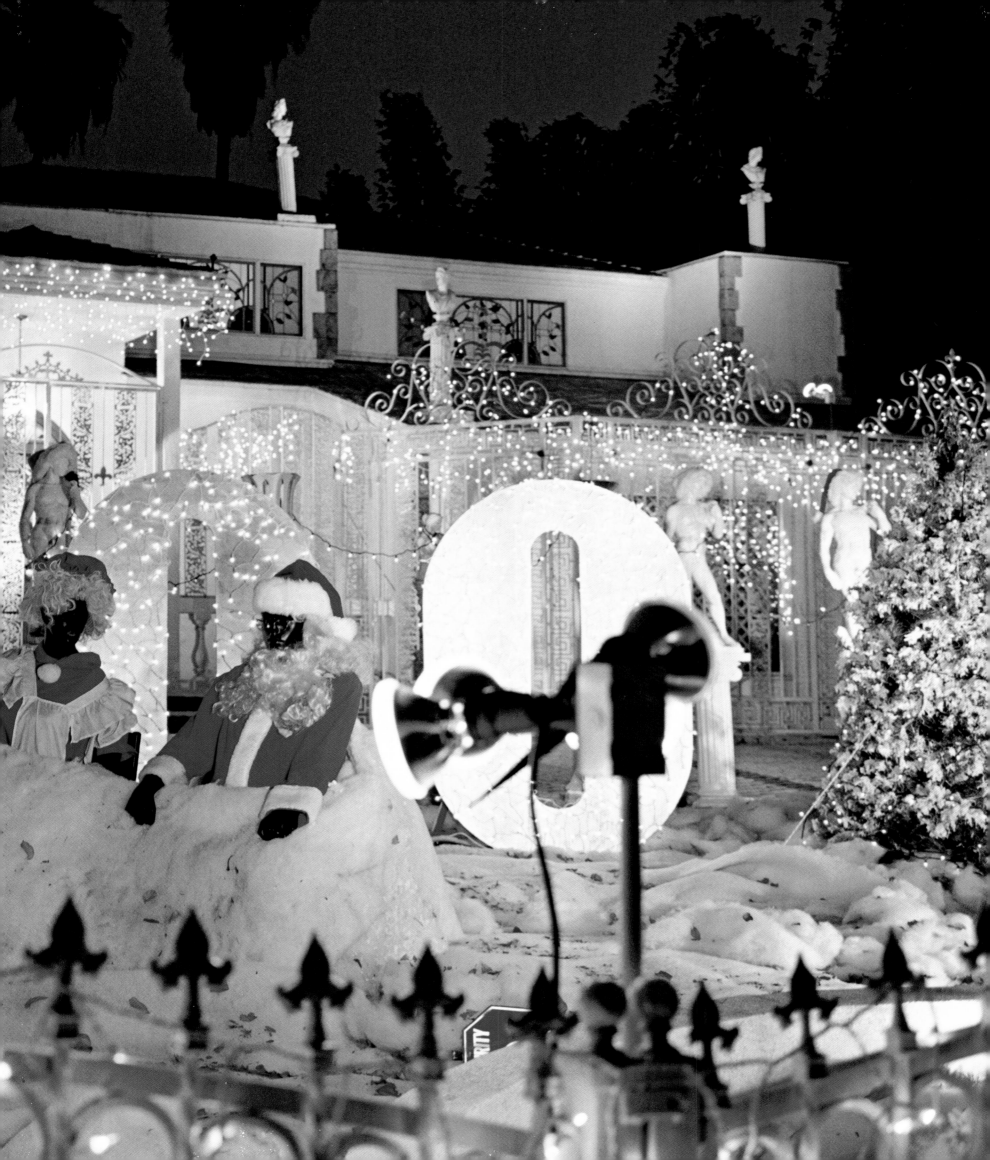

Index to plates

Dewey Nicks

Dewey Nicks, born in St. Louis, the gateway to the West, is the son of an advertising man. Family vacations were spent visiting Hollywood landmarks and hiking up and down Sunset Boulevard. Intoxicated with its glamour and eccentricity, Nicks moved to California where he studied photography at the Art Center College of Design in Pasadena.

Although he is a successful commercial photographer and director, it was fashion shoots for magazines like *Vogue*, *GQ* and *W*, that provided professional exposure for Nicks, as well as a backstage pass into L.A. subcultures. Plastic surgery, customized interiors and, above all, car culture lured him inside the genius of the surreal that so defined his dream of California and this, his first book, *Kustom*.

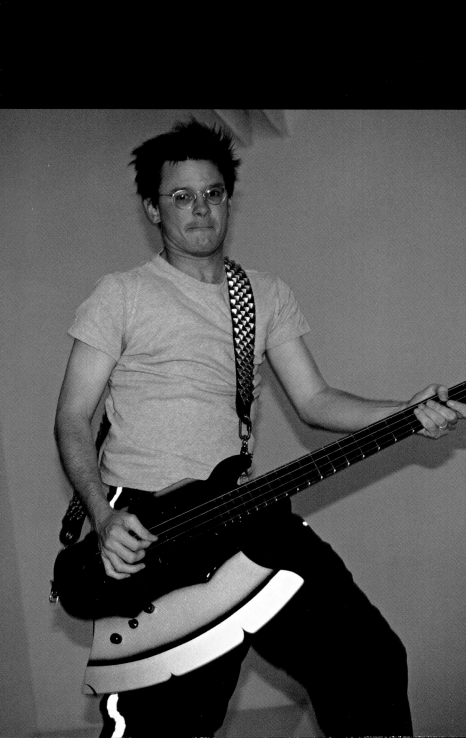

riend and collaborator Lisa Eisner for being so Kustom.
d for his care-filled treatment. Krista Rauschenberg for her
enugopal, Tom Adler, Greg Goldin, and Stephen Zeigler

Rebecca Bihr, John Collazos, Steve Dubrowski, Hugh Gannon,

e Bayley, Andy Boonthong, Tina Brown, Dominique Browning,
th Crowe, Warren Dern, John Duffin, Brad Dunning,
ilfiger, Susan Hootstein, Paul Jasmin, Audrey Kisner,
Jeff Preiss, Steve Ritchie, Chelsea Ryan, Pam Shamshiri,
Spindler, Kyle Thai, Mike Toth, Linda Wells, Anna Wintour,
Jicks.

oto Lab, Los Angeles, California.

This book is dedicated to Stephanie.

First Edition Published by Greybull Press
Los Angeles, California, USA

©Copyright 2000 Greybull Press

All rights reserved. No part of this book may be reproduced
by any means, in any media, electronic or mechanical, including
photocopy, recording or any other information storage and
retrieval system, without permission in writing from Greybull Press.

Photographs ©Copyright 2000 Dewey Nicks

Designed by Lloyd (+co)

Production by Lorraine Wild and Amanda Washburn

Robert Evans Interview by Greg Goldin

Edited by Lisa Eisner & Roman Alonso

Distributed by D.A.P./Distributed Art Publishers
New York, New York, U.S.A

Printed by Cantz, Germany

First Edition 2000

ISBN 0-9672366-2-2

Library of Congress Catalog Card Number: 00 134391

GREYBULL PRESS